P9-CDV-202

OLYMPICPORTRAITS
ANNIE LEIBOVITZ

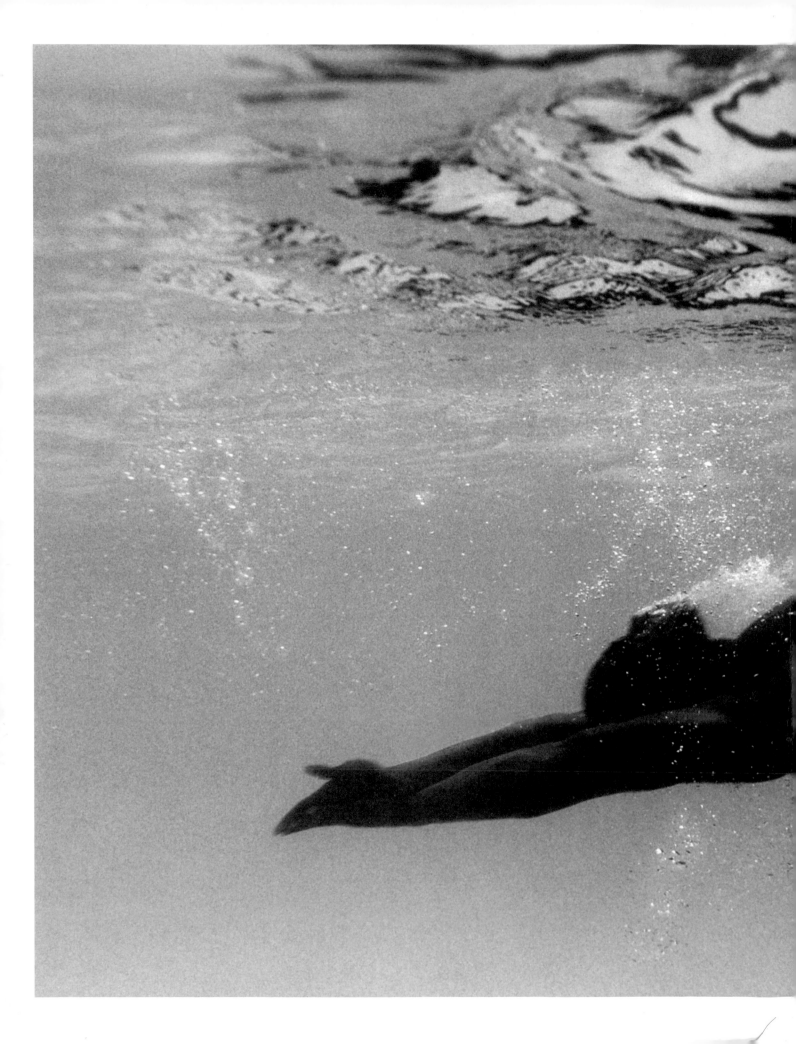

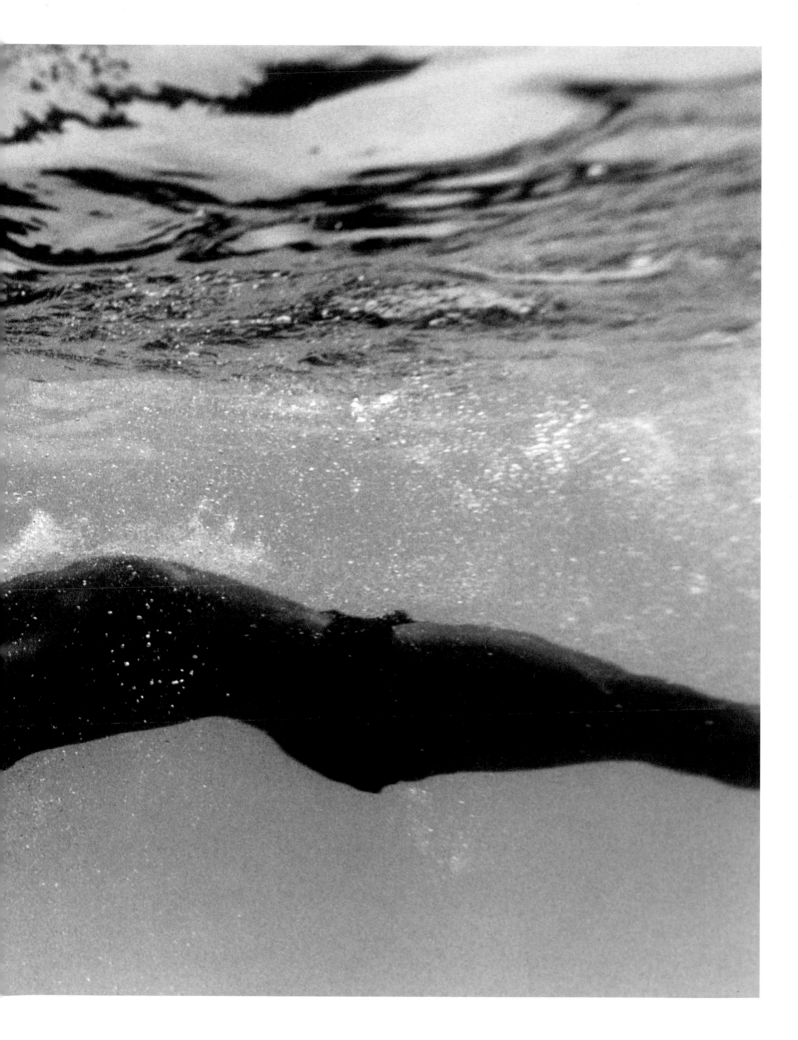

OLYMPICPORTRAITS
ANNIE LEIBOVITZ

A Bulfinch Press Book
Little, Brown and Company
Boston New York Toronto London

Designed by Raul Martinez

executive producer: Cassandra Henning
producer & stylist: Lisa LaMattina
printers: Jim Megargee & Cornelia van der Linde

First Edition
ISBN 0-8212-2366-6
Library of Congress Catalog Card Number 96-85445

Bulfinch Press is an imprint and trademark of Little, Brown and Company (Inc.)
Published simultaneously in Canada by Little, Brown & Company (Canada) Limited

PRINTED IN THE UNITED STATES OF AMERICA

INTRODUCTION

The invitation by the Atlanta Committee for the Olympic Games (ACOG) to take pictures of any aspect I liked of the 26th Olympiad, to be held in Atlanta in the summer of 1996, is the kind of assignment a photographer dreams about. Not because I'm a sports photographer but precisely because I am not a sports photographer. I'm a portrait photographer, a portrait photographer who has always been more interested in what people do than in the way they look. But what they do usually is reflected in the way they look. And there's nothing people do which is more intensely reflected in how they look than athletics. The energy, the concentration, the discipline of sport is something preeminently visual. The only activity that is comparable, in its sheer visualness, is dance . . . and perhaps it's my dance photography that has best prepared me for this work.

The pictures in this book are a selection of the photographs I took of American athletes who were training to take part in the Games in Atlanta. In meets and competitions all over the country, the best athletes were testing themselves, and being tested, as part of the process of qualifying for a place on the American teams. My photographs were done in individual and group sessions that I set up with the athletes. This gave me the opportunity to depict movement close up, intimately — when movement was the subject. Of course, it wasn't always the subject. Each time I worked with an athlete I had two possibilities: I could concentrate on the person (a portrait in the more conventional sense) or I could concentrate on the sport. Sometimes I was able to do both.

The first shootings took place in California over several days in December 1993. I brought some very young female gymnasts and their gymnastic equipment to a dry lake bed outside Los Angeles; I took some runners there, too. Then I did a shoot at the UC Davis Olympic pool with a swimmer and two divers. In the spring of 1995 I began a year of concentrated shootings around the country, which took me to the Olympic Training Center at Colorado Springs, where I photographed fencing, wrestling, and weightlifting; to Atlanta, where I photographed women's field hockey at the Clark Atlanta University Stadium, the modern pentathlon at a riding academy, men's volleyball in a park outside the city, and team handball in a downtown studio; and again to Colorado Springs, to photograph track cycling in the Memorial Park Velodrome and boxing in the Olympic Training Center. The work continued in venues in California (San Diego, Chula Vista, Irvine, Mission Beach, Culver City), Texas (Houston, Fort Worth), Florida (Miami, Key Biscayne, Sanford), Oregon (Portland), Georgia (Conyers, Savannah, Fort Benning, Atlanta), and Michigan (Marquette, Shelby Township) until early June 1996. All the categories of sports in which Olympic athletes compete are represented in the book.

Of course, some sports are more "visual" than others. Anything to do with water, from diving to rowing to sailboarding, seems wonderful. So does anything that involves a throw or a leap or jump, from decathlon to equestrian events, because of the extension of the whole body or the arm, the leg. The sports I expected to be beautiful were beautiful. I became a bit wary of the seductions of such traditionally elegant sports as diving, javelin throwing, fencing, pole vaulting — especially the ones that produce a heroic body line. I was glad to find grace and heroic form and appealing oddity where I didn't expect it: in synchronized swimming, for instance, and in men's water polo, where the photographs show the work that's done out of sight, under the water.

Anyone who looks at photographs of previous Olympics will see that the ideal form in a given sport is not something fixed once and for all. When the aim is to get the pole vaulter over the crossbar more quickly, the diver into the water faster and with less splash, these sports won't be performed in the same way, with the movements once thought most beautiful. The pole is now fiberglass, so the jumpers are jumping higher; they can pull themselves up and over the crossbar without flinging out their legs to clear it, then drop straight down. There are no more swan dives. The dive is mostly straight lines.

As I've said, there is something similar in photographing dancers and photographing athletes. In both, you are photographing ideal bodies and ideal uses of the body. And because athletes, like dancers, are performers, they are often asked to pose. But sport is not, any more than dance, *about* posing. It's about movement — which the photographer is trying to catch in a single image. Film, TV, video can record the movement. A photograph must represent it. And that limitation is its strength. A photograph is the most powerful, the most memorable rendering of movement precisely because you get to stop the moment and look at it. That's why we remember photographs, and can summon up hundreds of them in our heads. You don't remember, in the same sense, moving images. (From moving images, you only remember "stills.")

So, in sport as in dance, the camera is making a fixed image of something happening in time. The fixed image represents a fraction of a second of that movement. It has to be just the right slice of time, right in the sense that it can stand for — and suggest — the whole movement. And it's all happening very fast. In the first photograph I took of the sprinter Dennis Mitchell coming out of the starting blocks, all I had was his foot. (Rule: You don't see it when you photograph it. If you see it, you've missed it.) Eventually I did get the shot. It shows that when Mitchell came out of the starting block, he was literally parallel with the ground — it looks as if he's about to fall. (His start was so fast that he had to go half the length of a football field before he could stop.) That was the moment I wanted, before the leg straightens and the body goes diagonal.

In sport, unlike dance, speed is always a plus. To go faster, higher, farther, longer — that is the point in many, though not all, sports. (In dance, you want to go higher — the dancer wants to be freed from gravity — but not necessarily faster or longer.) And there is a different role of competition. Dance is competitive, but the competition is not expressed so numerically. Sport is centered on the keeping and breaking of records.

Women have been breaking records, by the increasing number of sports in which they participate and the rising level of their performance. This Olympiad is the first for the women's triple jump, the women's soccer team, and women's fast-pitch softball. I was moved by the range of the faces and bodies of the women athletes, the youngest to the most seasoned — from the Romanian-born gymnast Dominique Moceanu, who is fourteen years old, to the captain of the basketball team, Teresa Edwards, who will be competing at Atlanta in her fourth Olympic Games.

Every sport (like every art, including dance) has its stars and its superstars. And some of them are in this book, like Gwen Torrence and Michael Johnson and Dominique Moceanu and Carl Lewis and Jackie Joyner-Kersee and Leroy Burrell and Mike Powell and Teresa Edwards (forgive me for the names I've inadvertently left out). But all the athletes I photographed for the book seemed to me heroic, whether they made the Olympic team or not (a few of them, despite the best expectations, didn't); whether, if they made the cut, they come away from these Games with a gold or silver or bronze medal or nothing. I admired them all — and the women especially — for the fierceness of their devotion to the idea of doing something better, always better.

The Games are intensely, heartbreakingly competitive. Every athlete wants to win. But every athlete also knows that the point of competing — of the effort, the strain, the self-sacrifice involved in training to be world-class — is not only winning, which often means being the fastest. It is also about being "in form." And about euphoria — about feeling good. That's why the book ends as it does: showing a terrific athlete, a world sailboarding champion, Mike Gebhardt, having a good time in the water, far from the struggle of winning and losing.

Originally, I had thought that the book would also include photographs taken during the Atlanta Summer Olympic Games. But that would bring other subjects before my camera besides the athletes: the spectators, the new facilities, the media coverage, the spectacle, the advertising. On the occasion of the centennial of the revival of the Games, it seems hard not to have some reservations about how far their current evolution has taken them from the spirit of Olympics past. But this issue barely arose in these photographs, except that I did have to insist with some, though not all, athletes that they not wear clothes with the logo of the company whose products they were endorsing.

That's why I chose to make a book out of photographs taken during the preparation for, on the road to, the 26th Olympiad. It's in the preparation for the Olympics that we can be closer to the spirit of what the Games were meant to mean — and do mean, ideally. To photograph athletes when they are still preparing means to concentrate on the athletes themselves. Their dedication, their joy, their pain, their mastery is what makes everyone care about the Olympic Games.

ANNIE LEIBOVITZ
June 1996

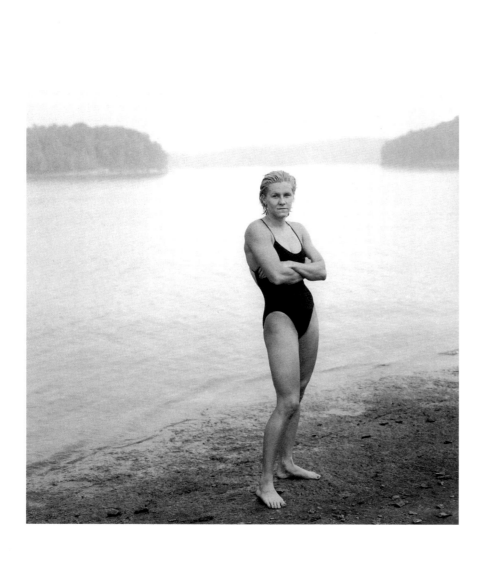

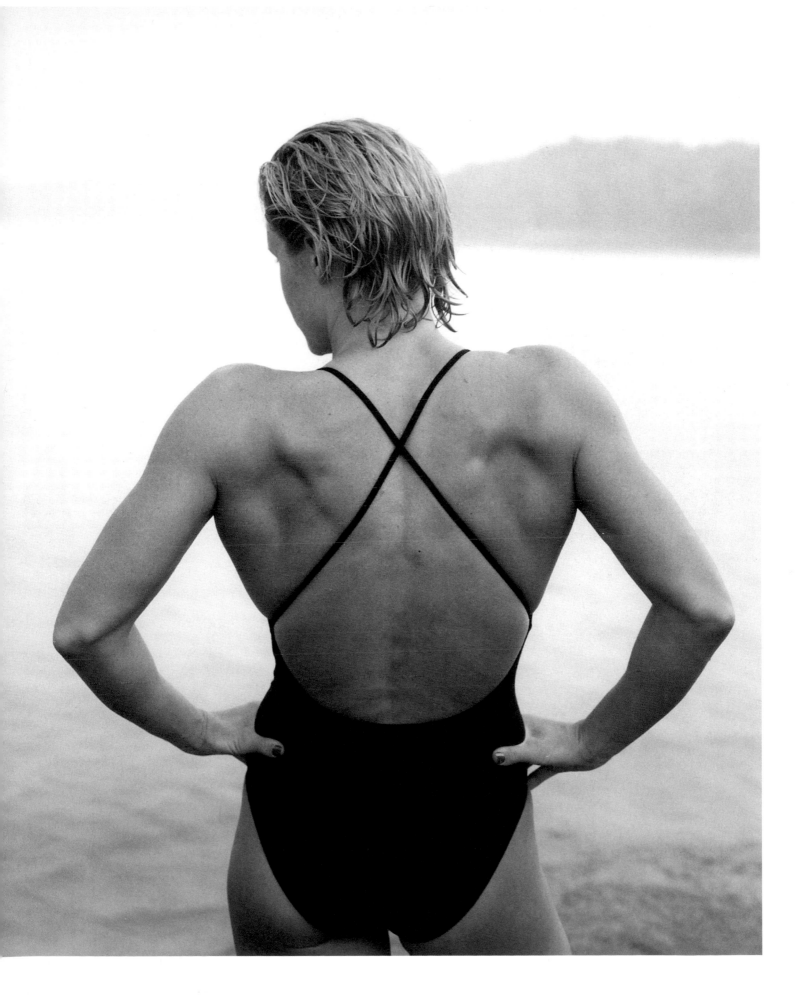

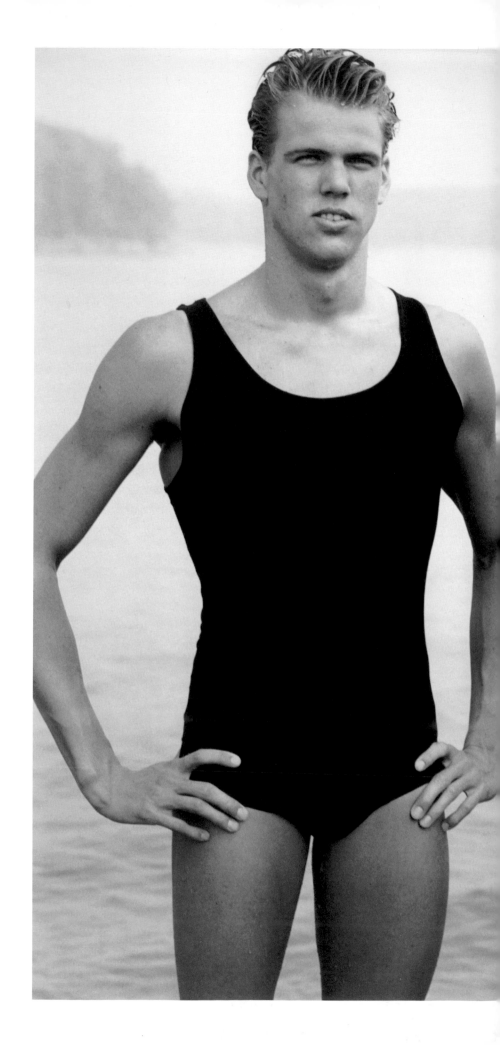

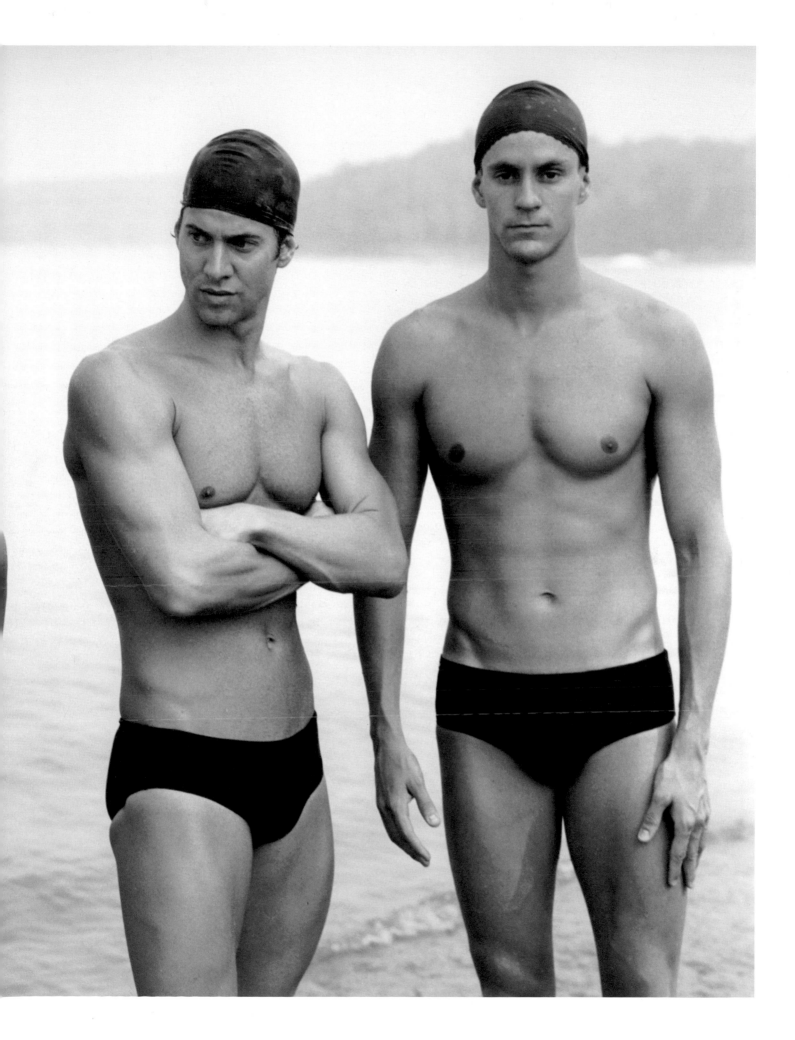

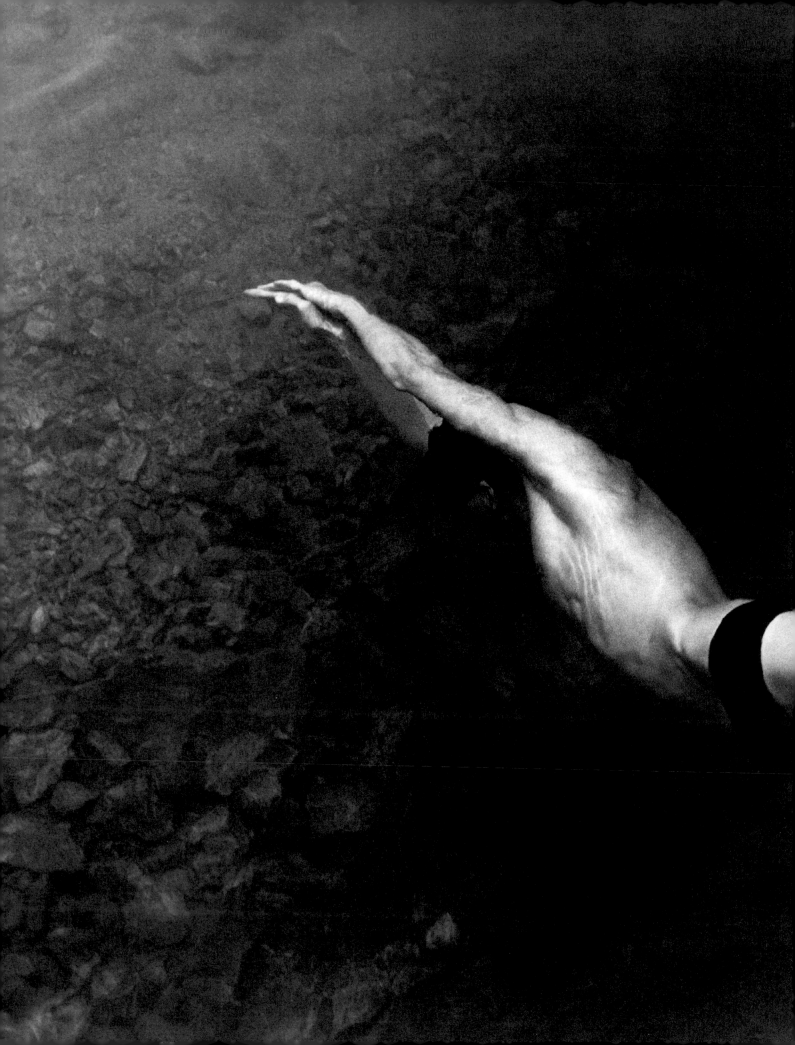

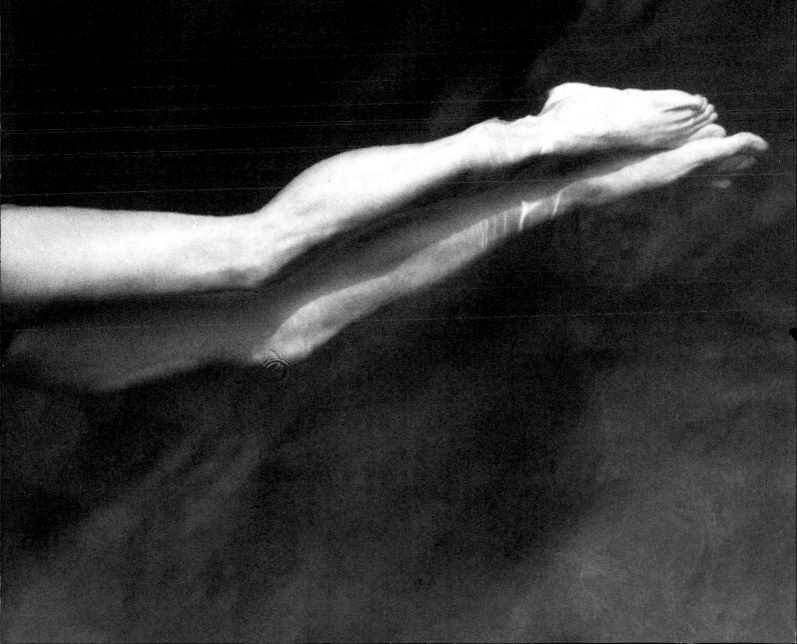

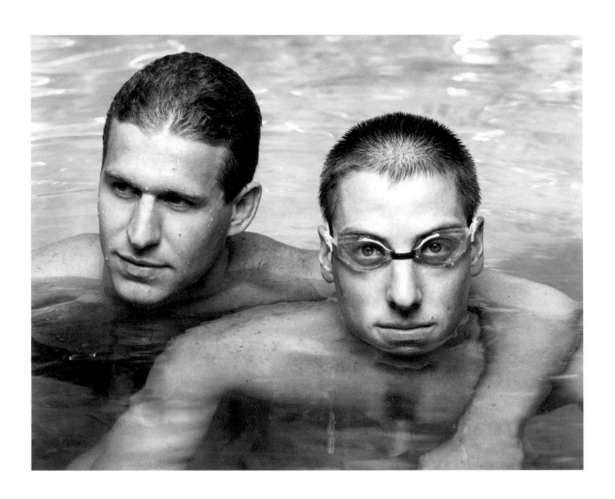

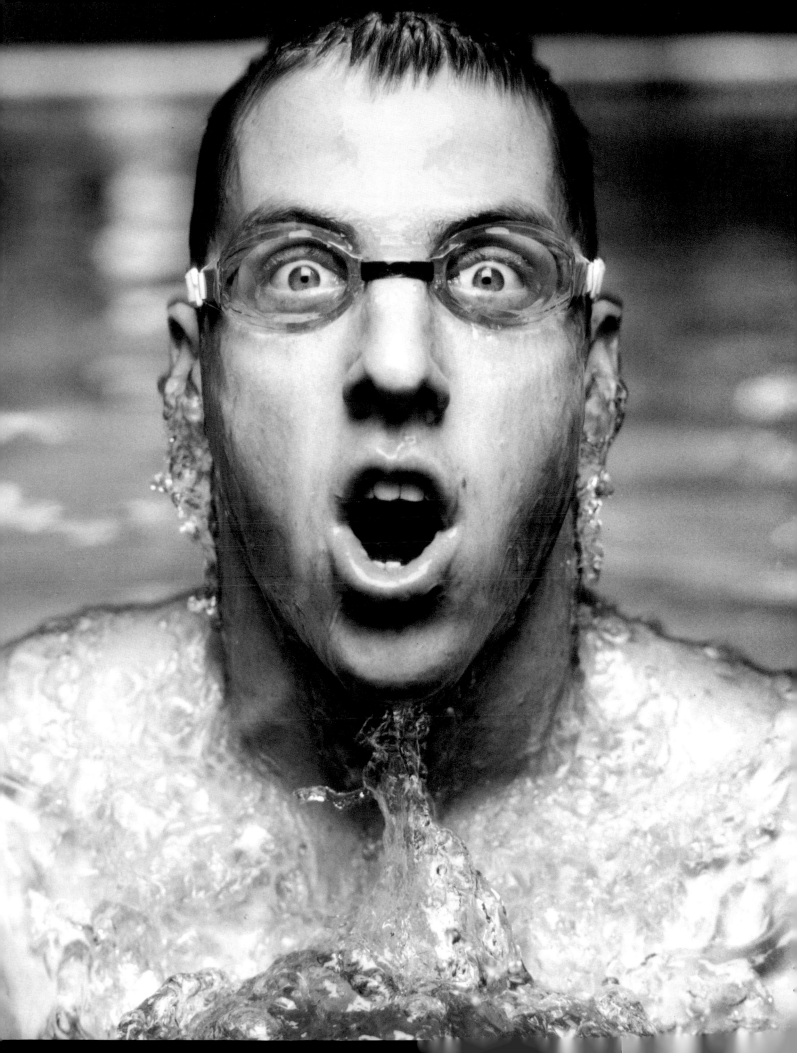

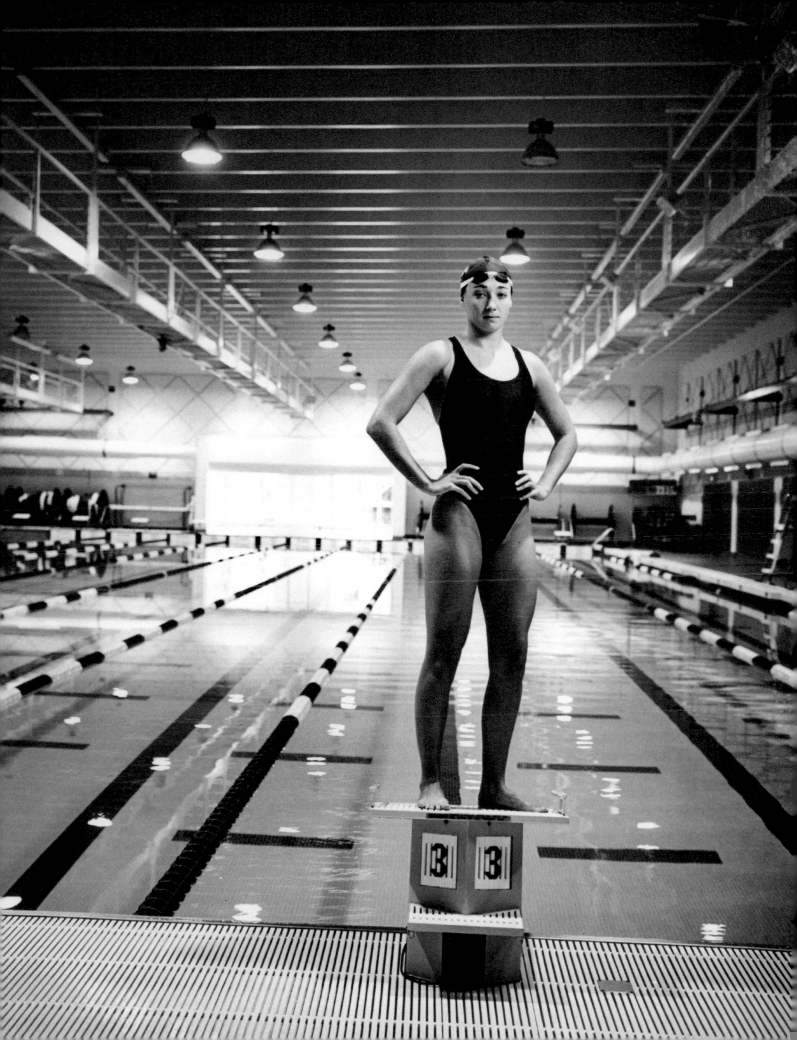

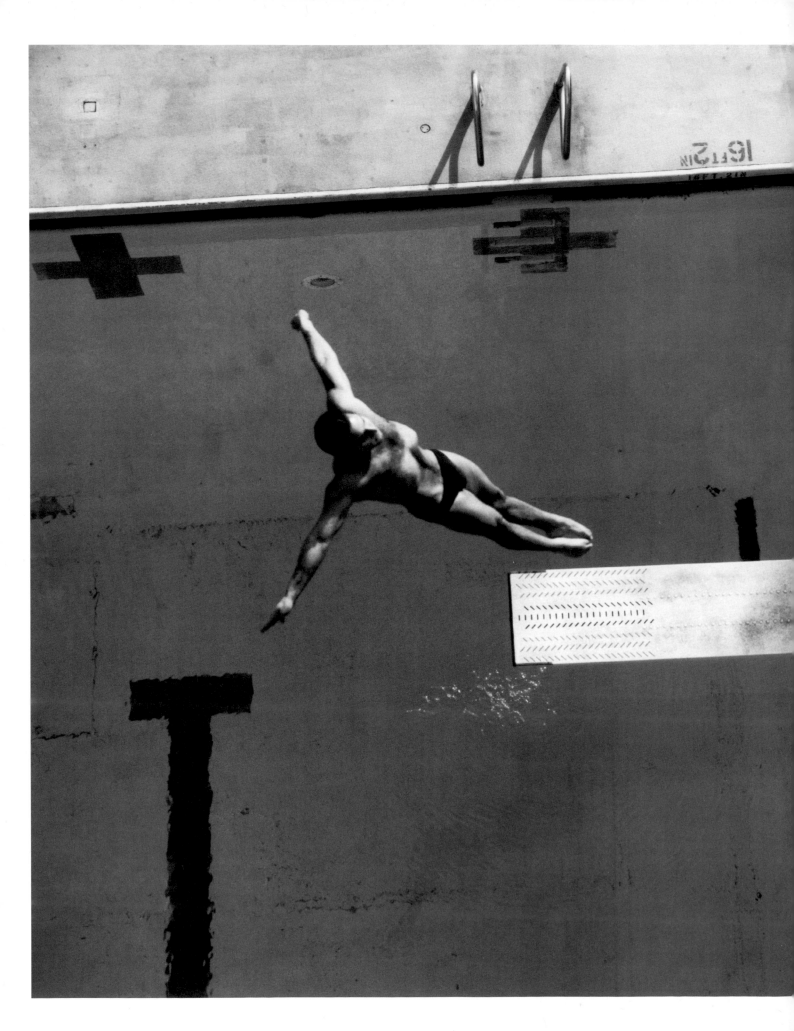

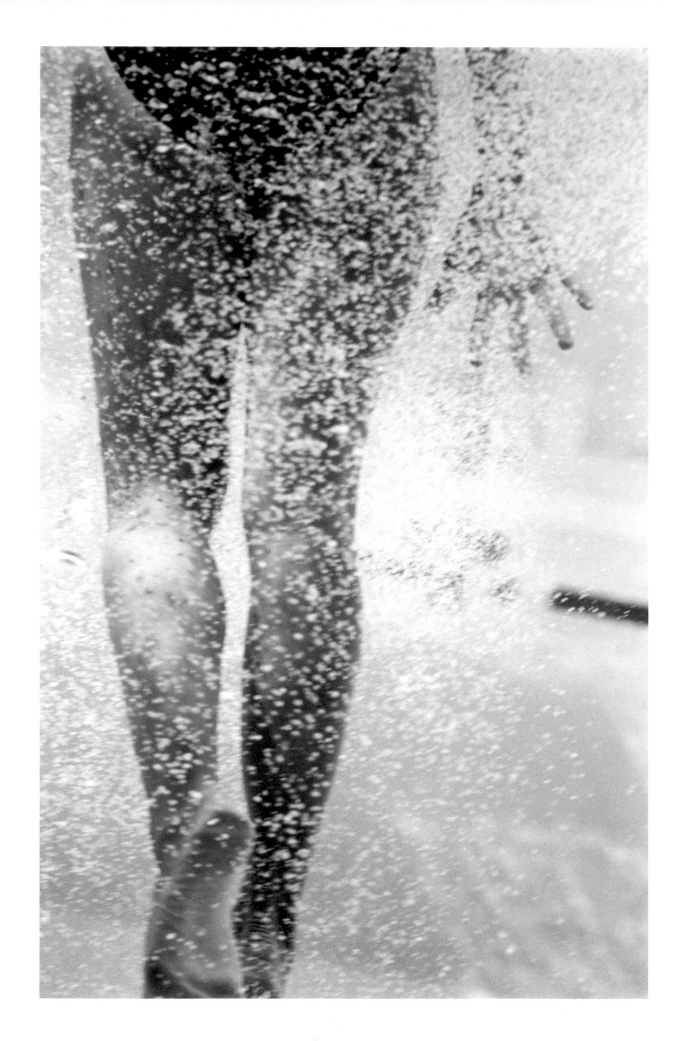

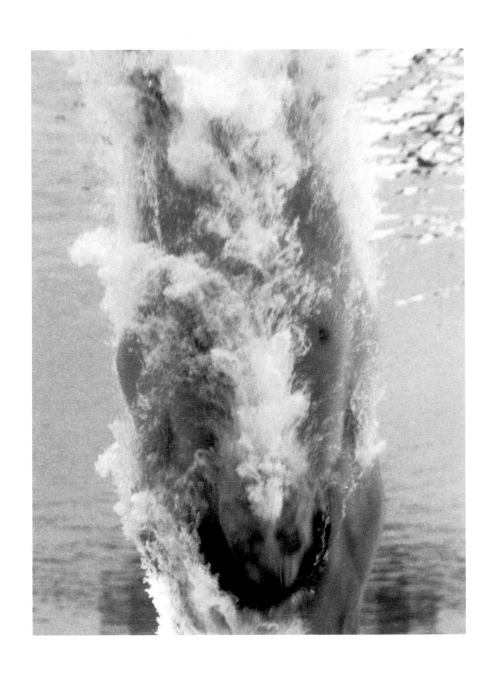

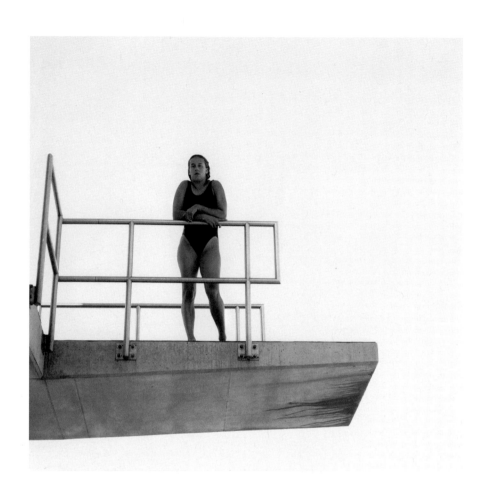

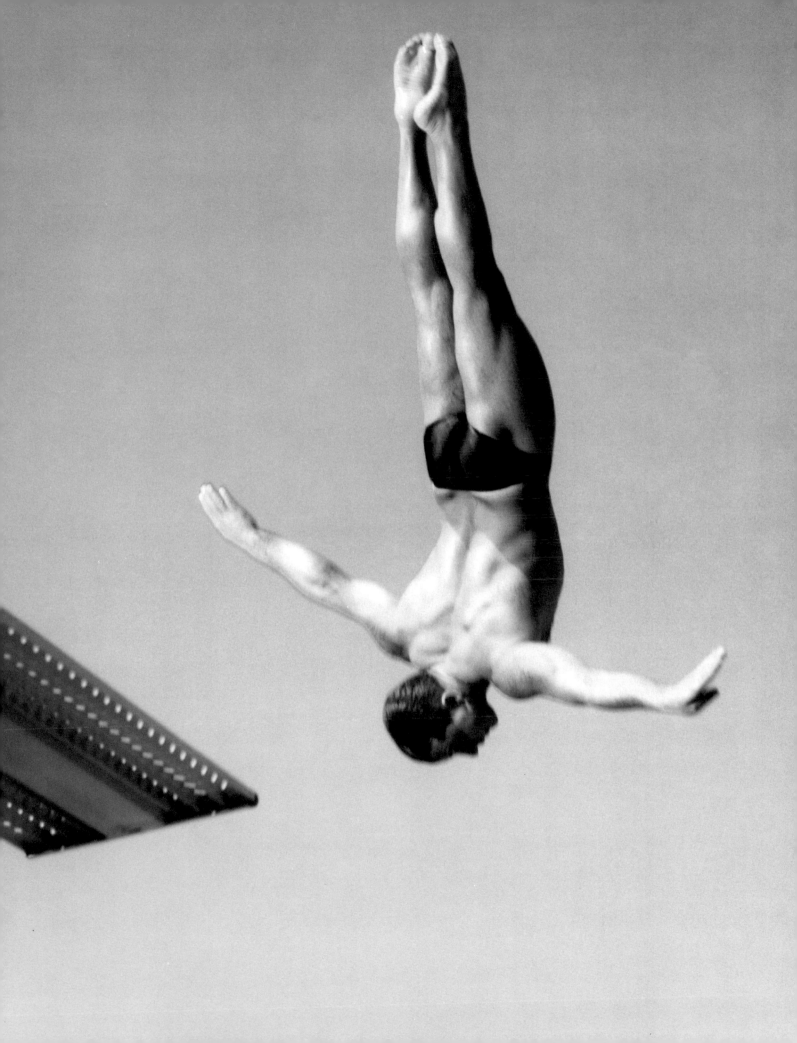

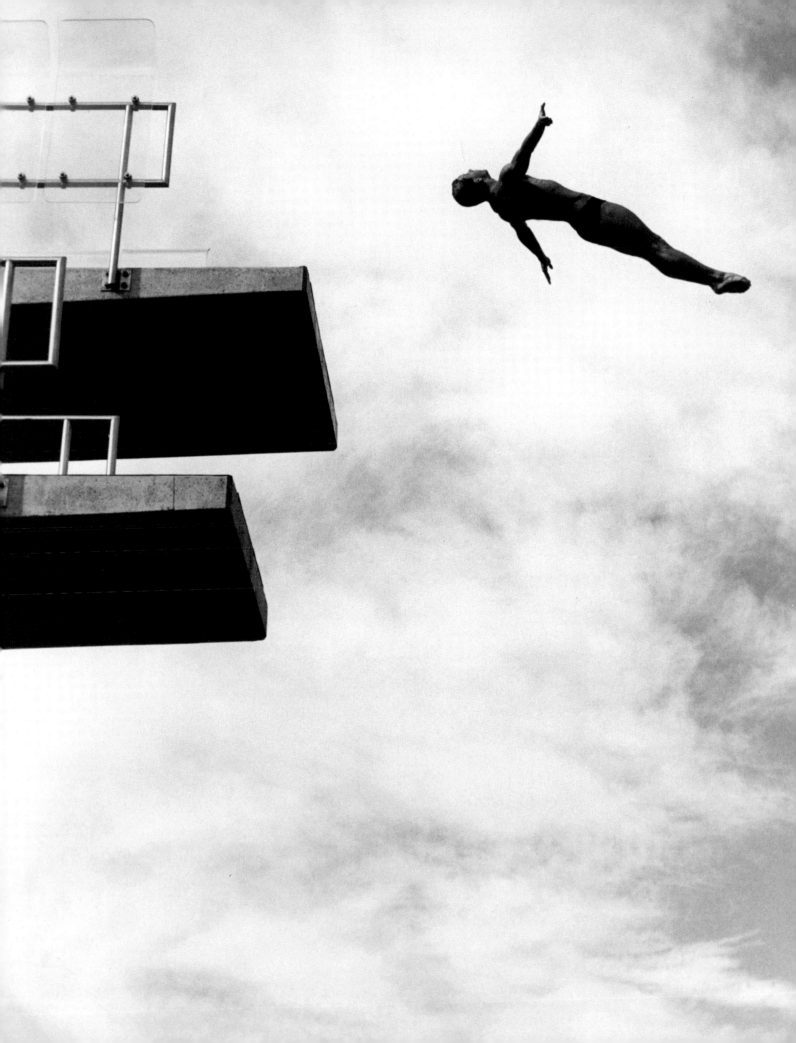

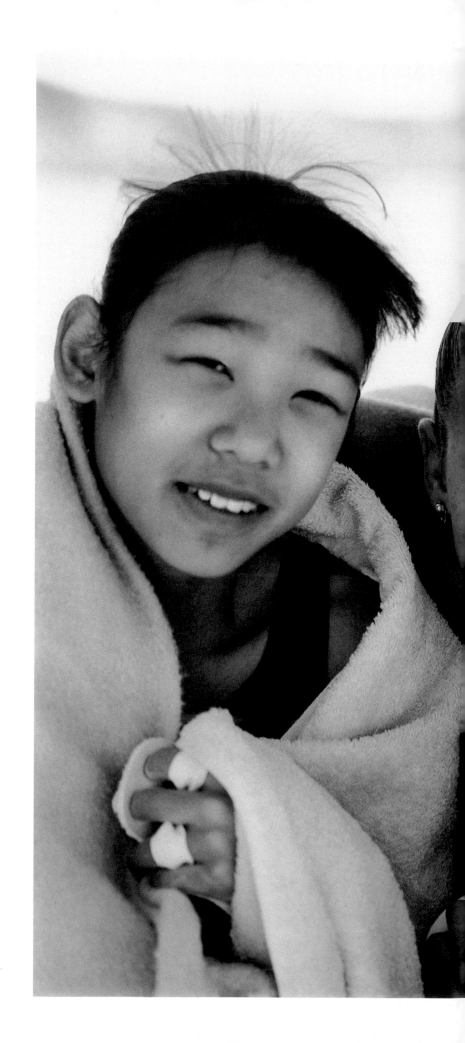

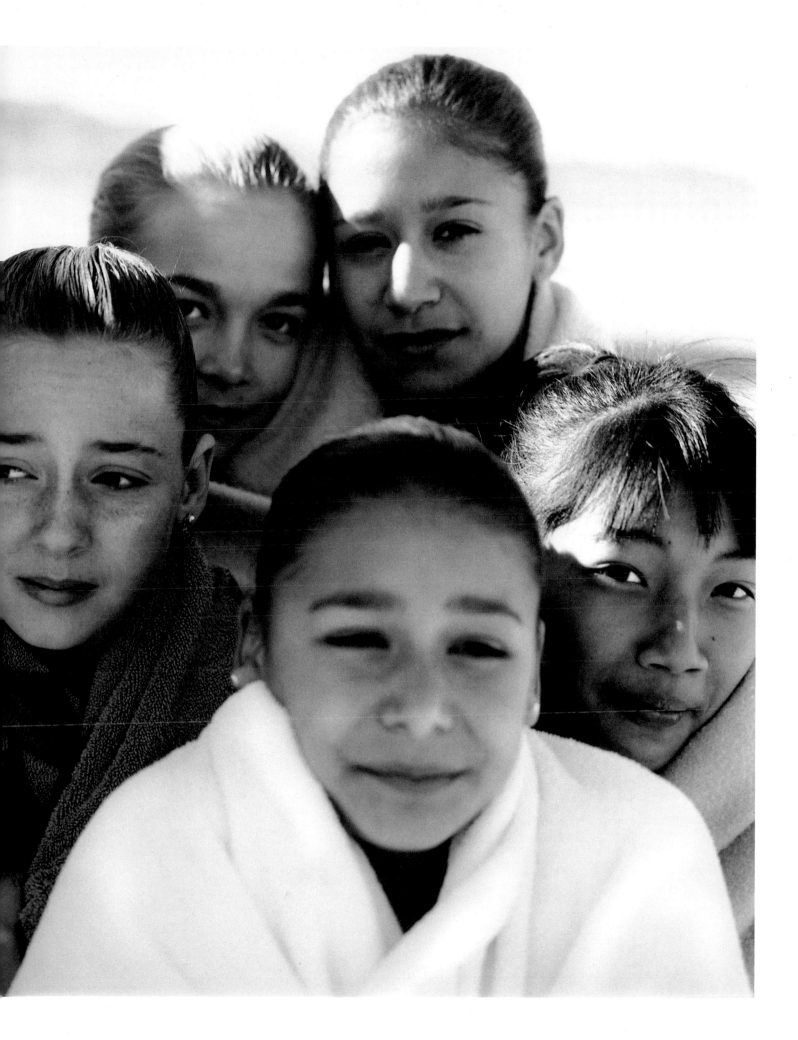

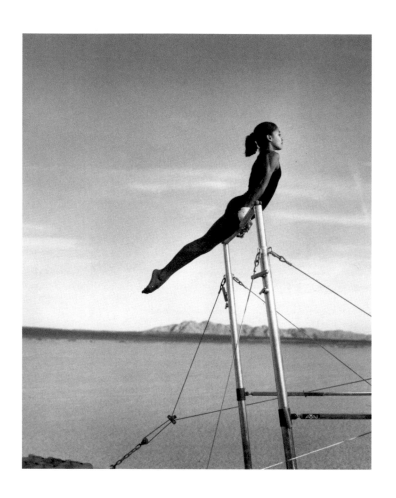

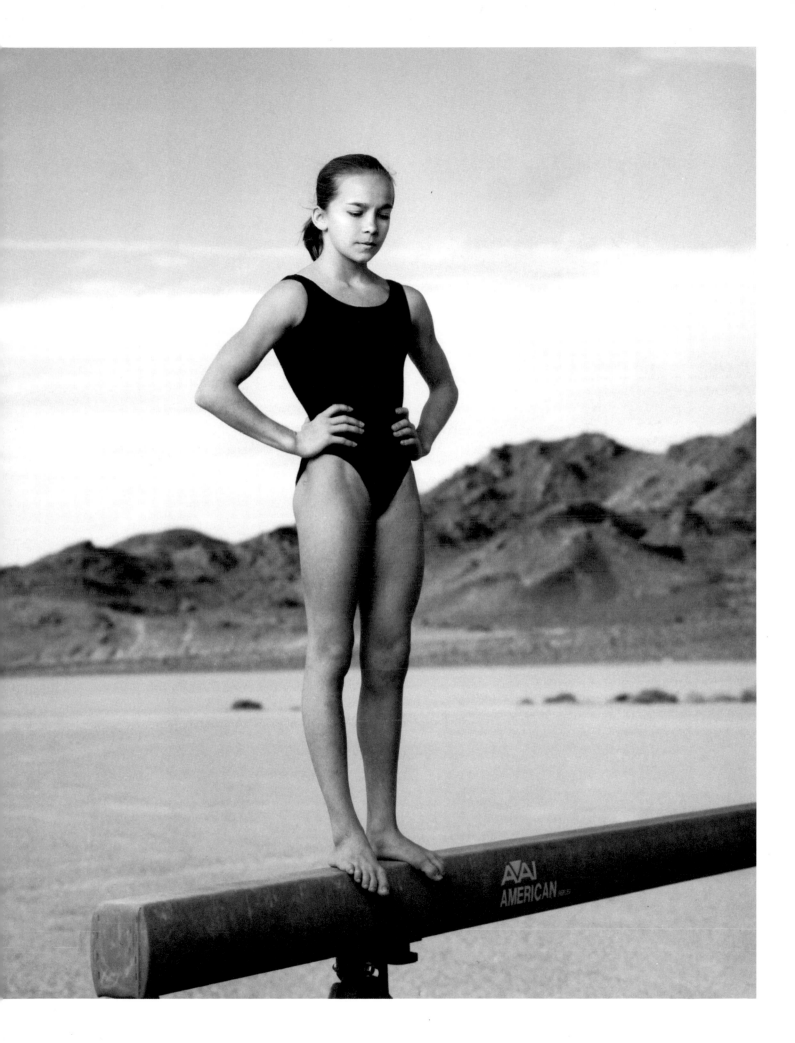

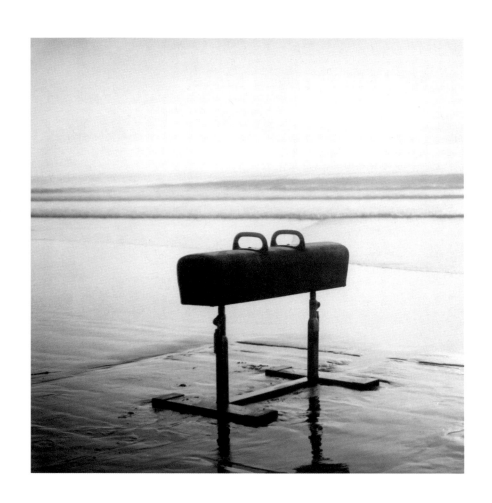

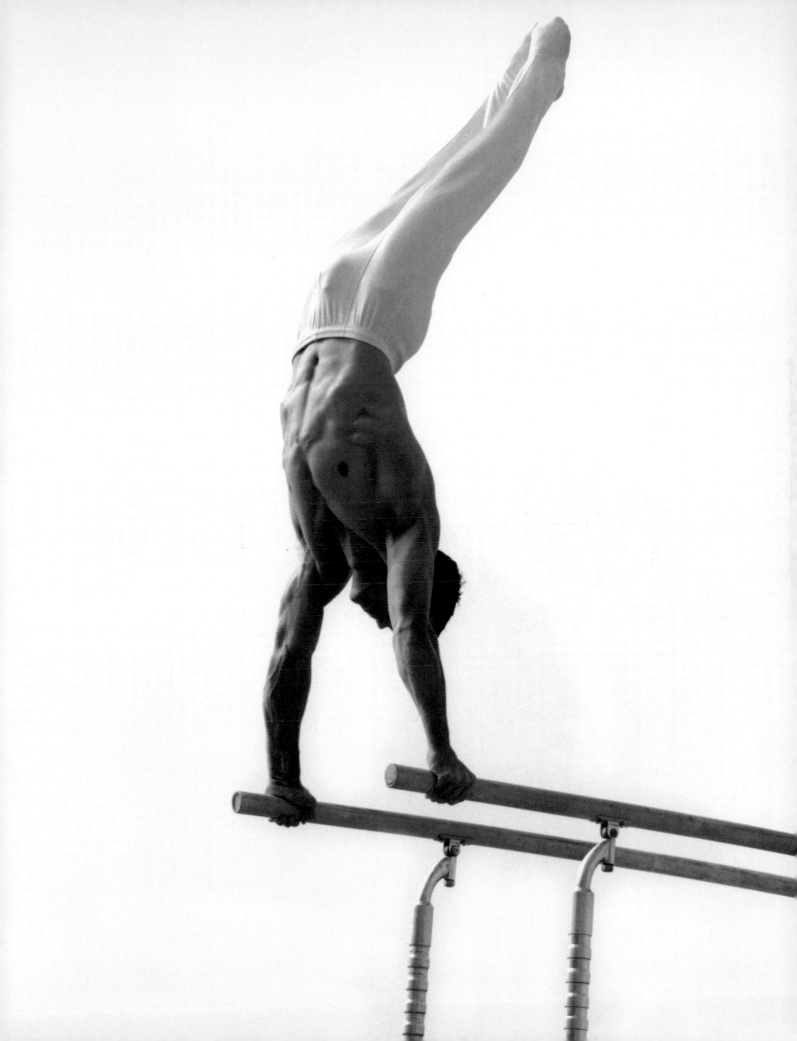

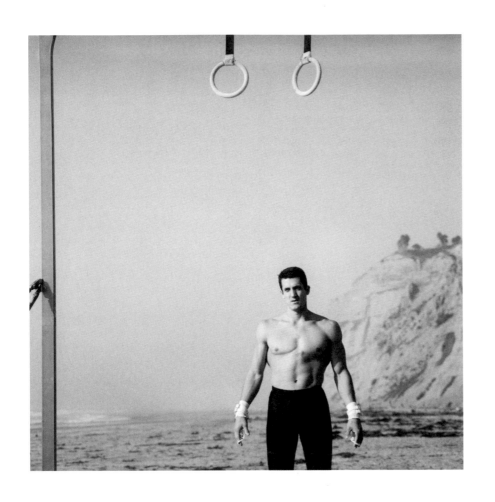

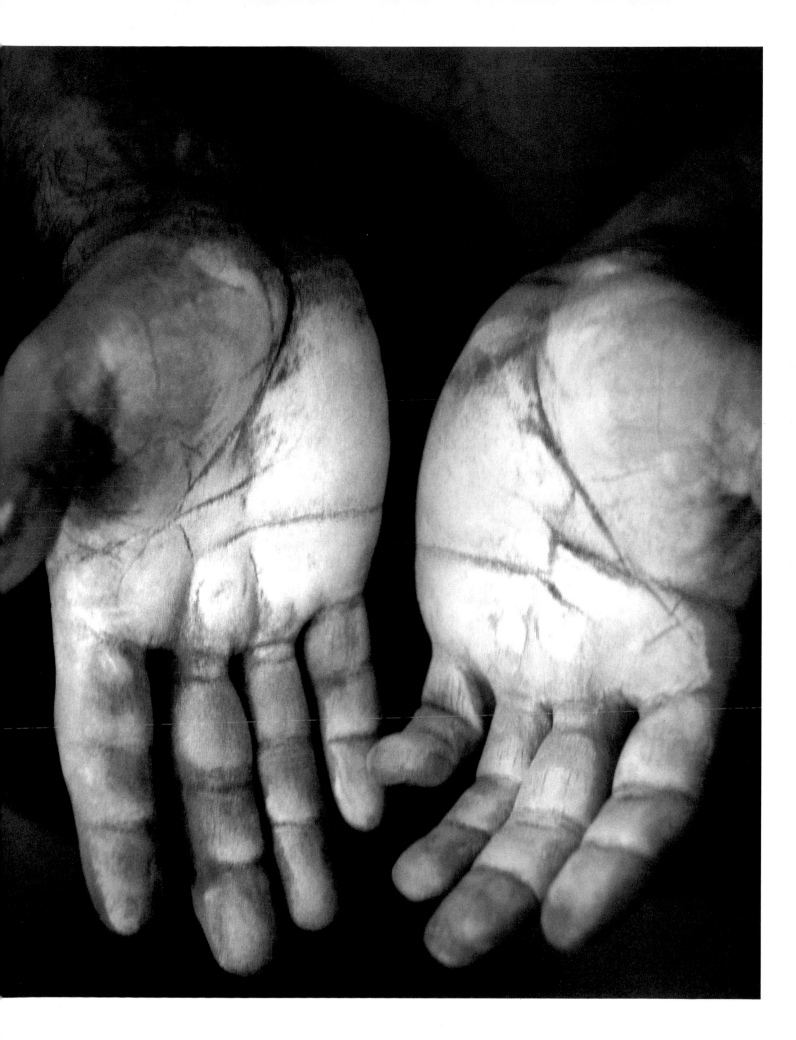

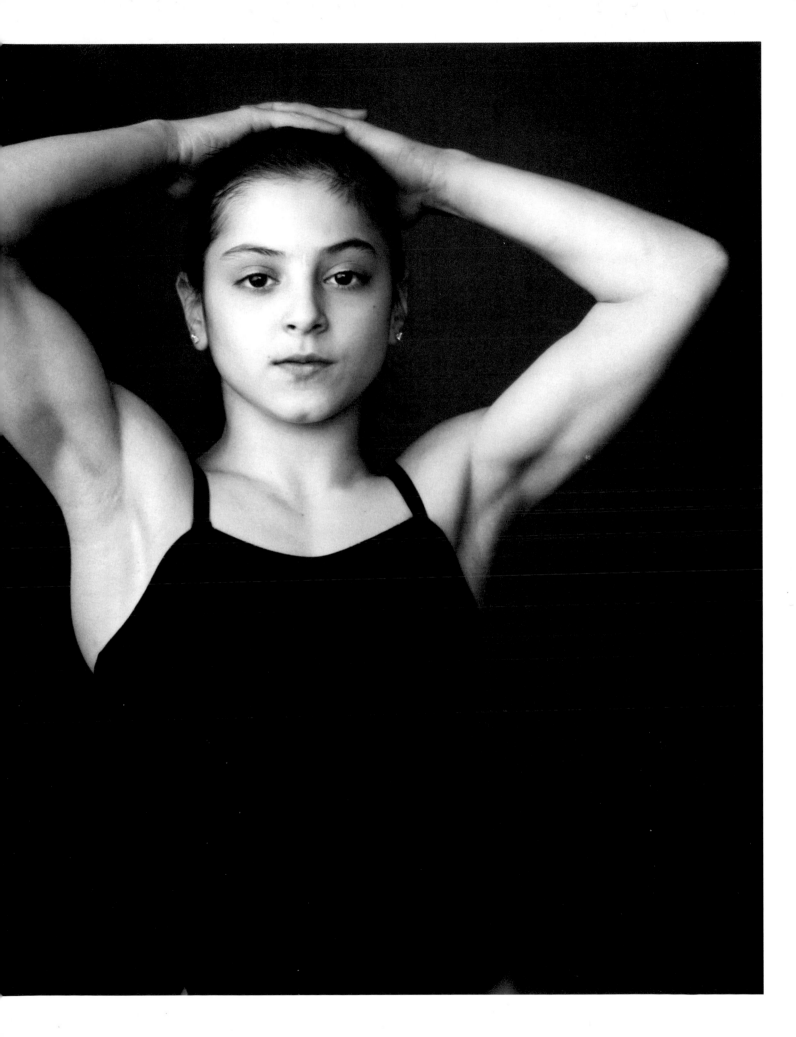

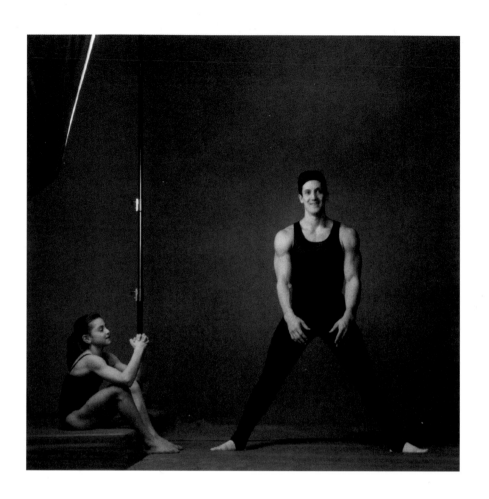

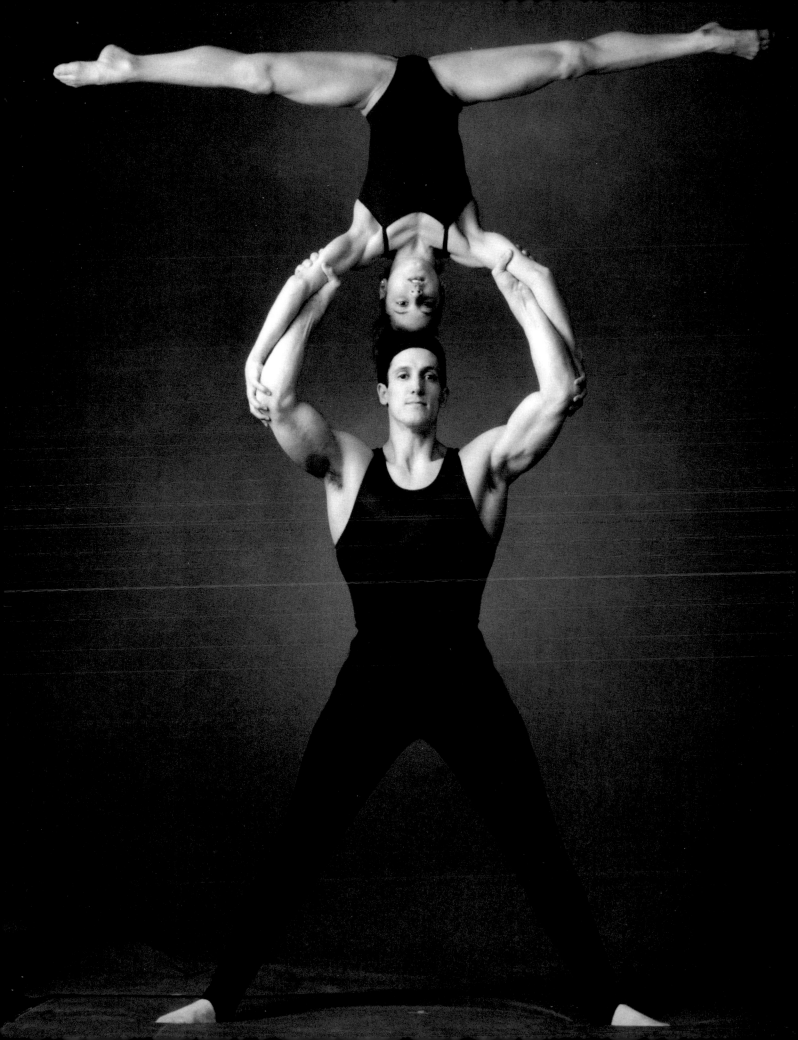

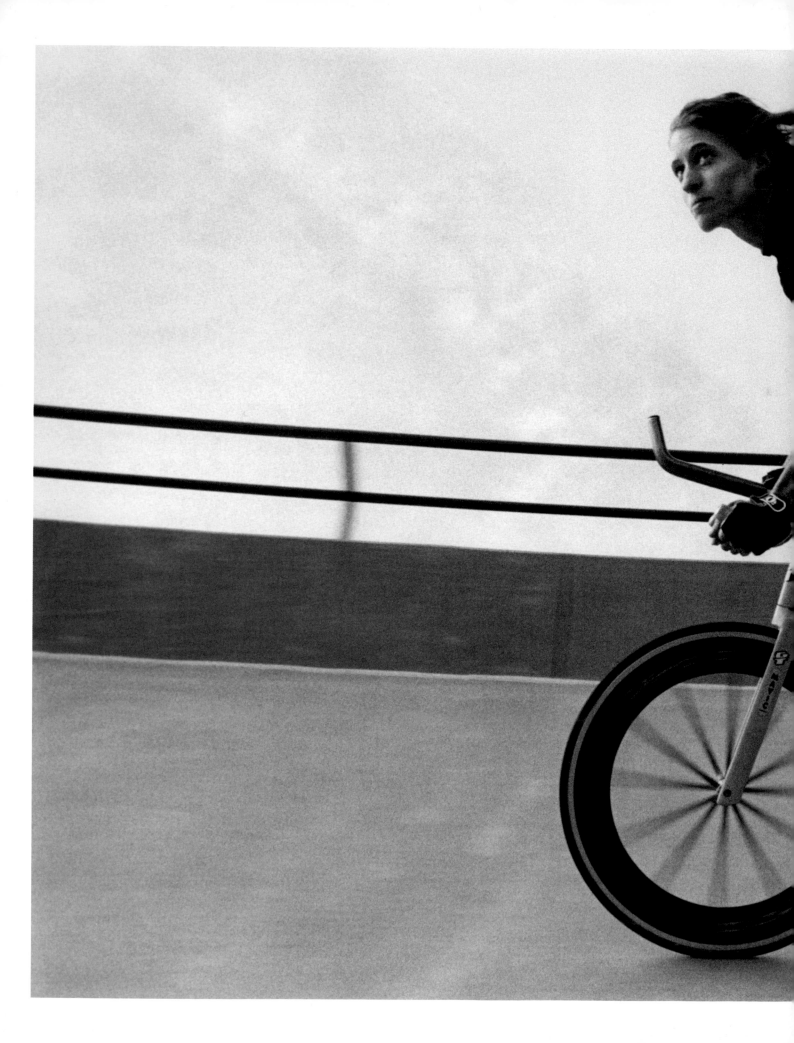

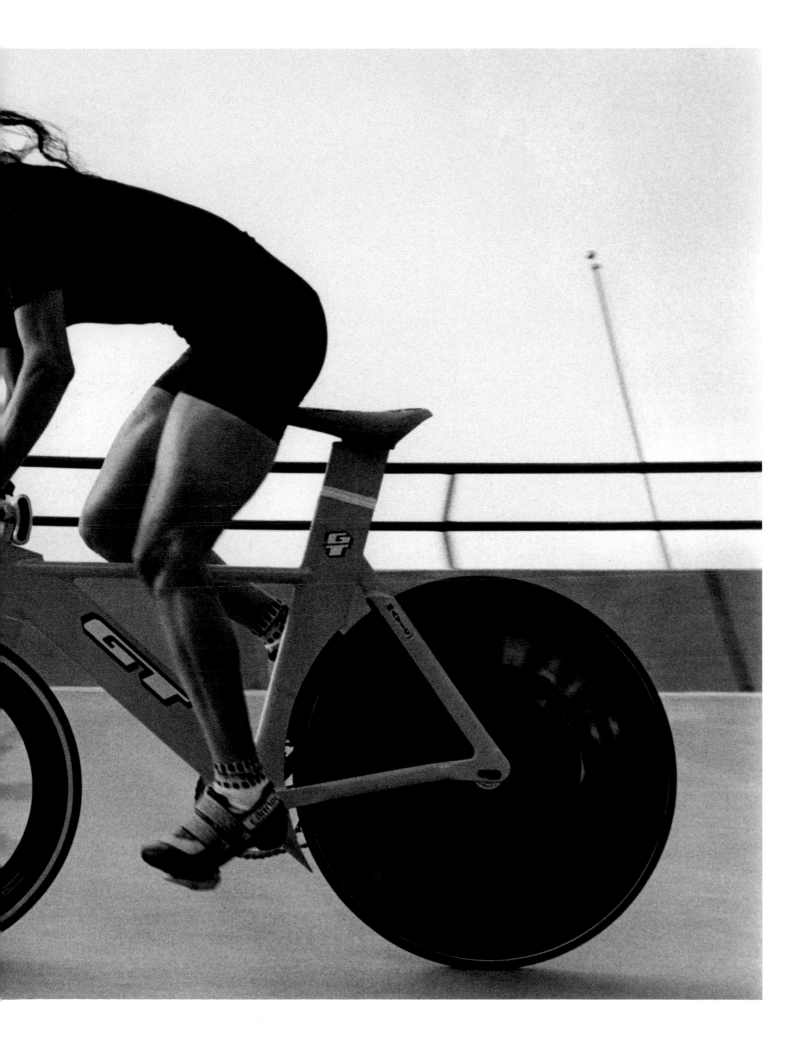

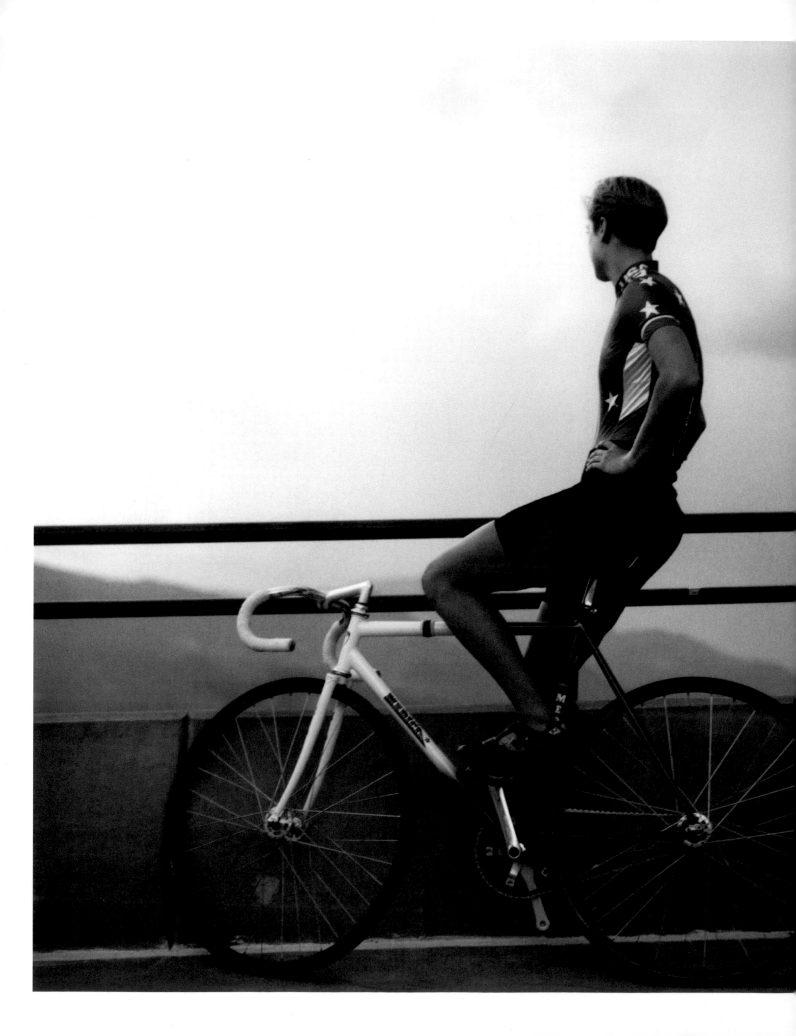

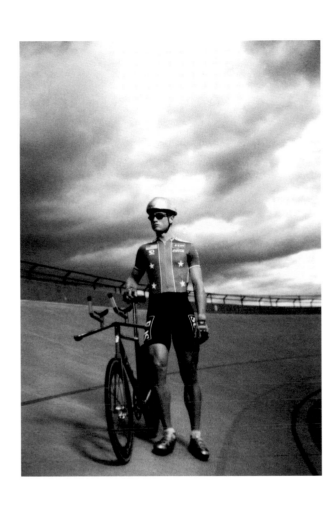

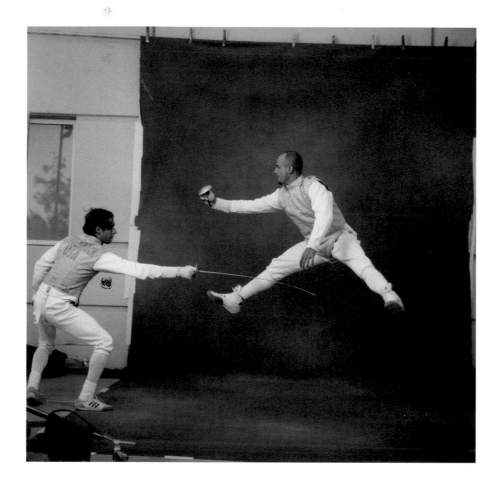

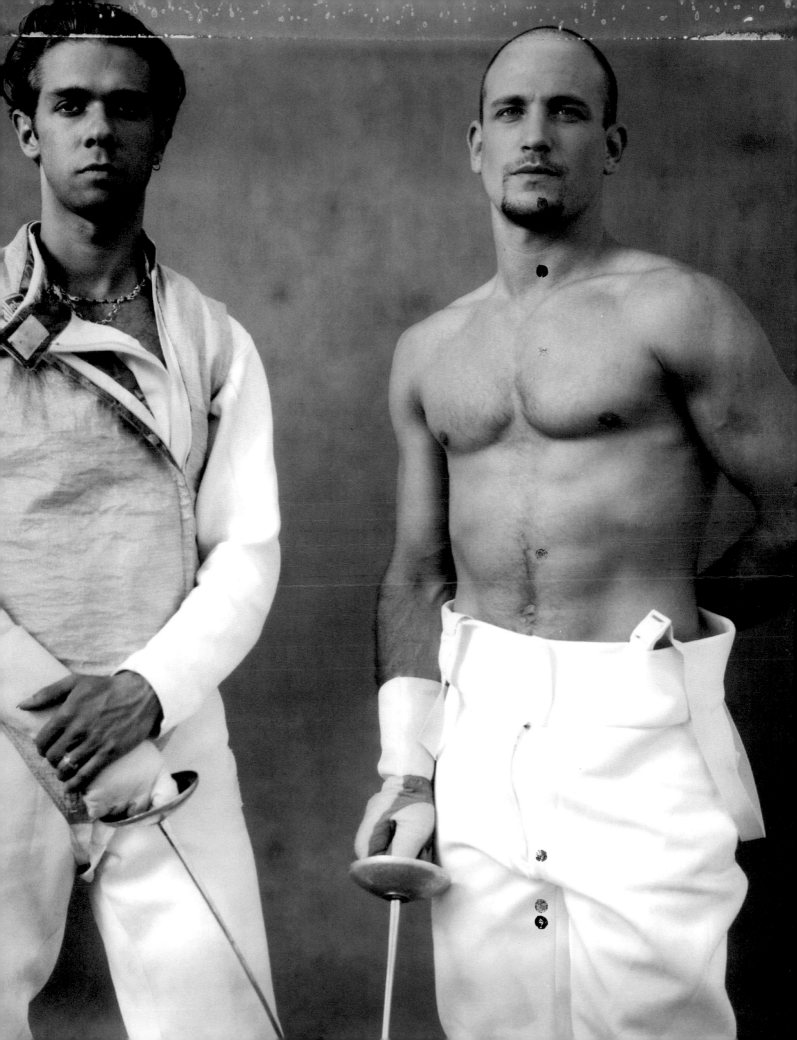

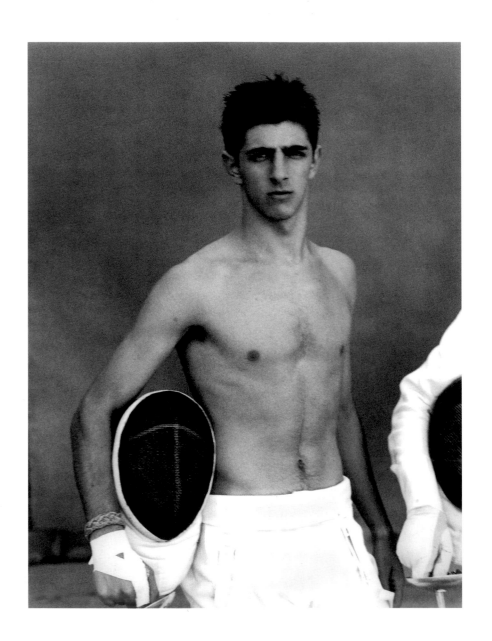

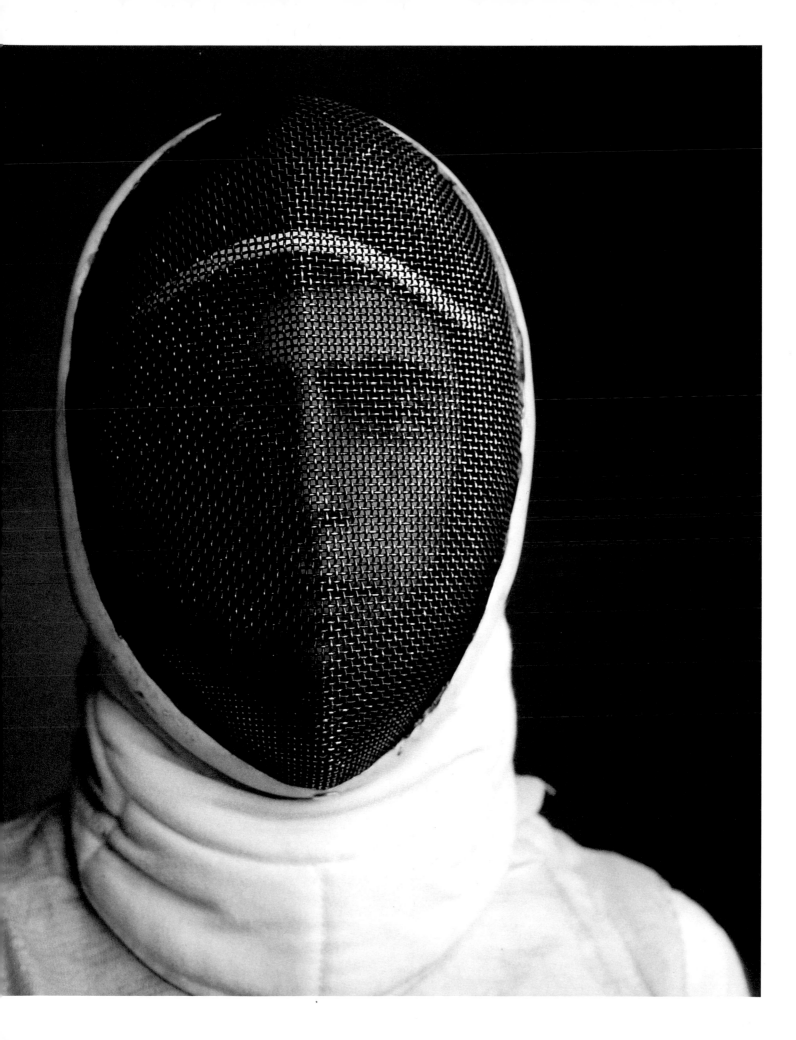

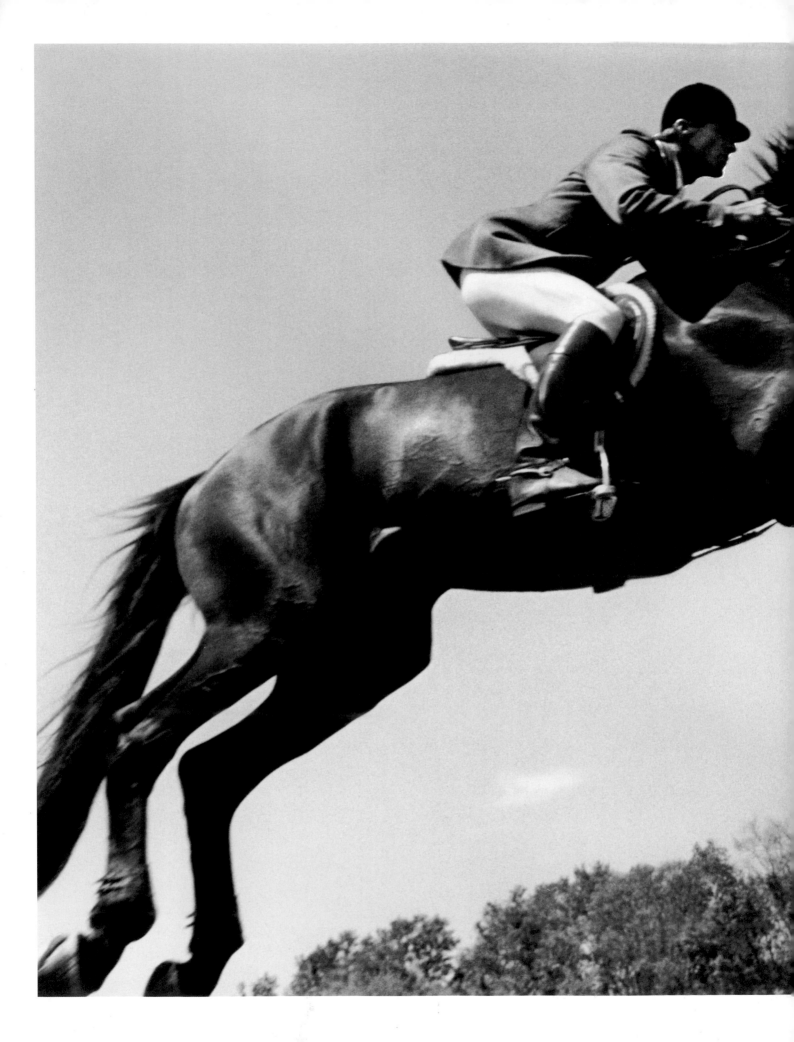

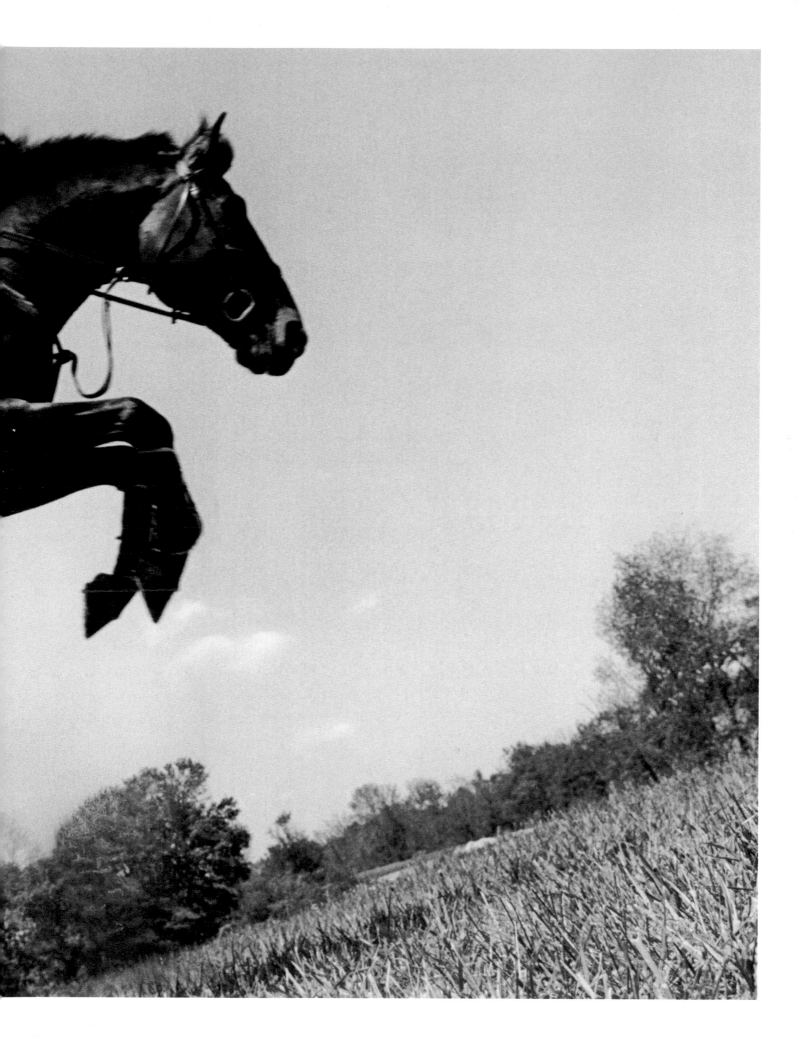

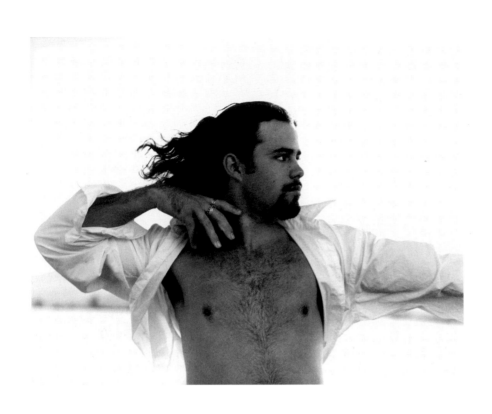

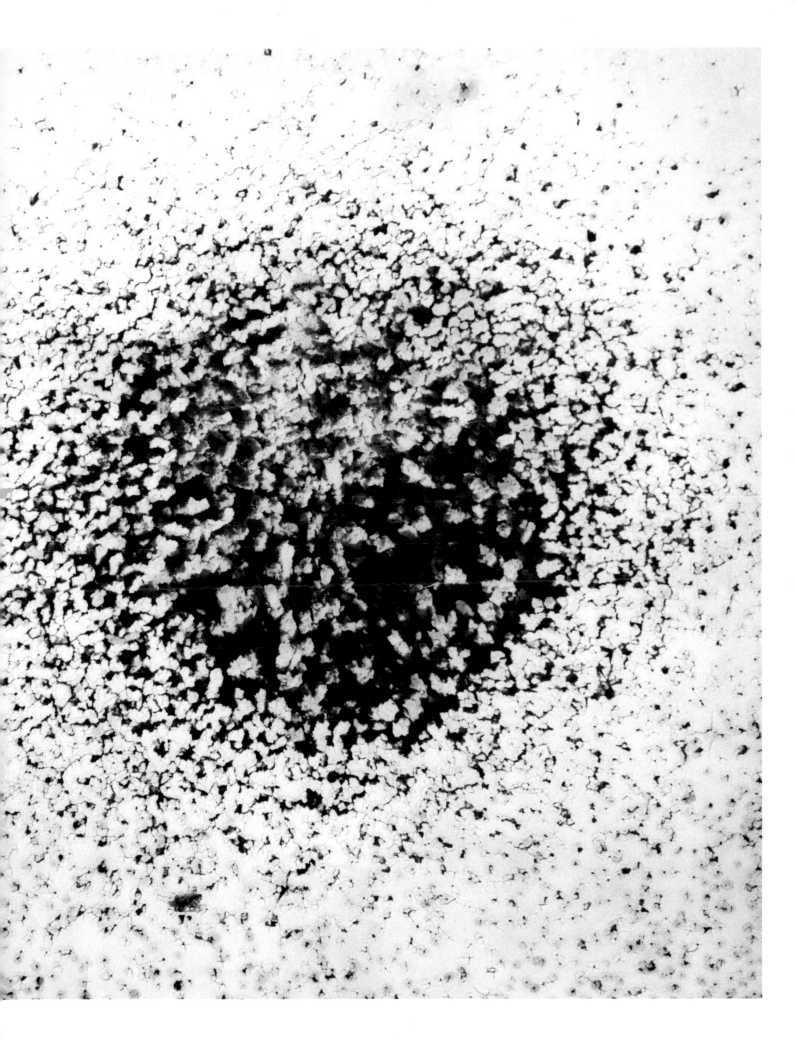

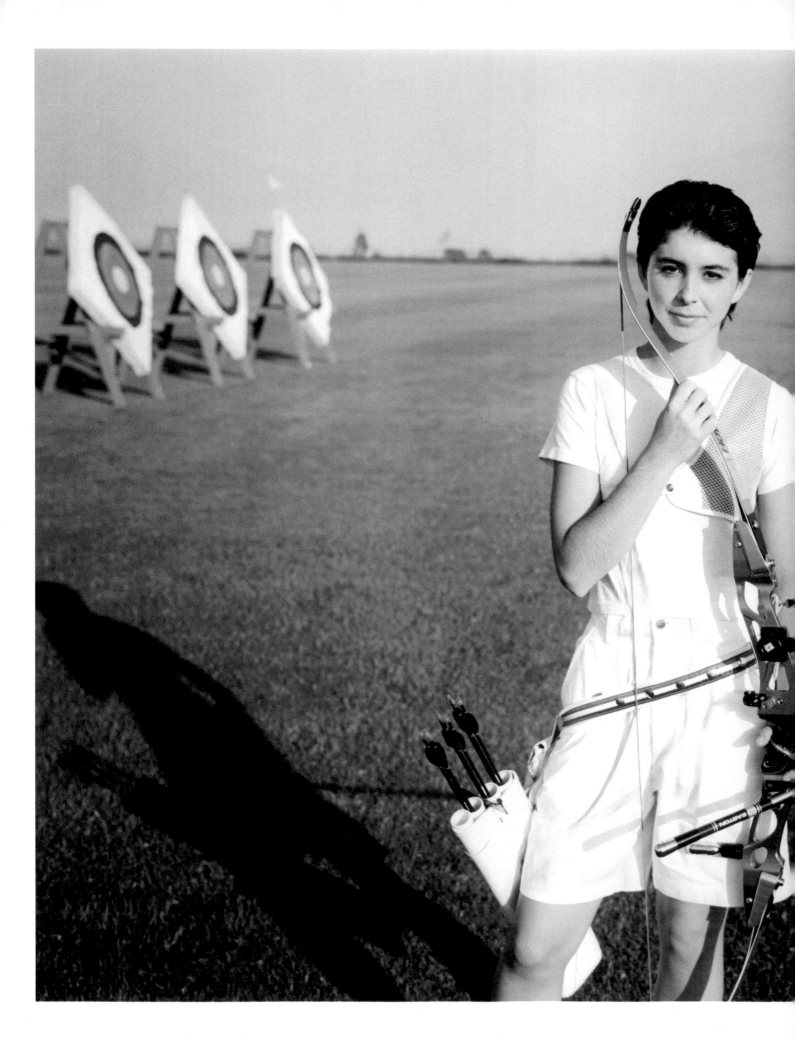

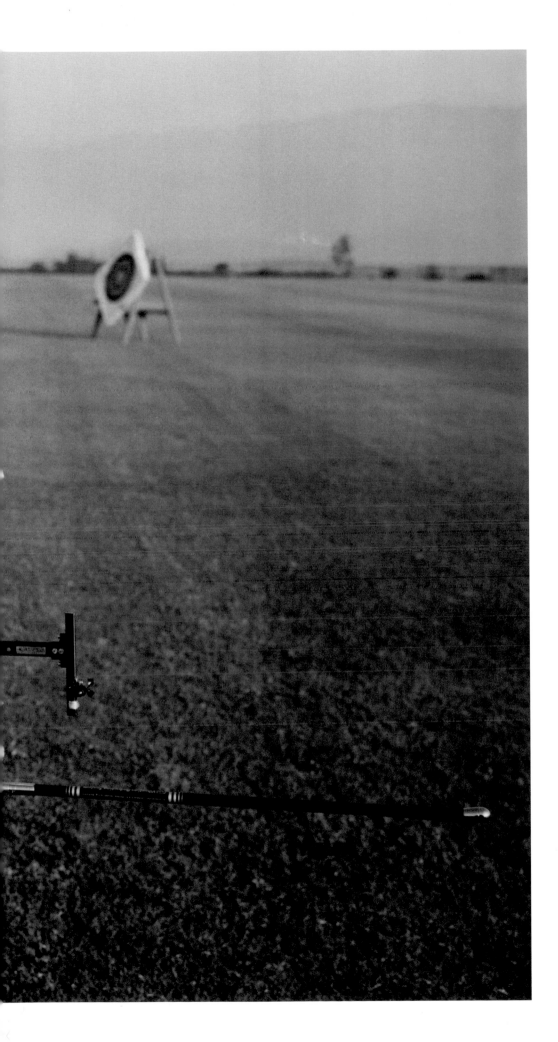

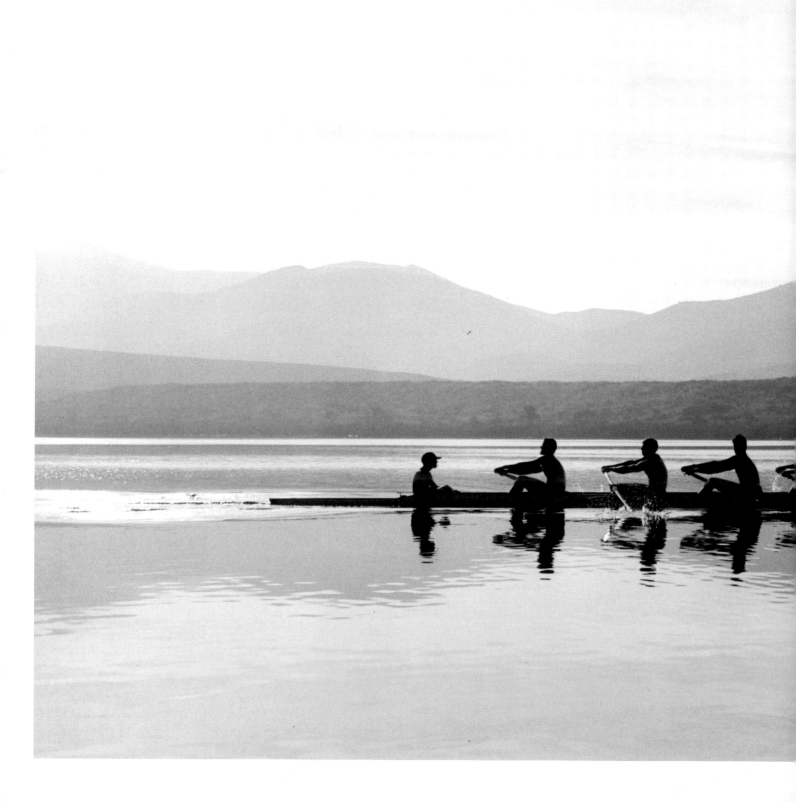

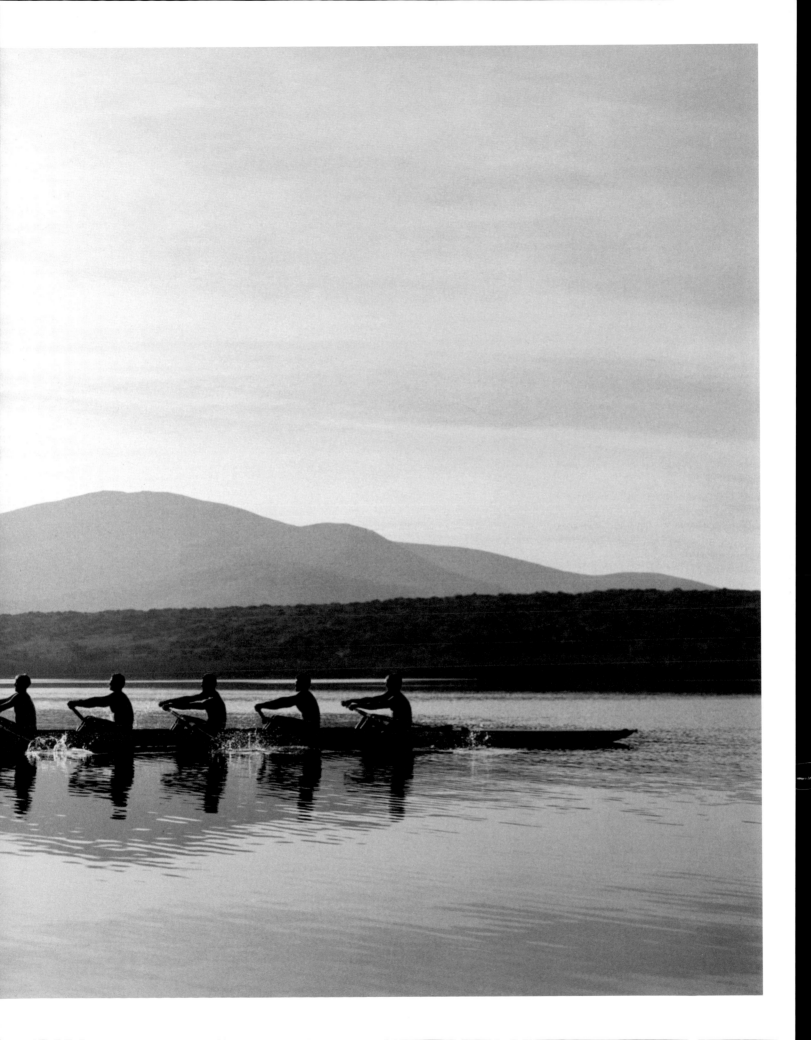

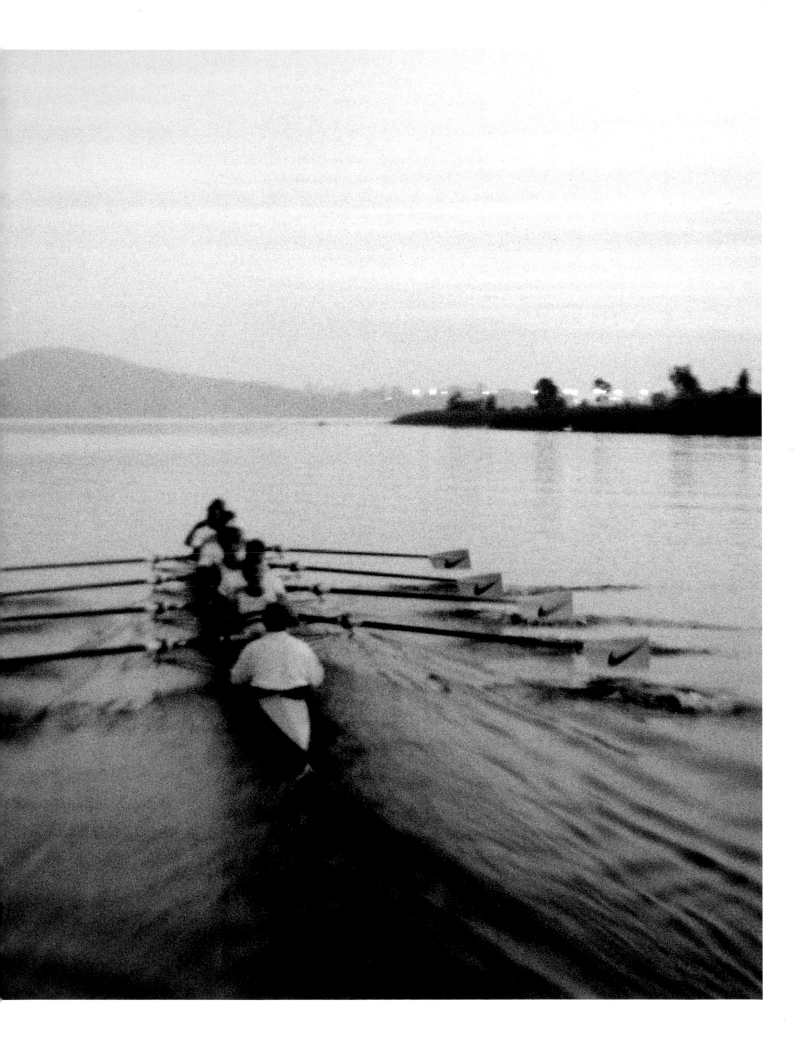

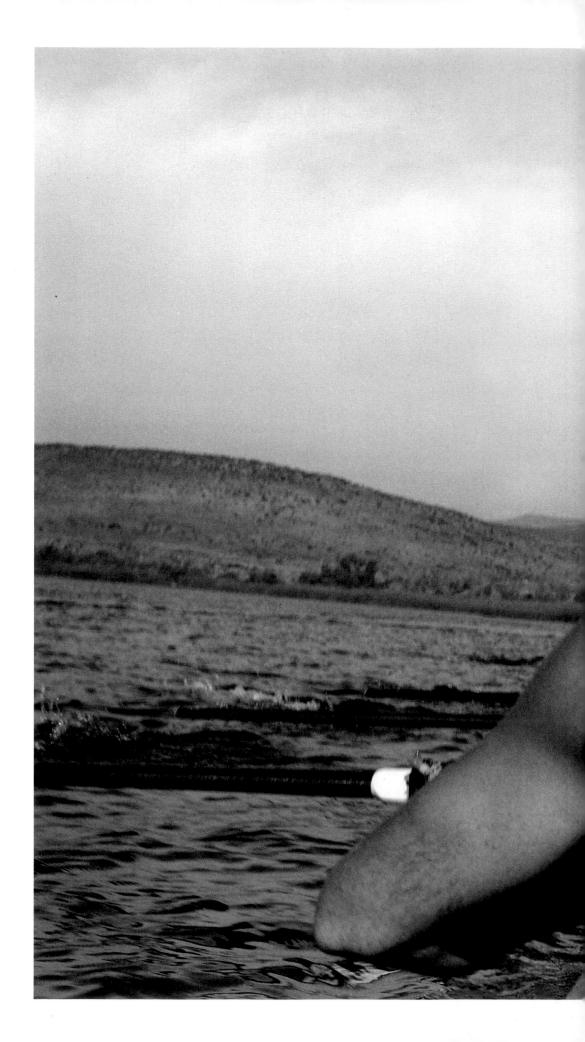

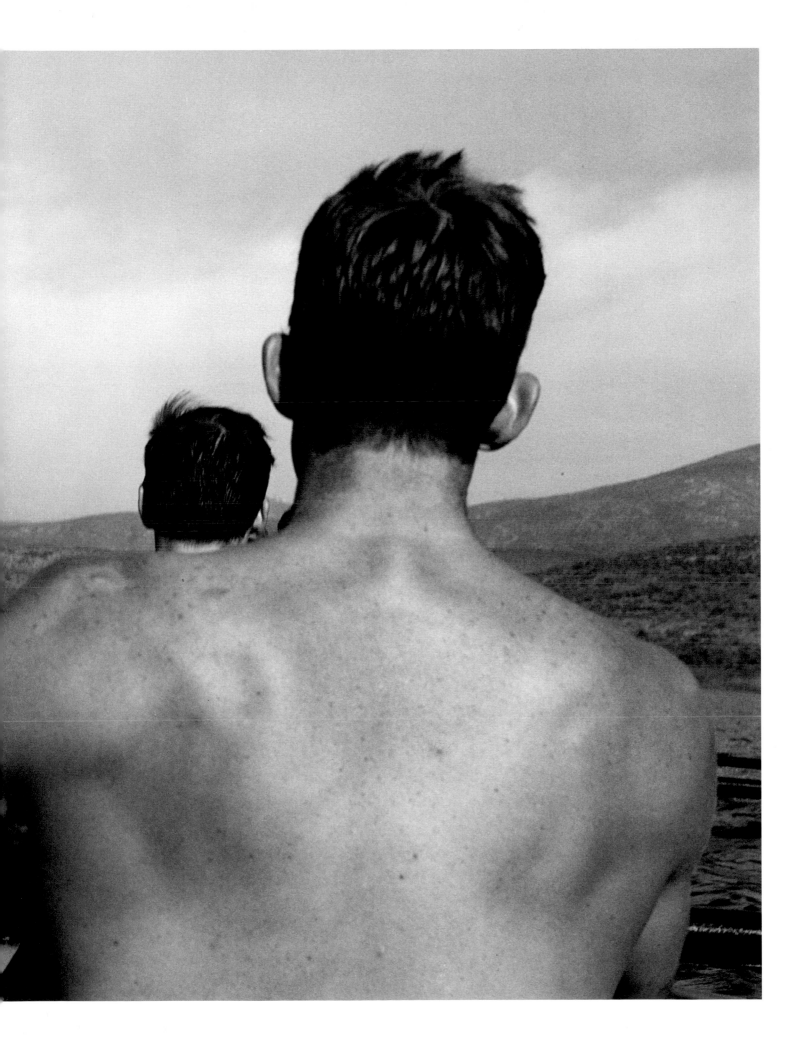

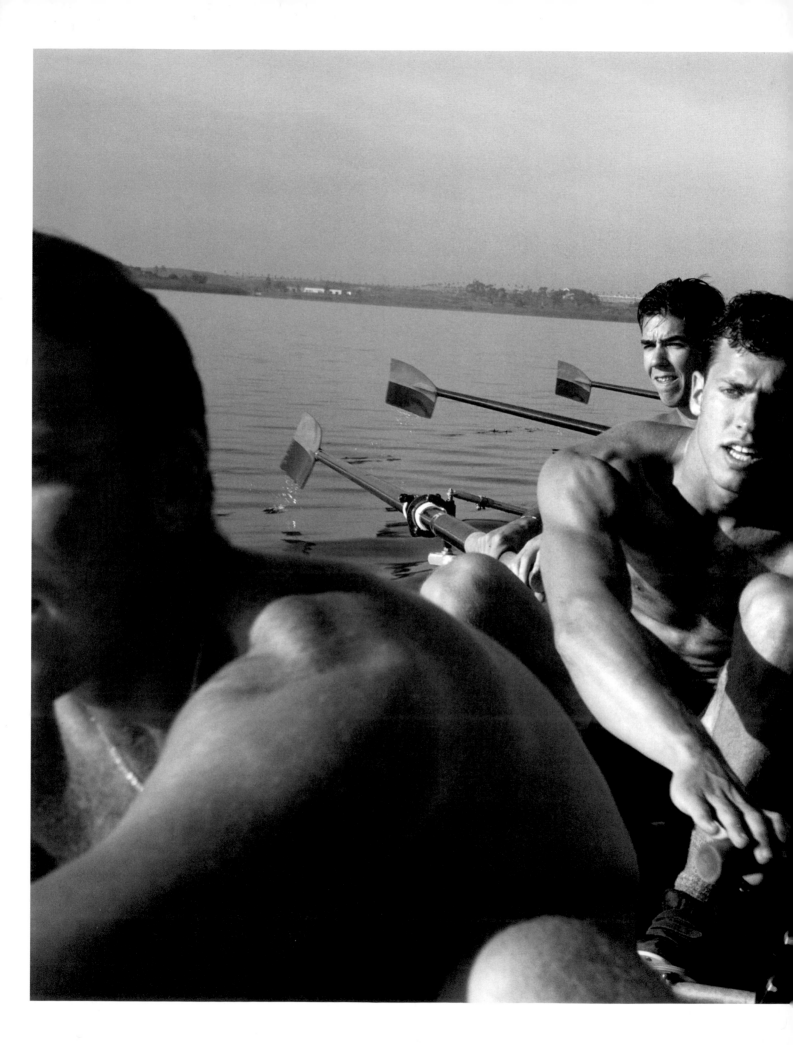

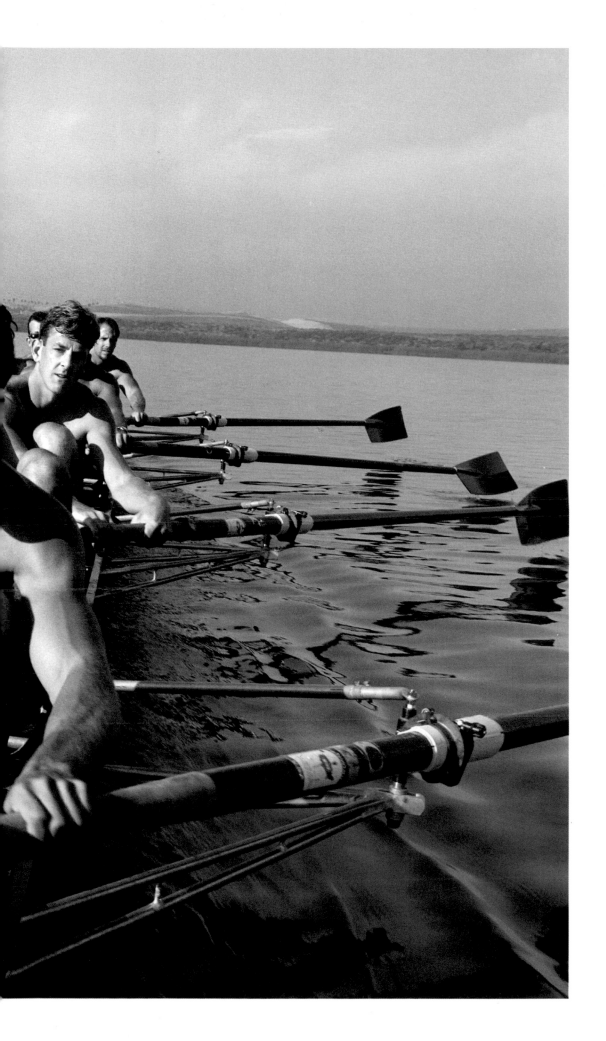

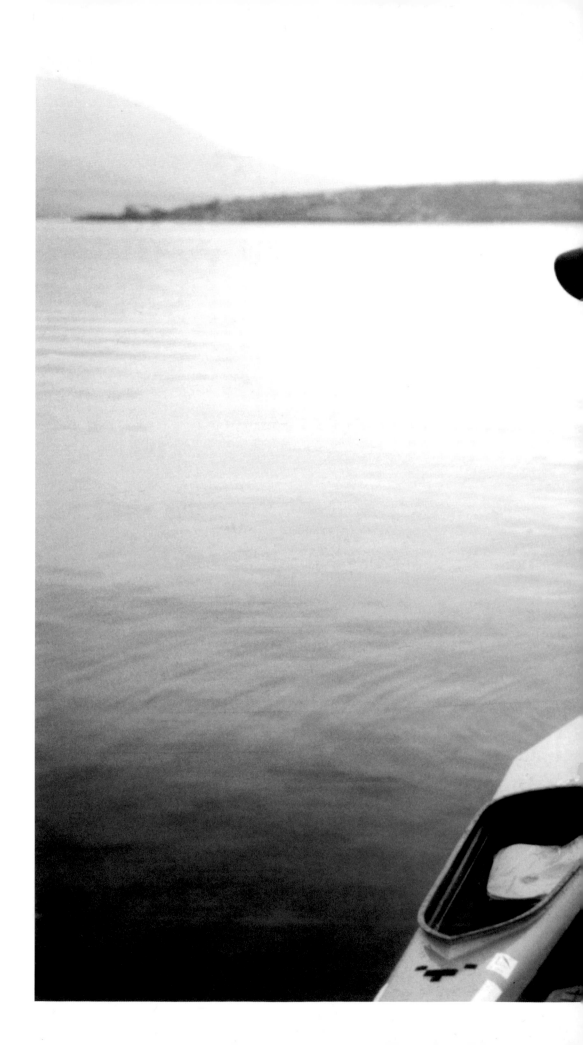

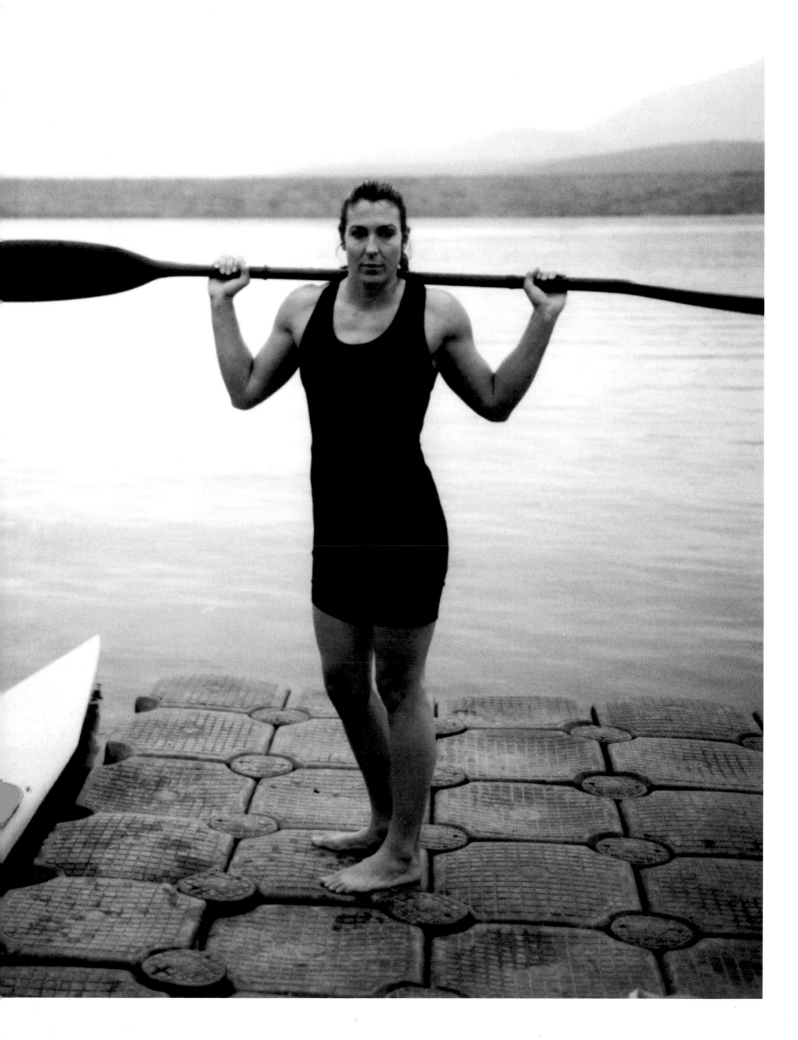

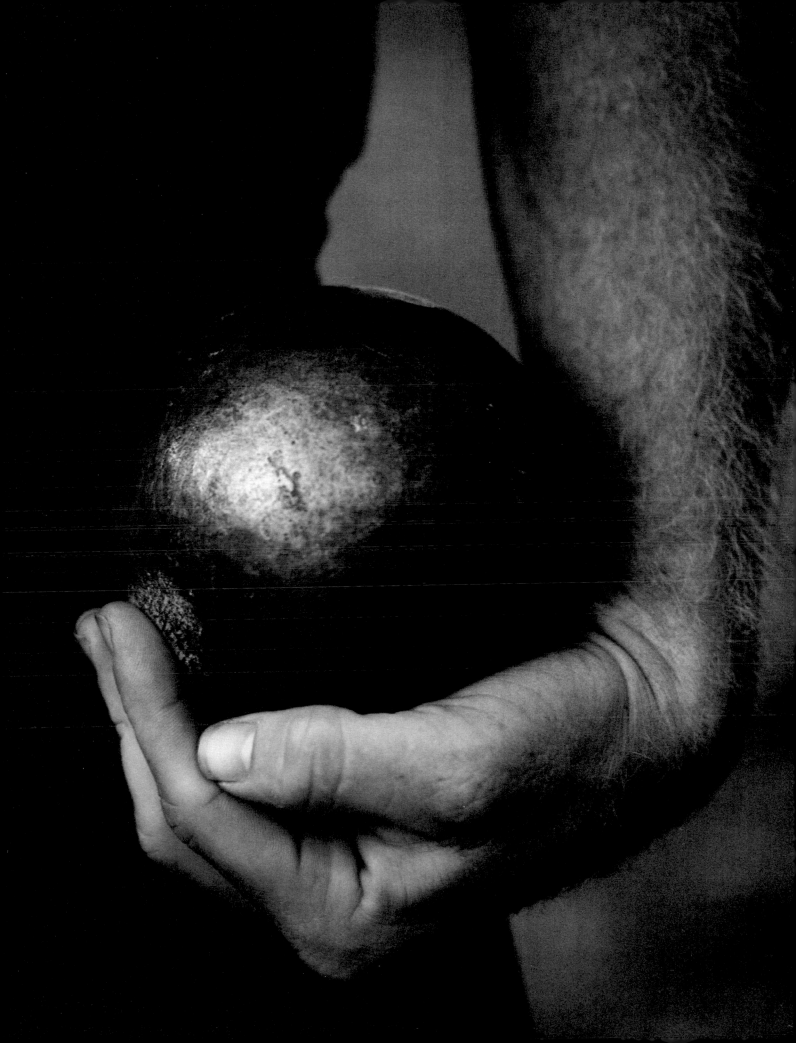

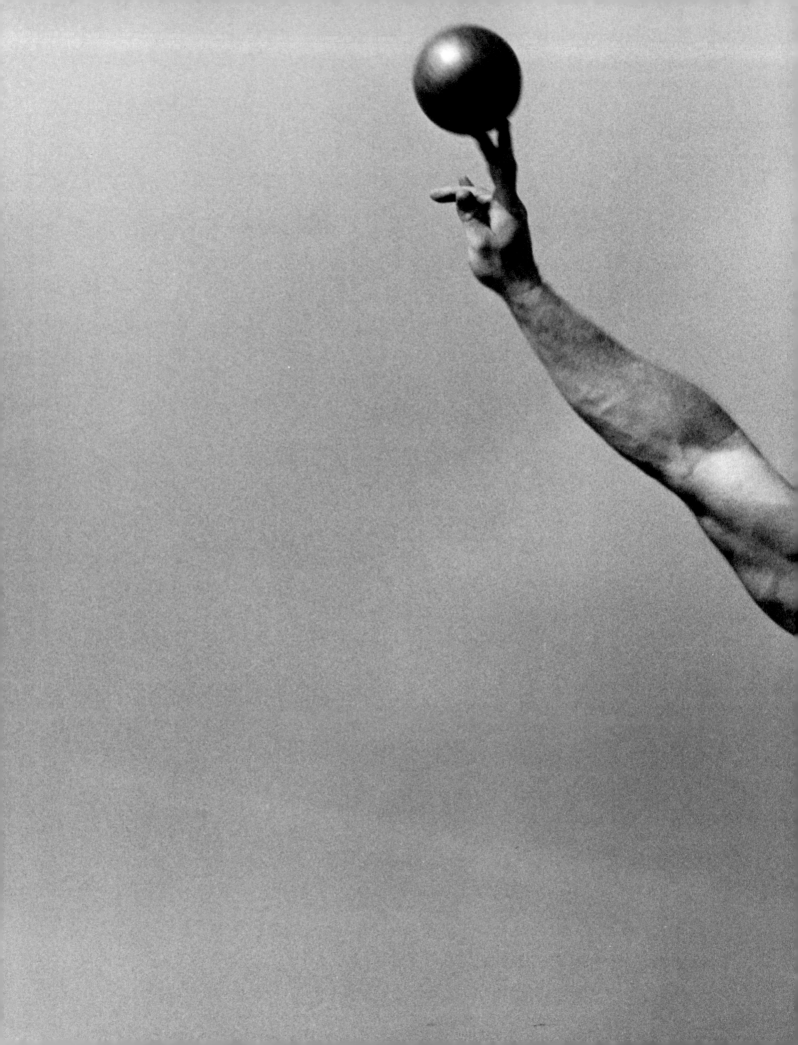

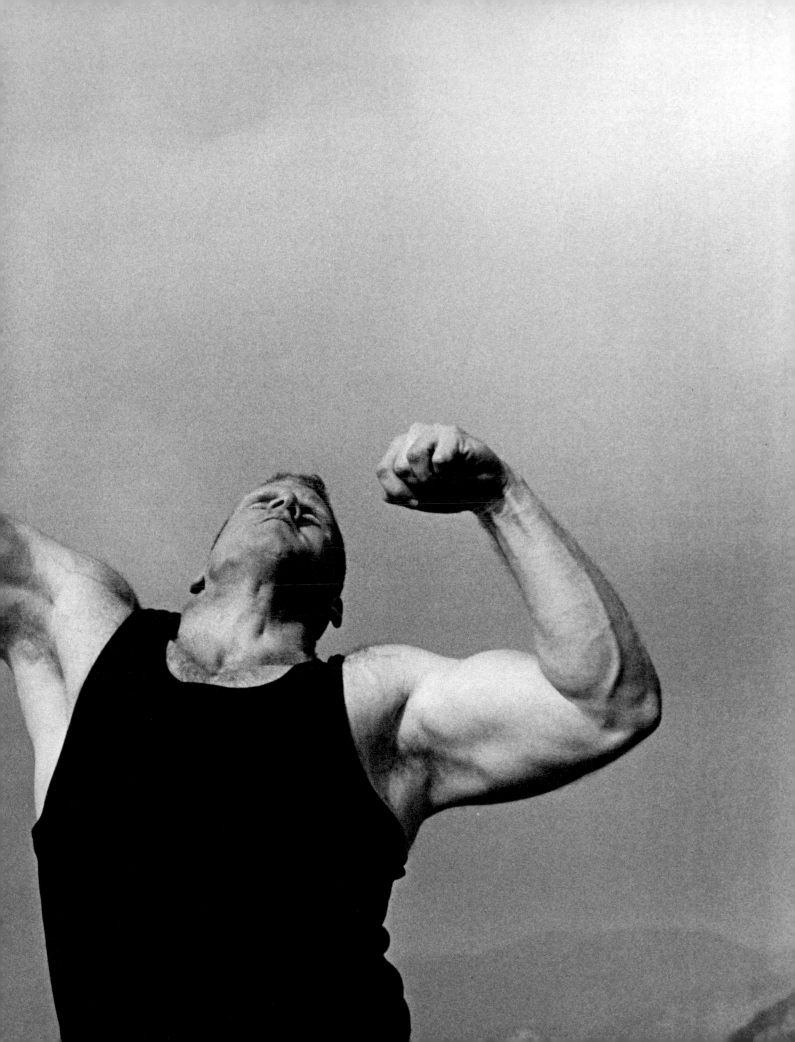

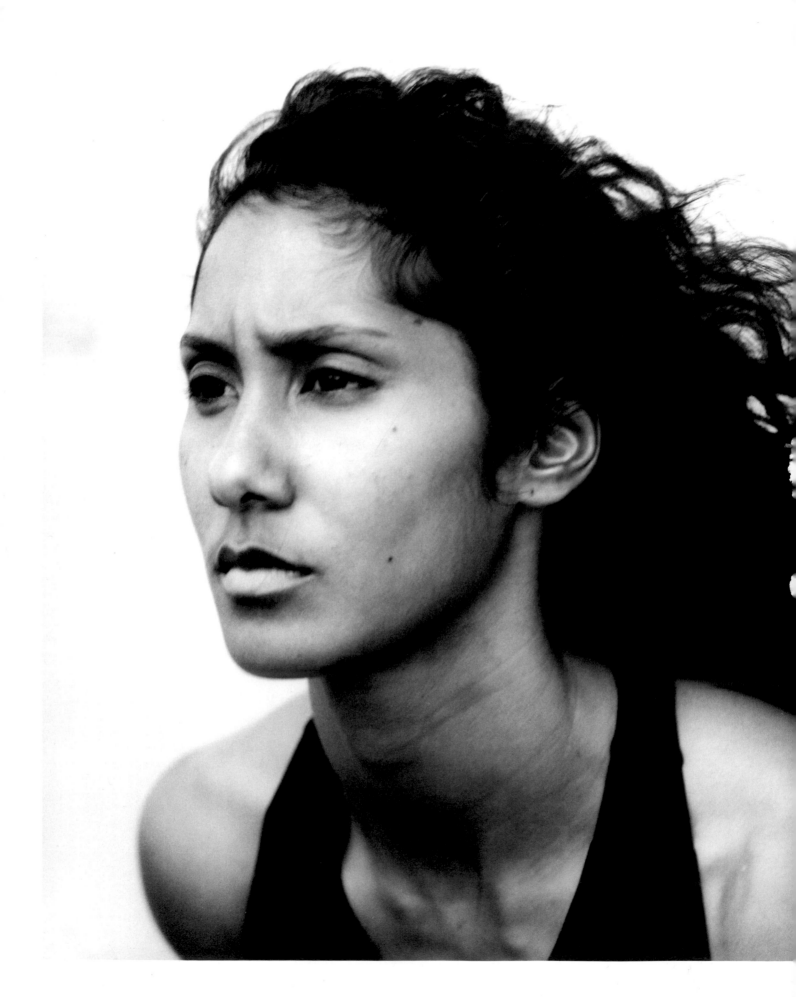

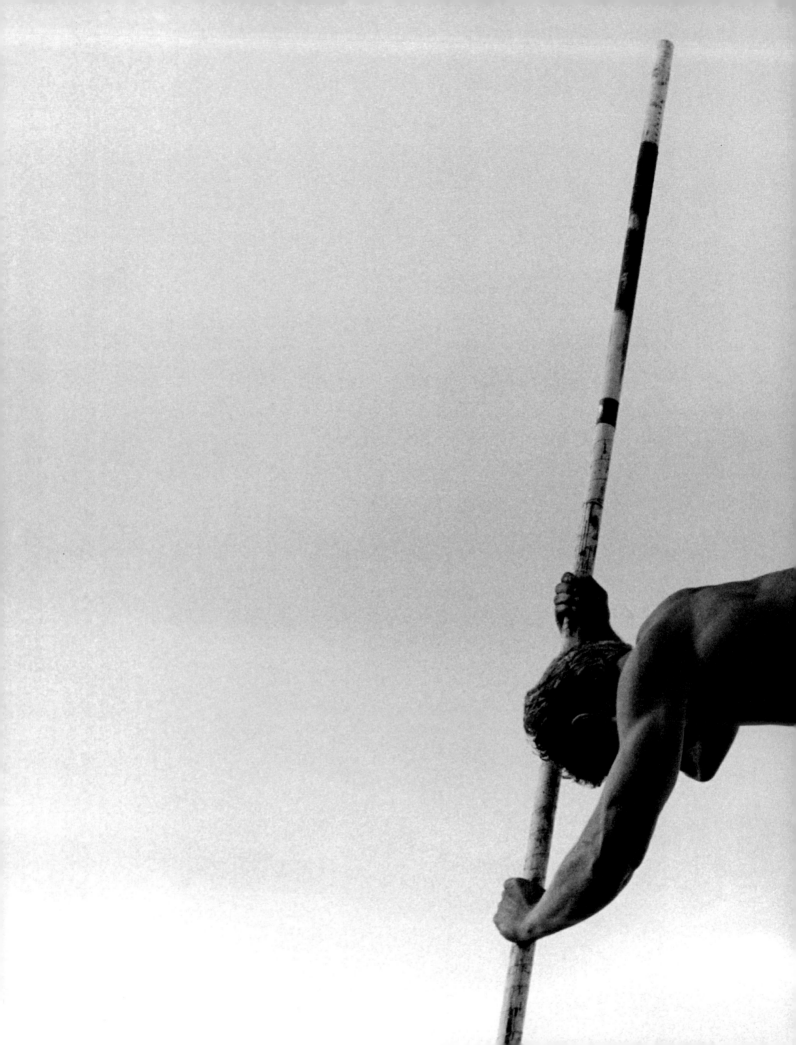

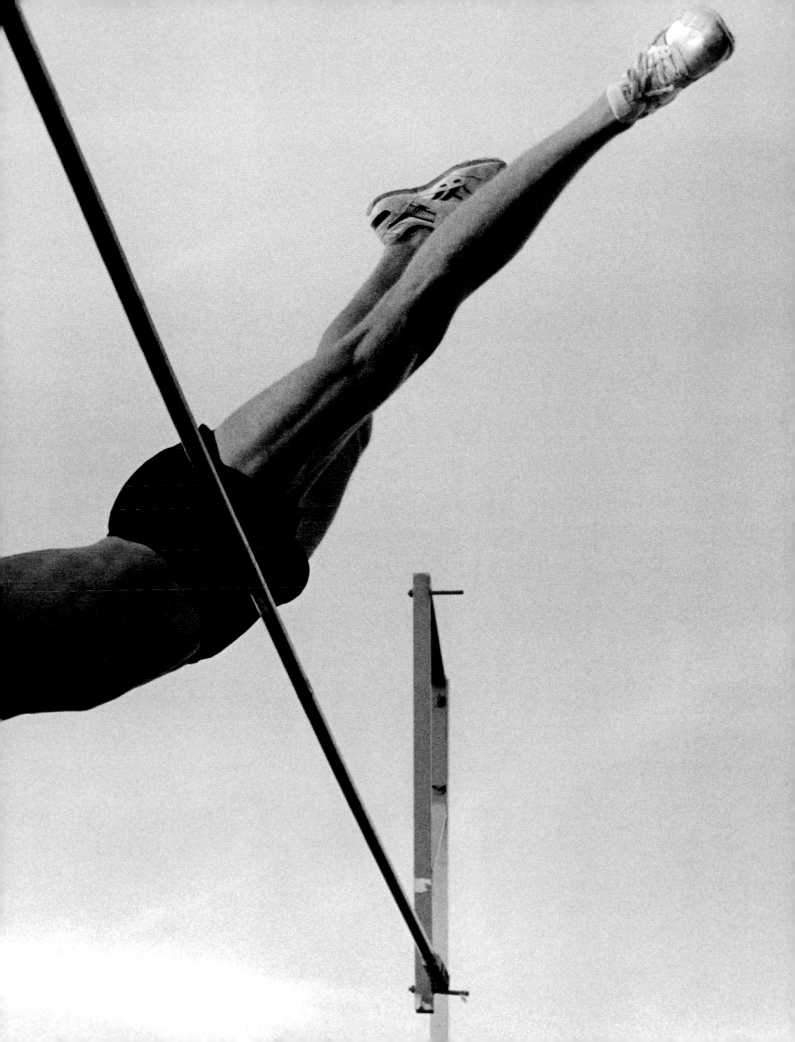

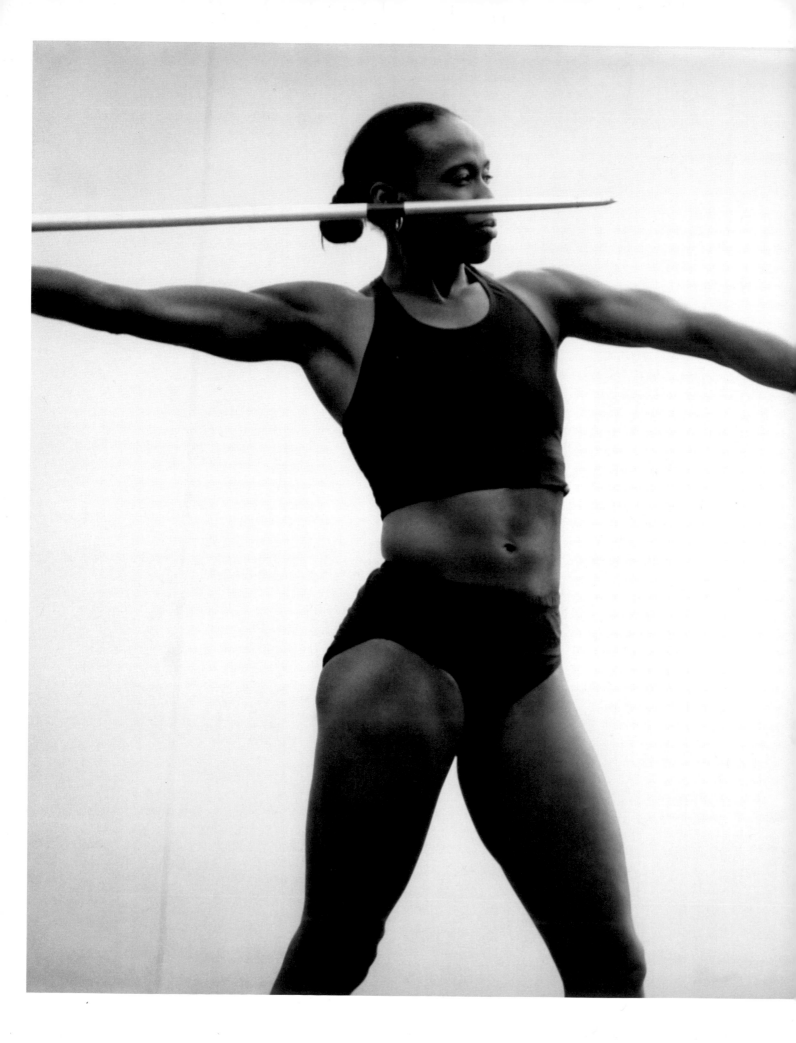

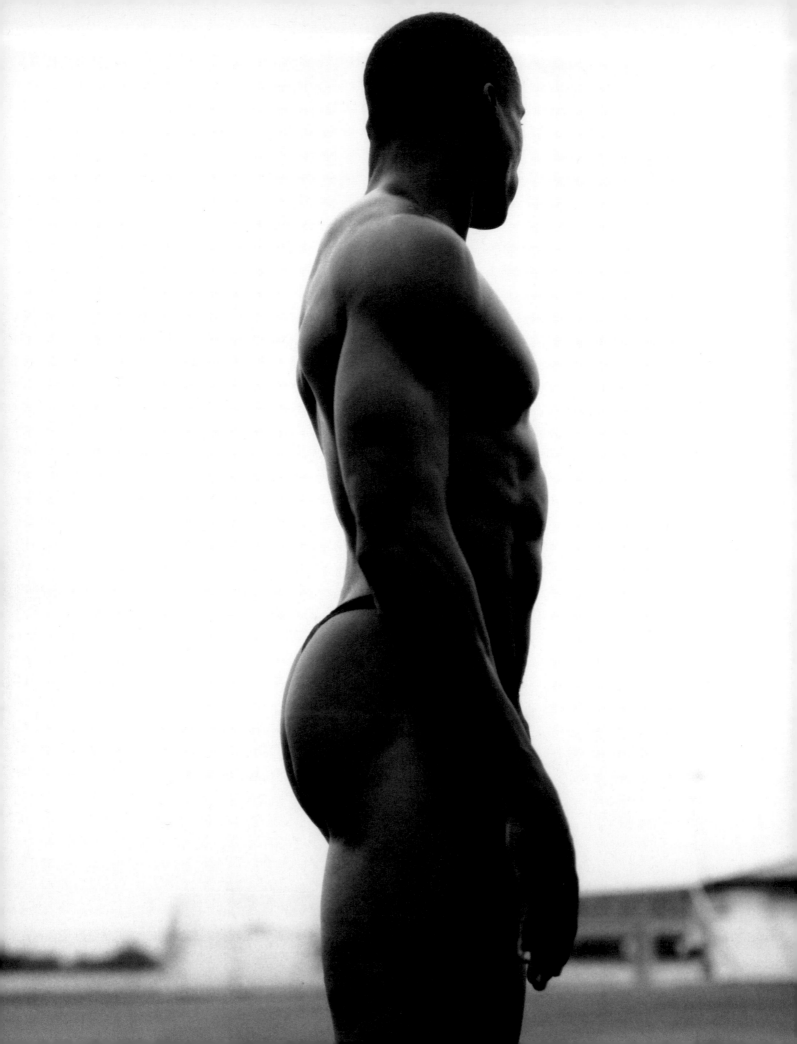

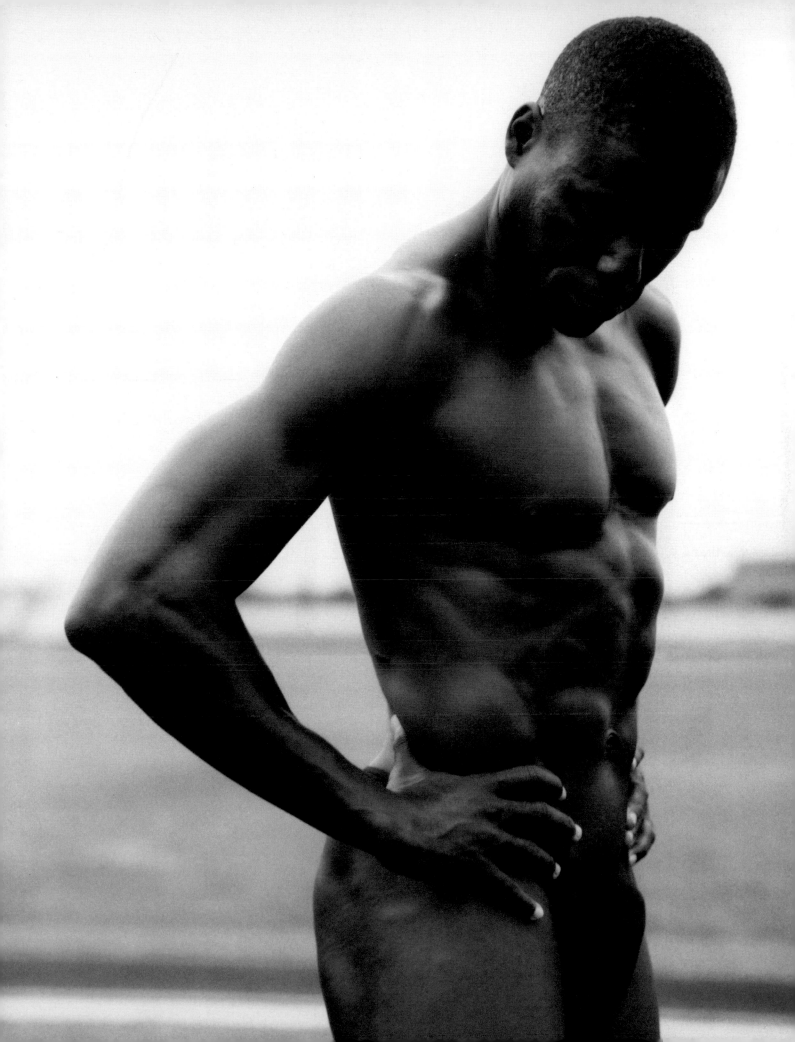

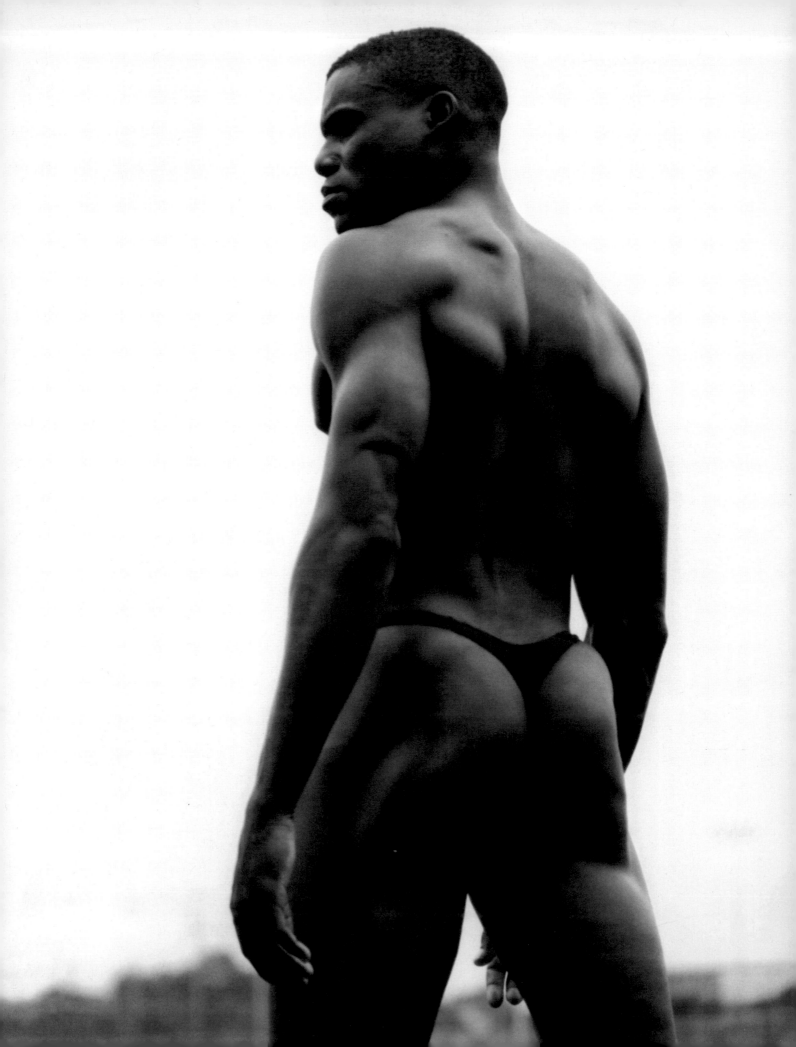

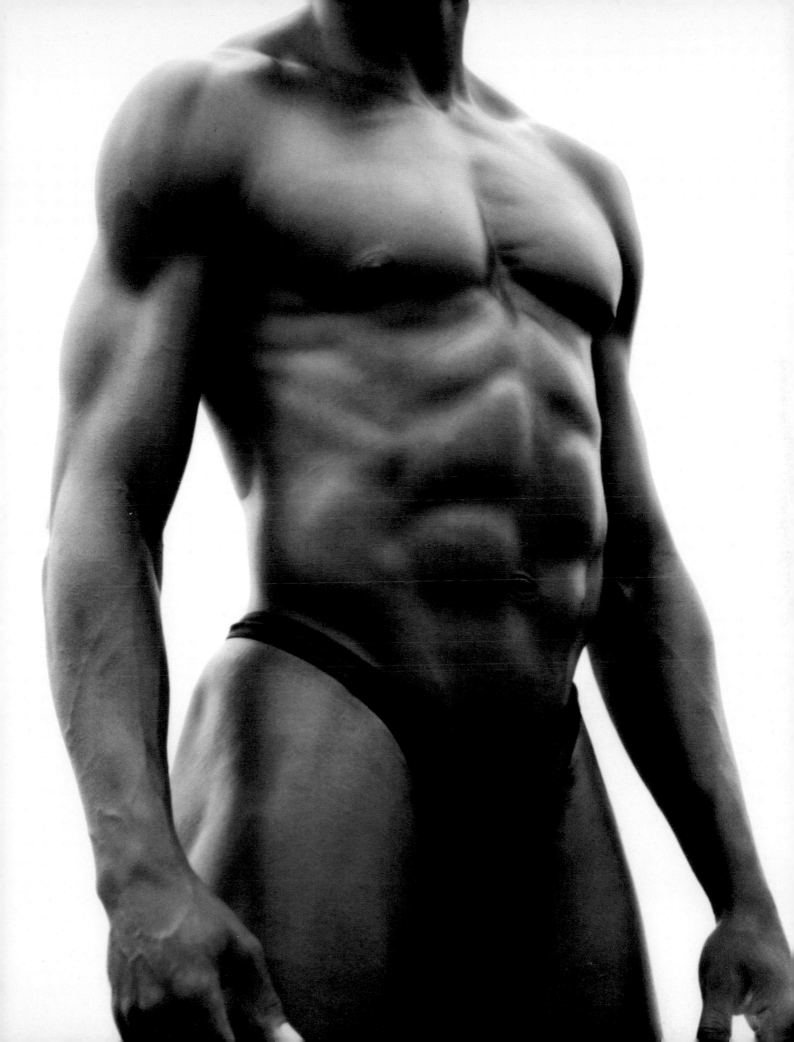

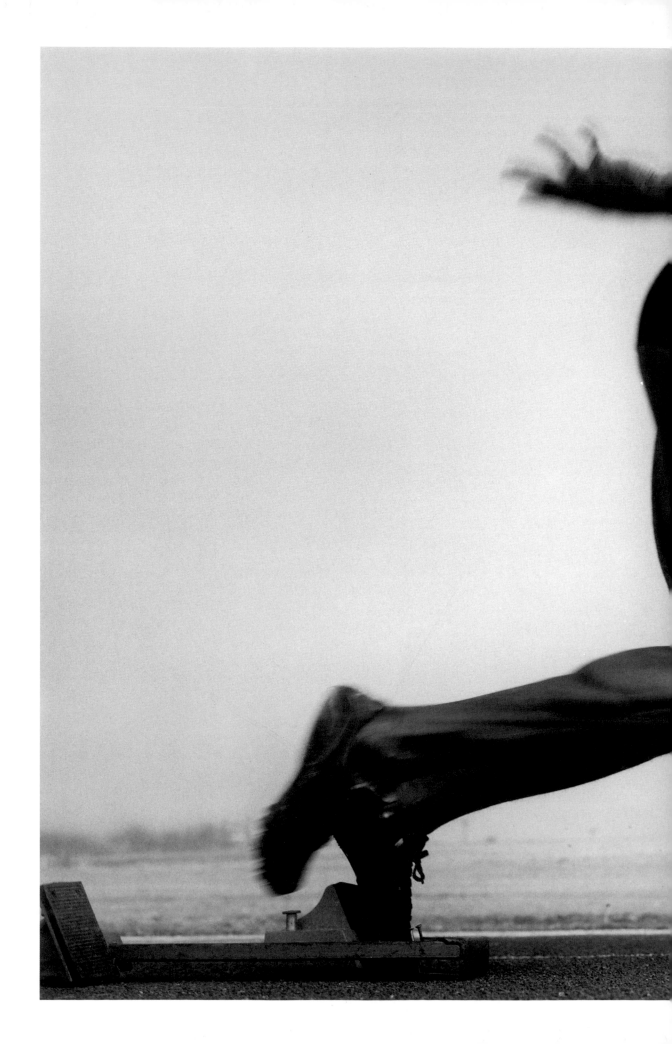

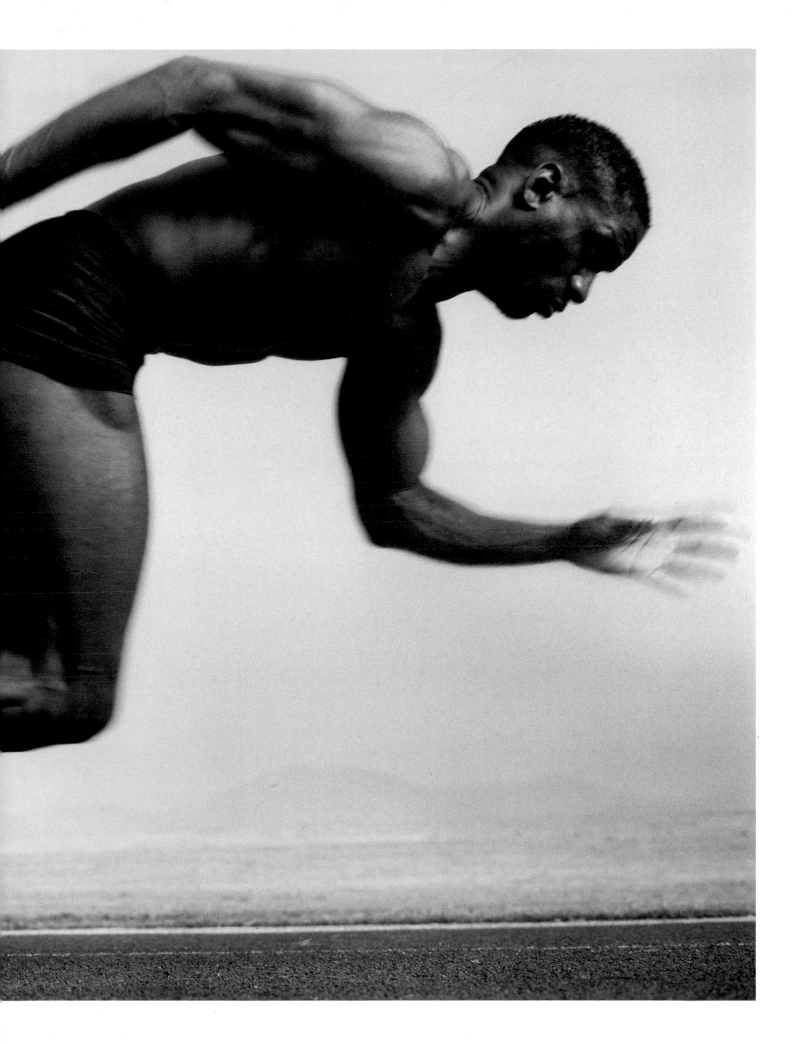

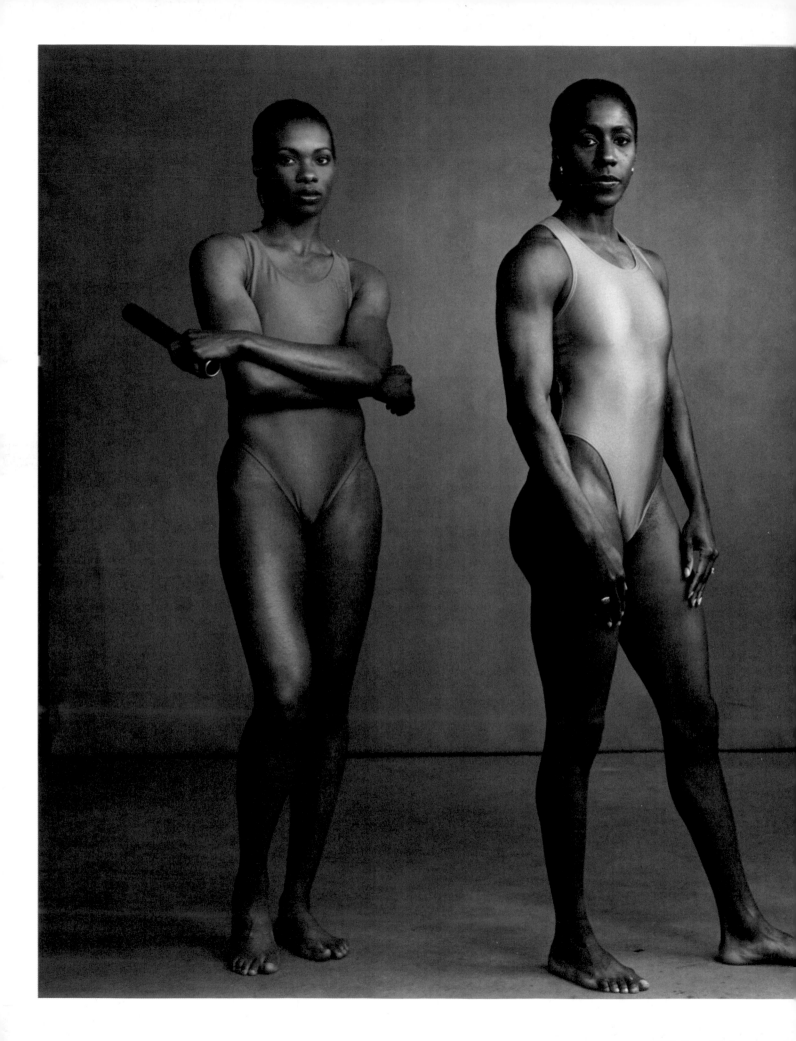

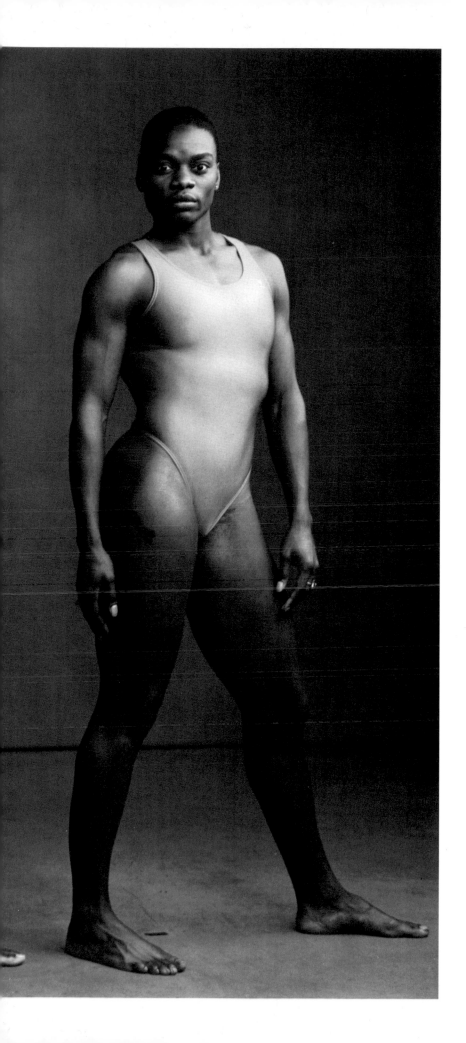

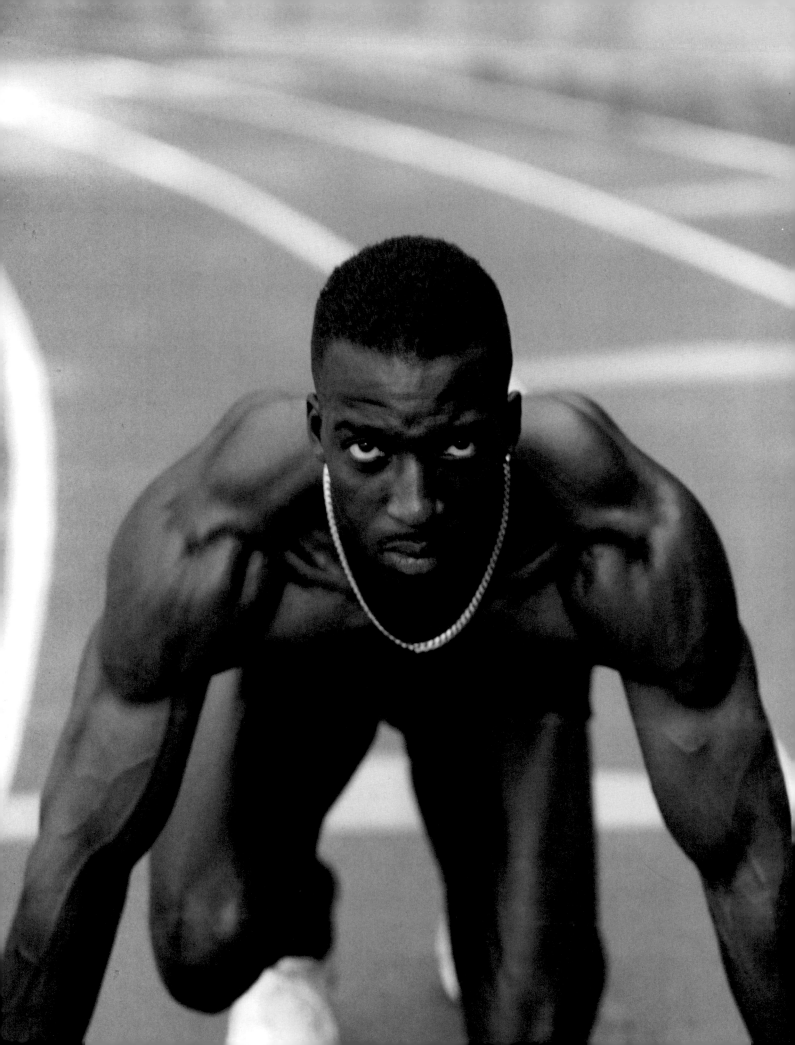

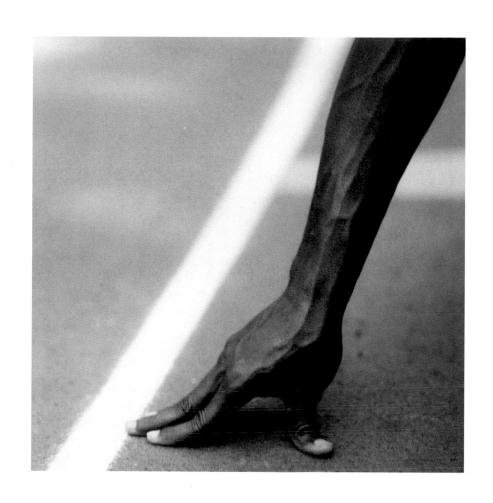

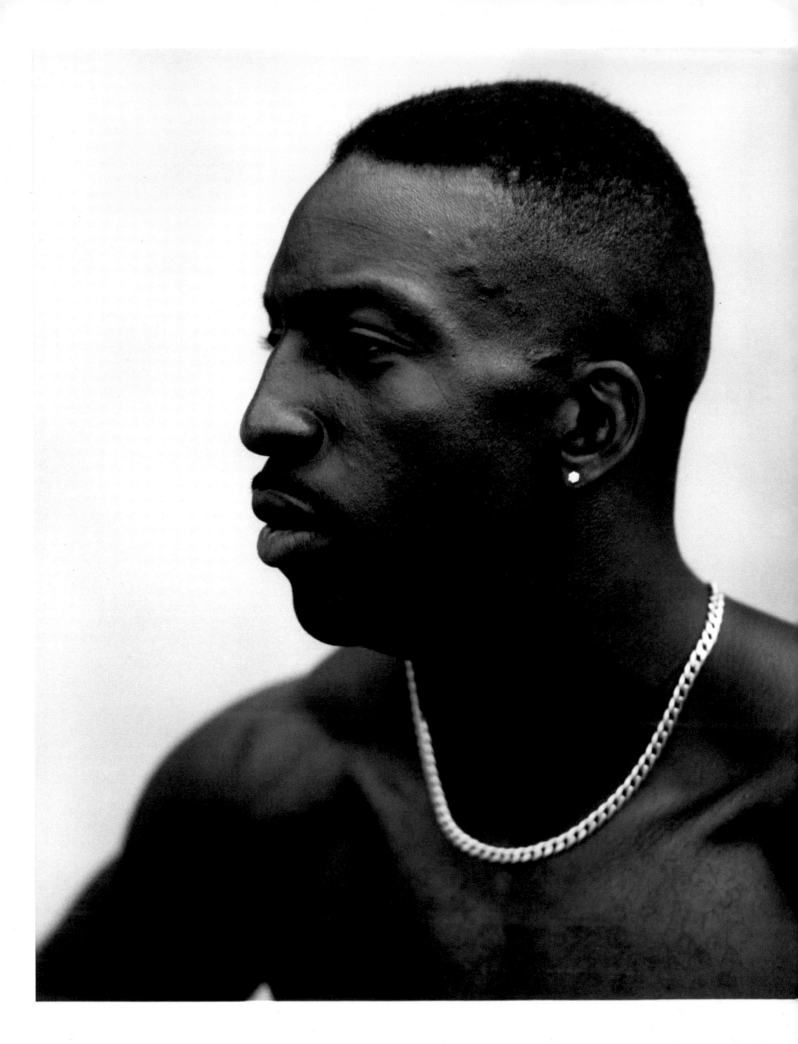

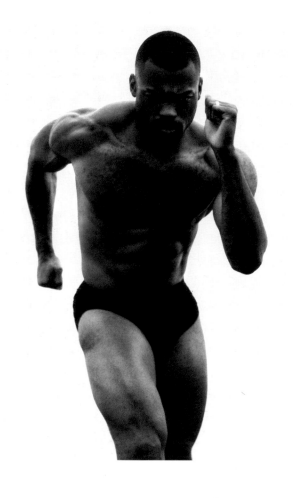

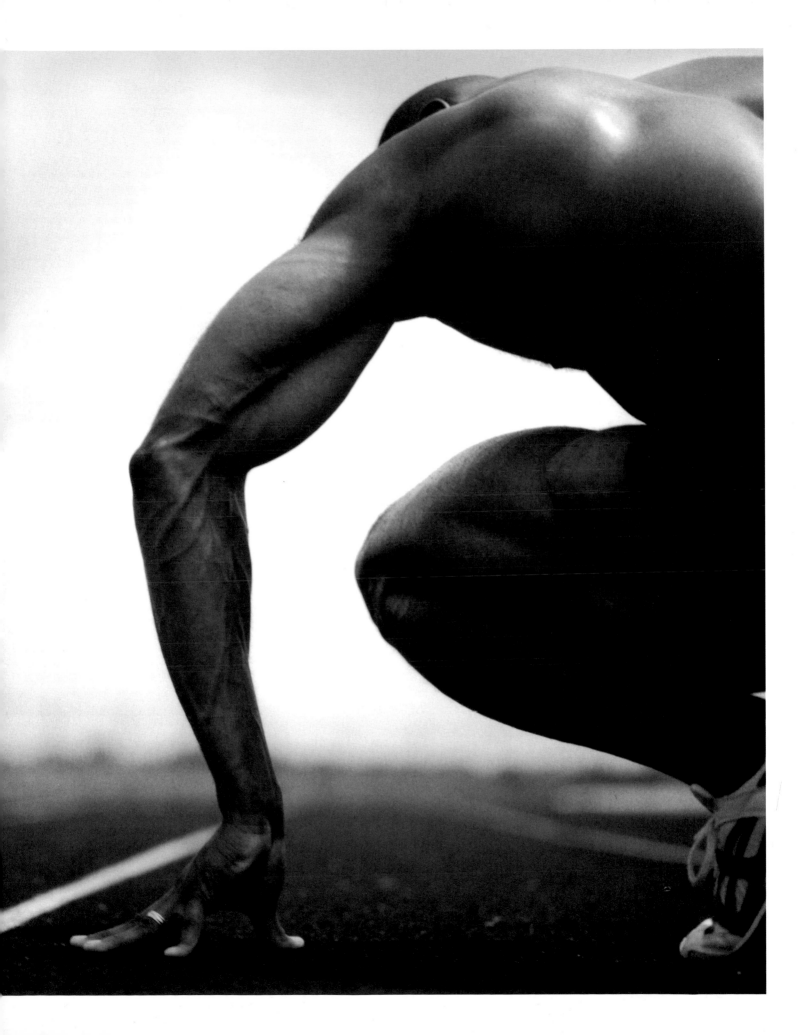

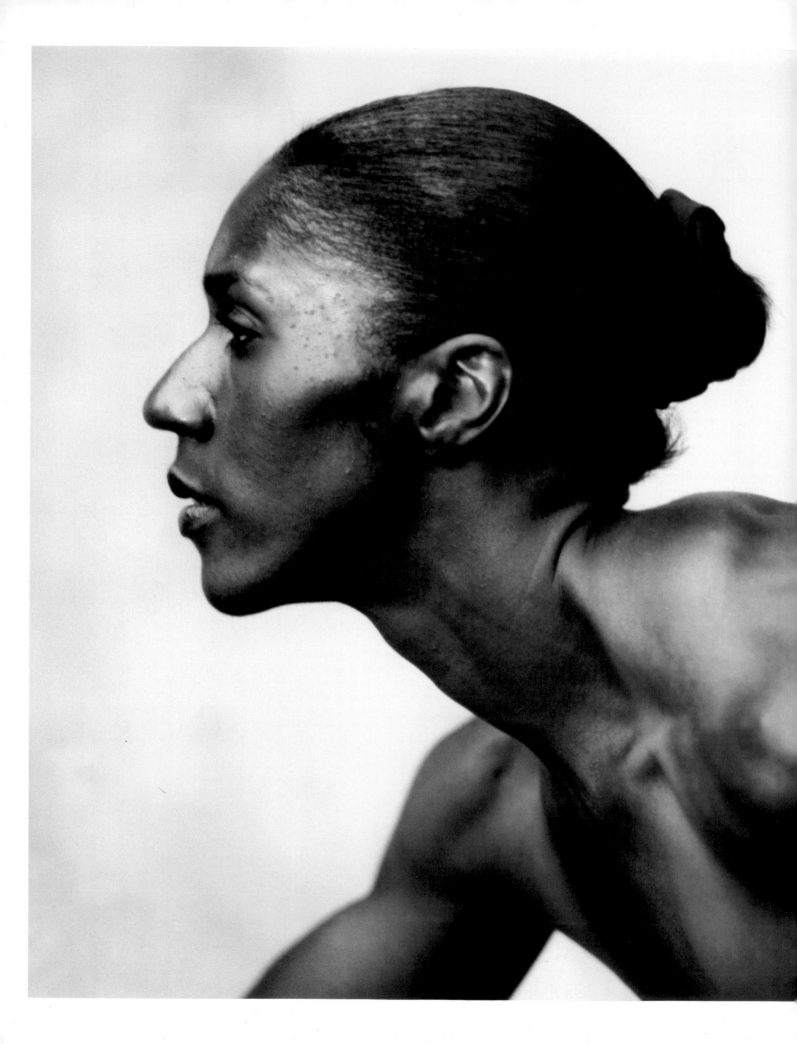

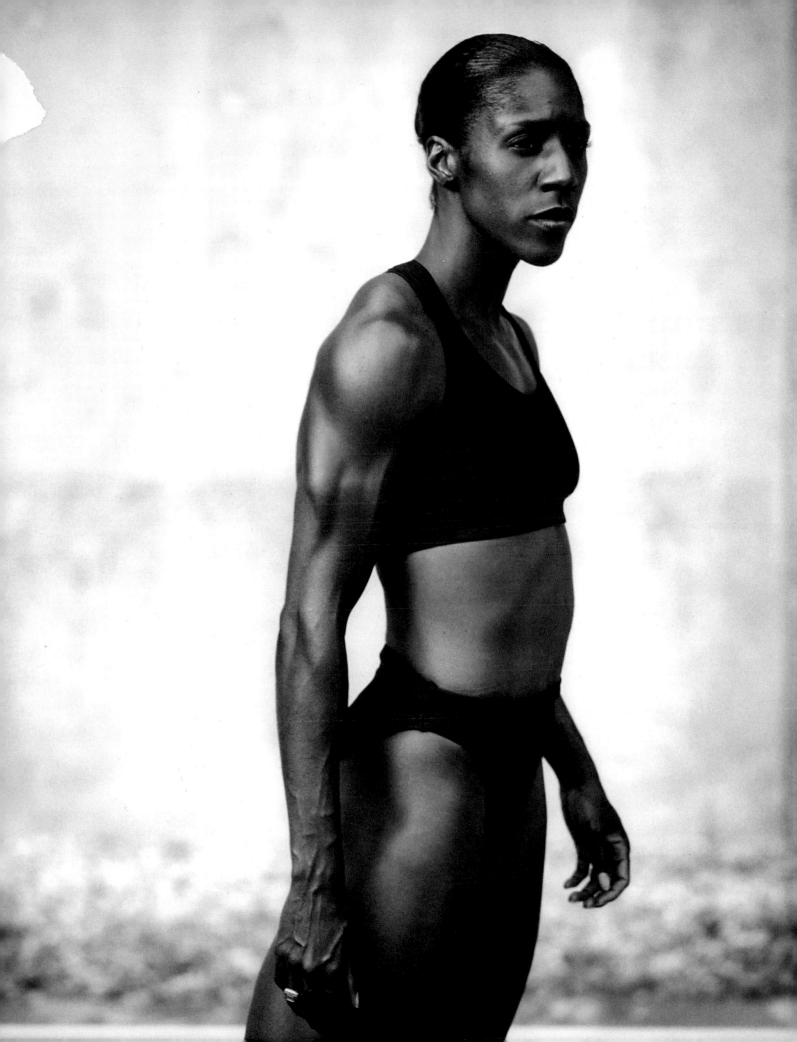

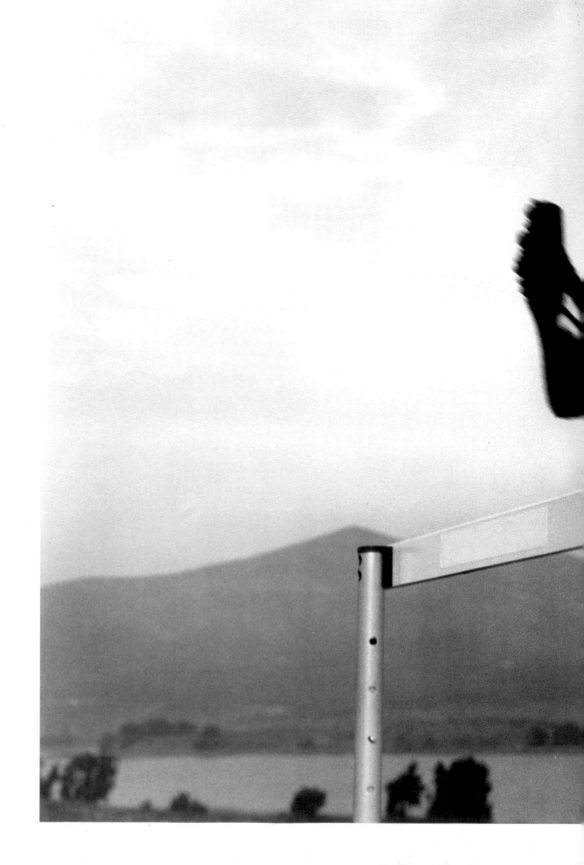

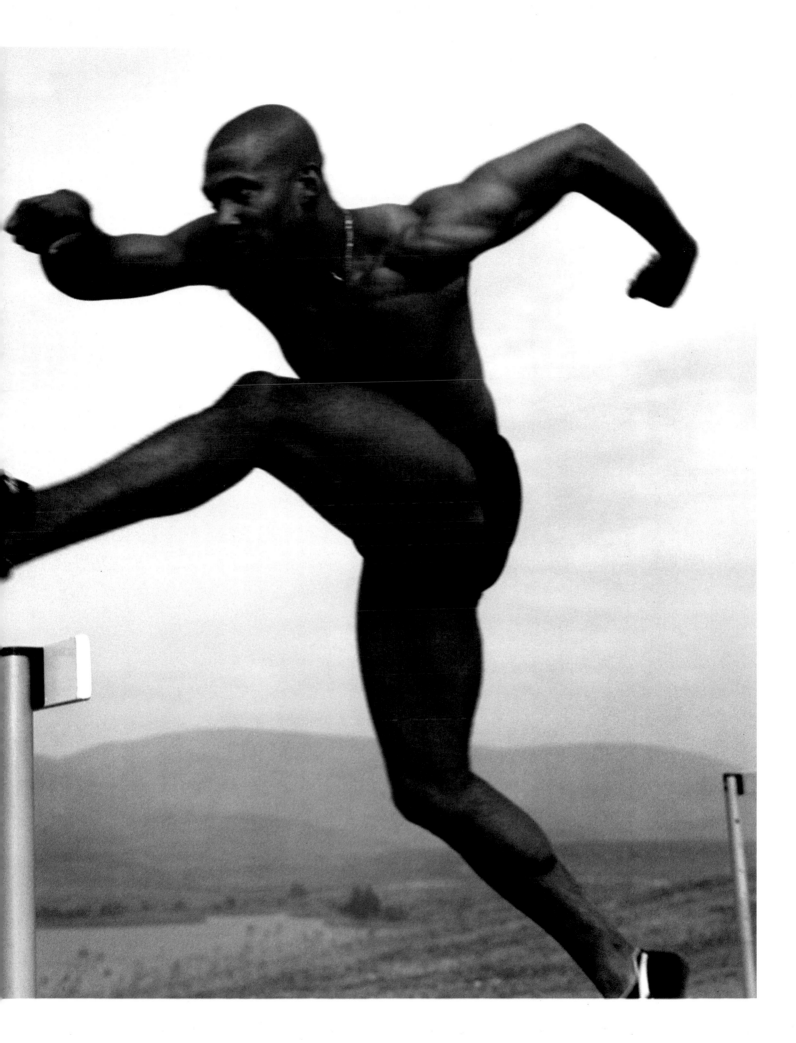

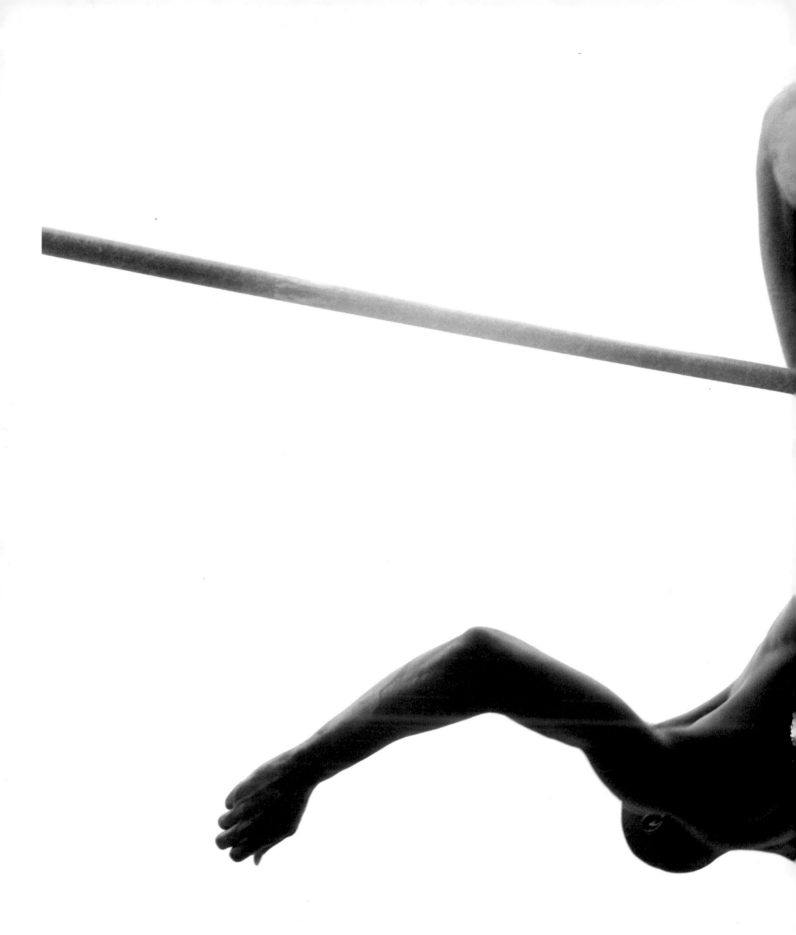

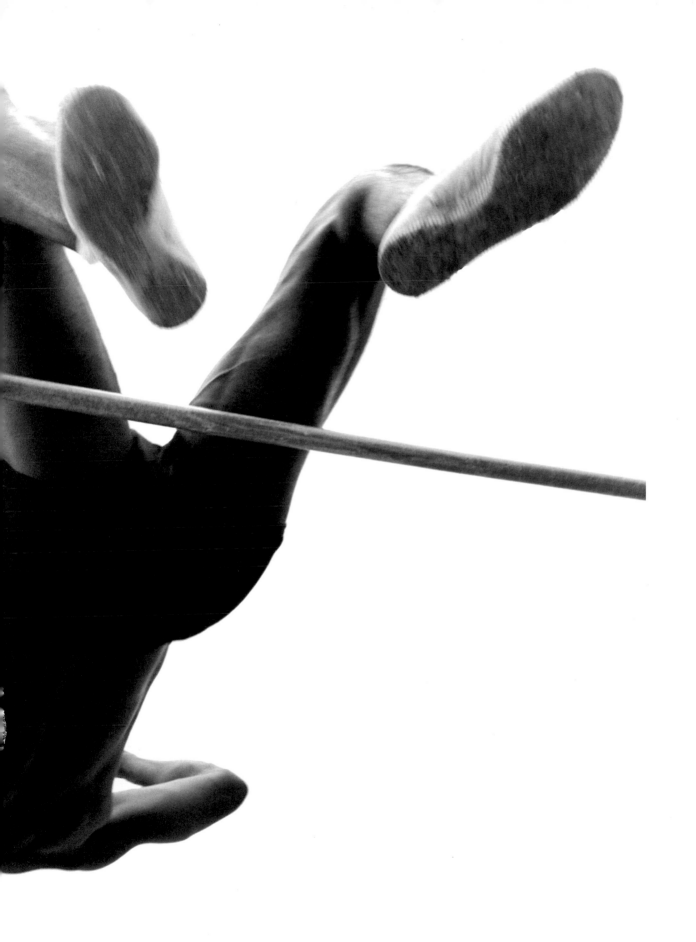

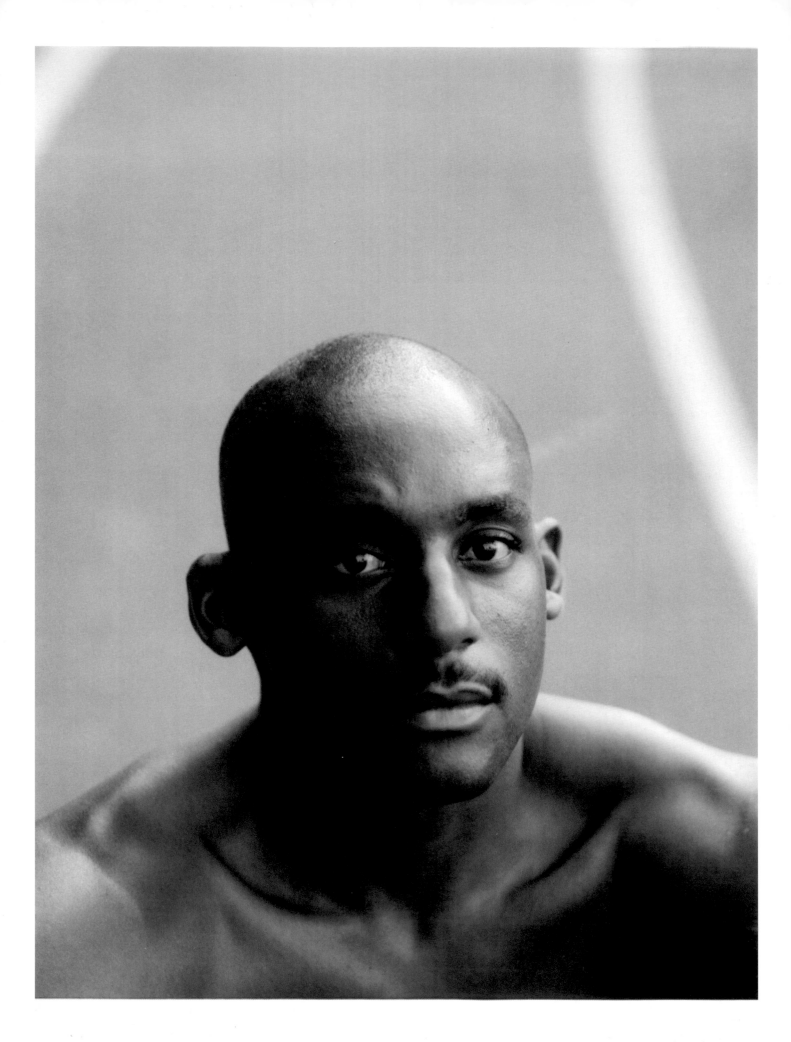

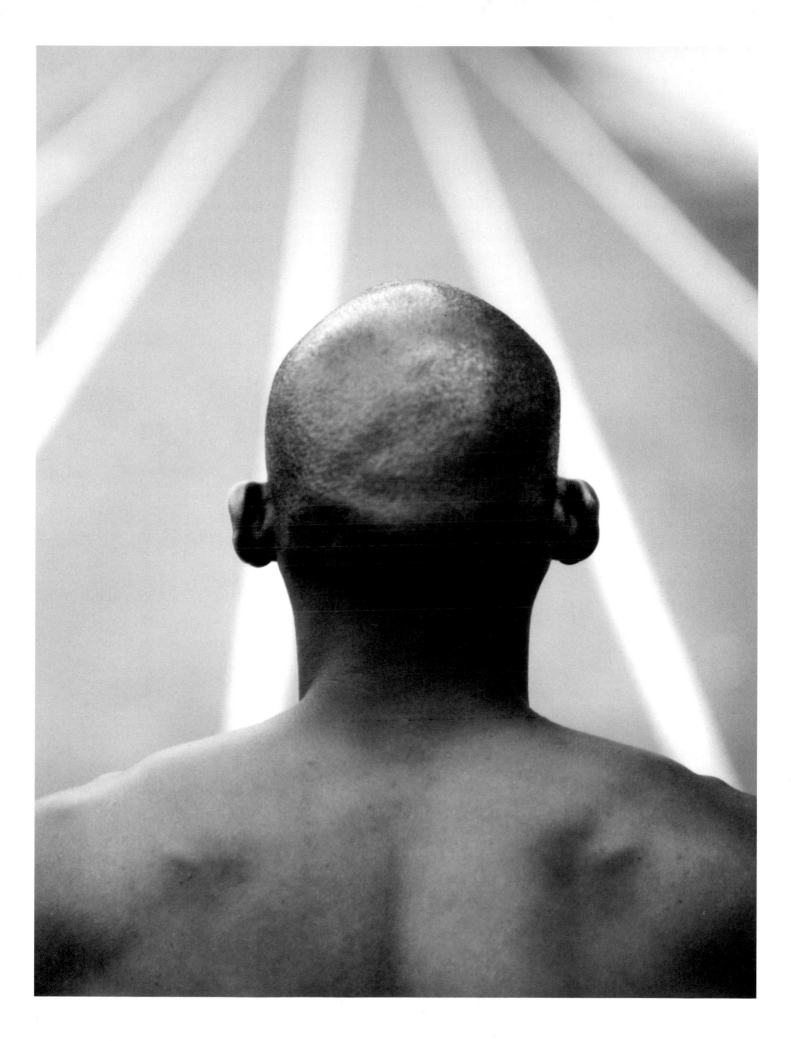

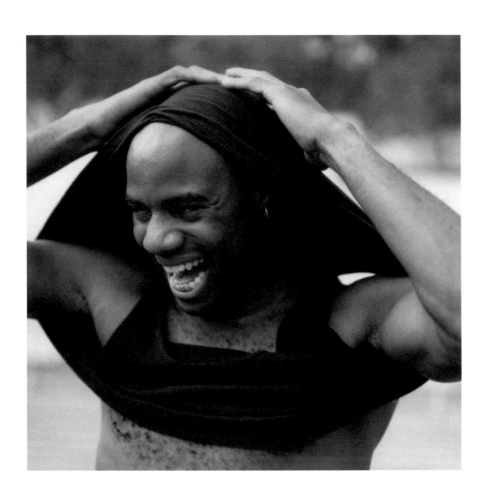

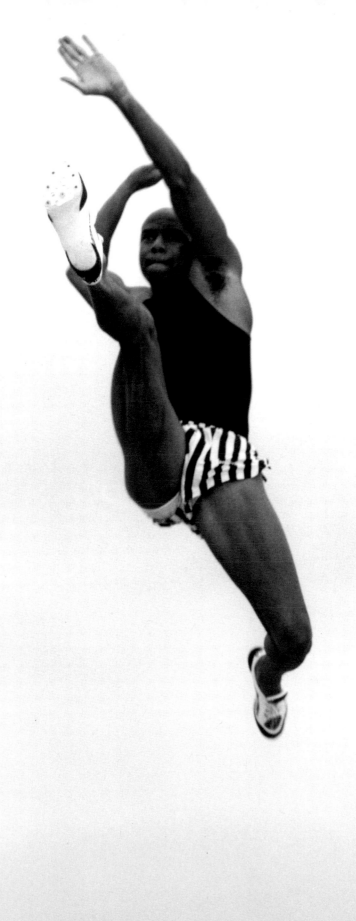

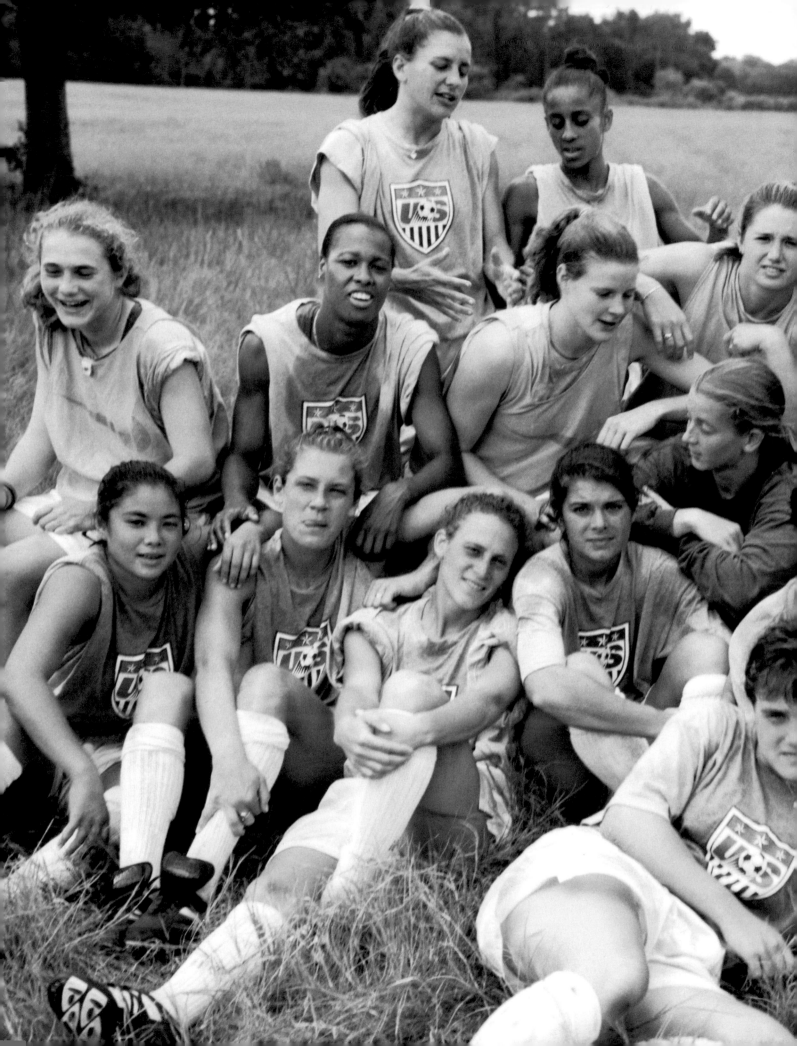

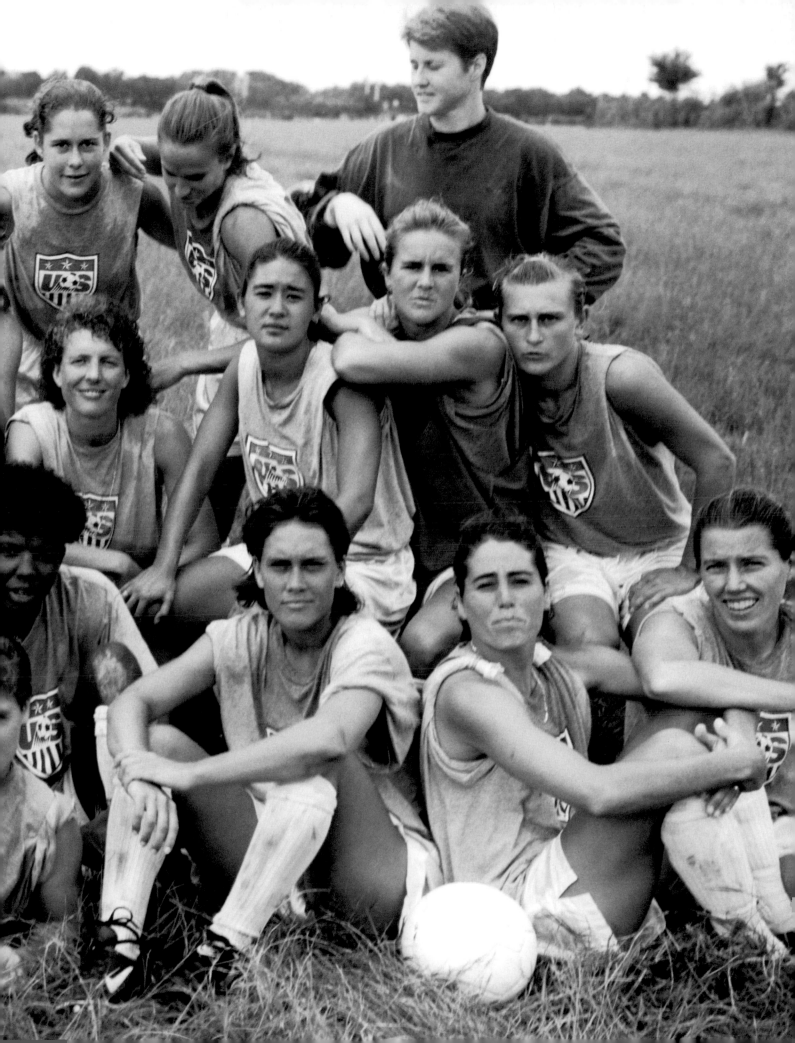

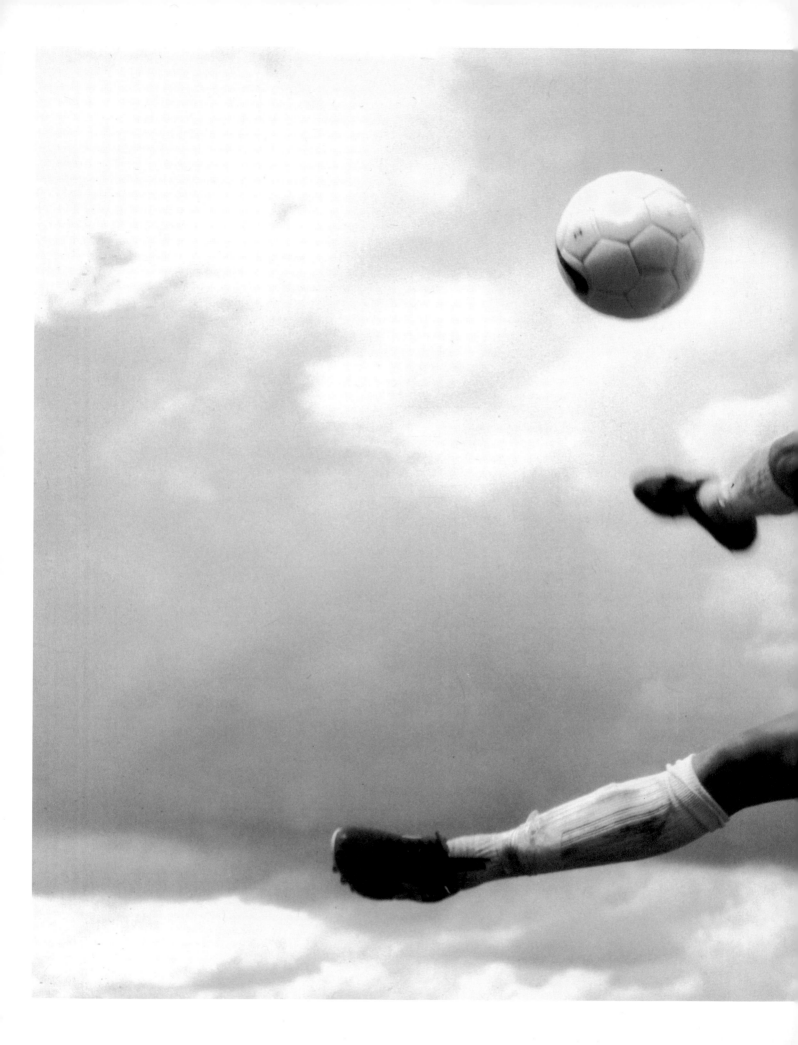

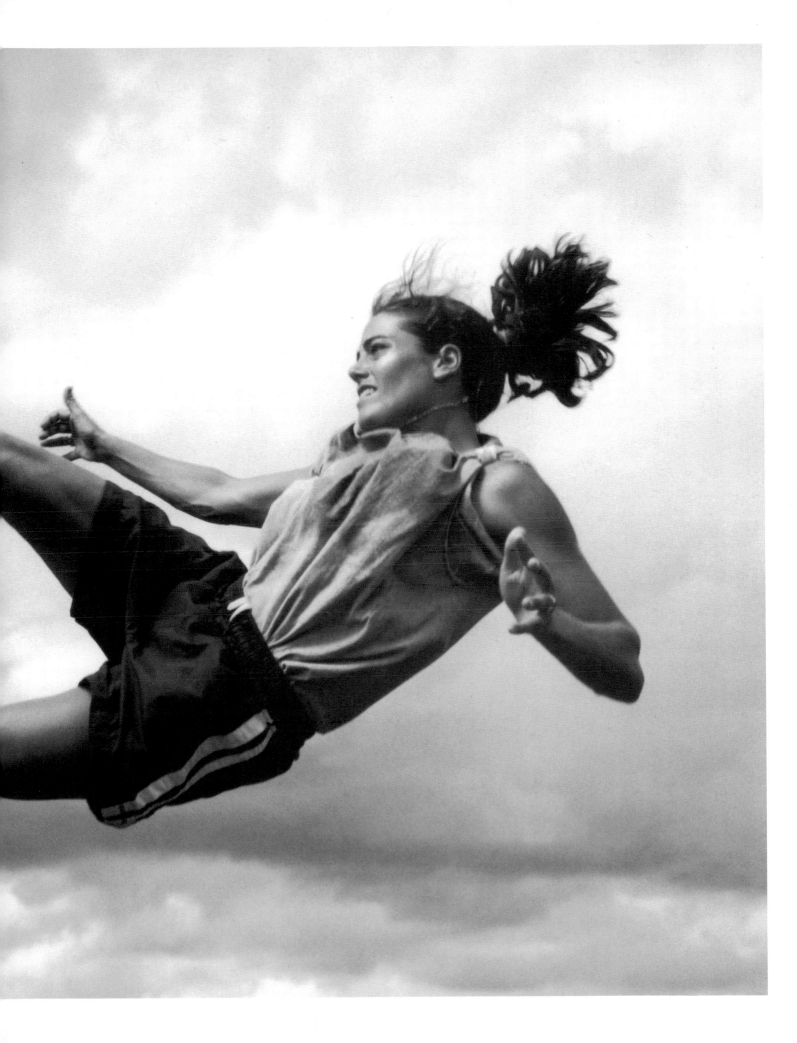

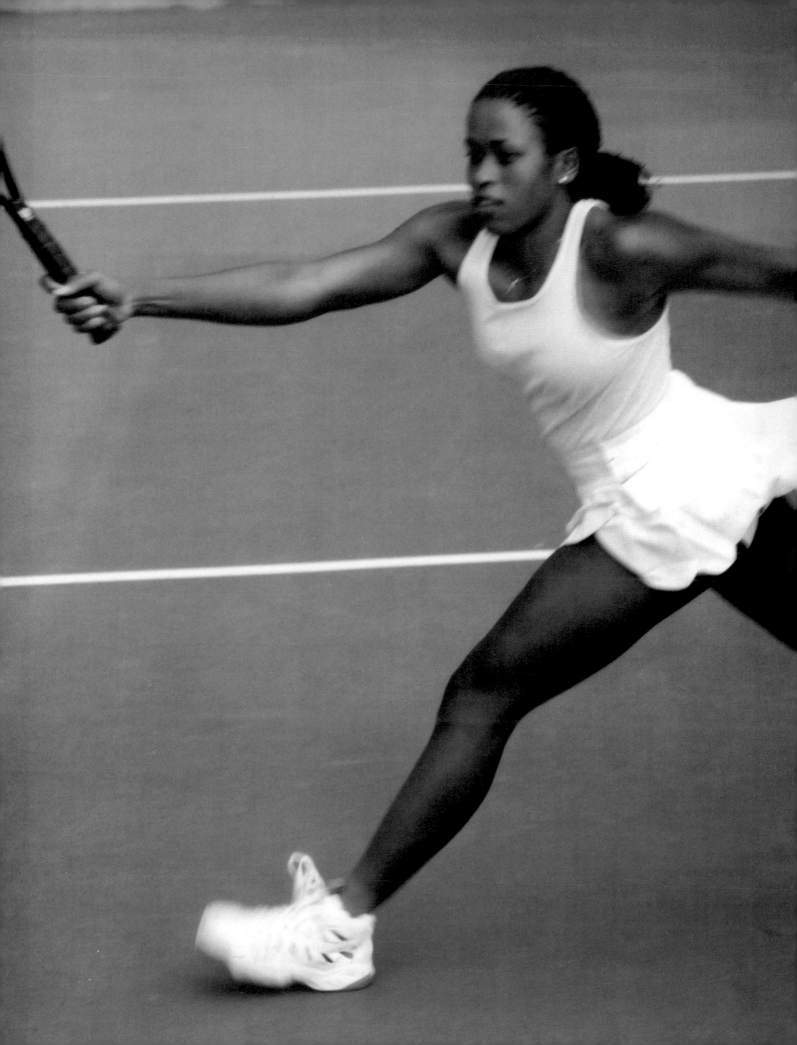

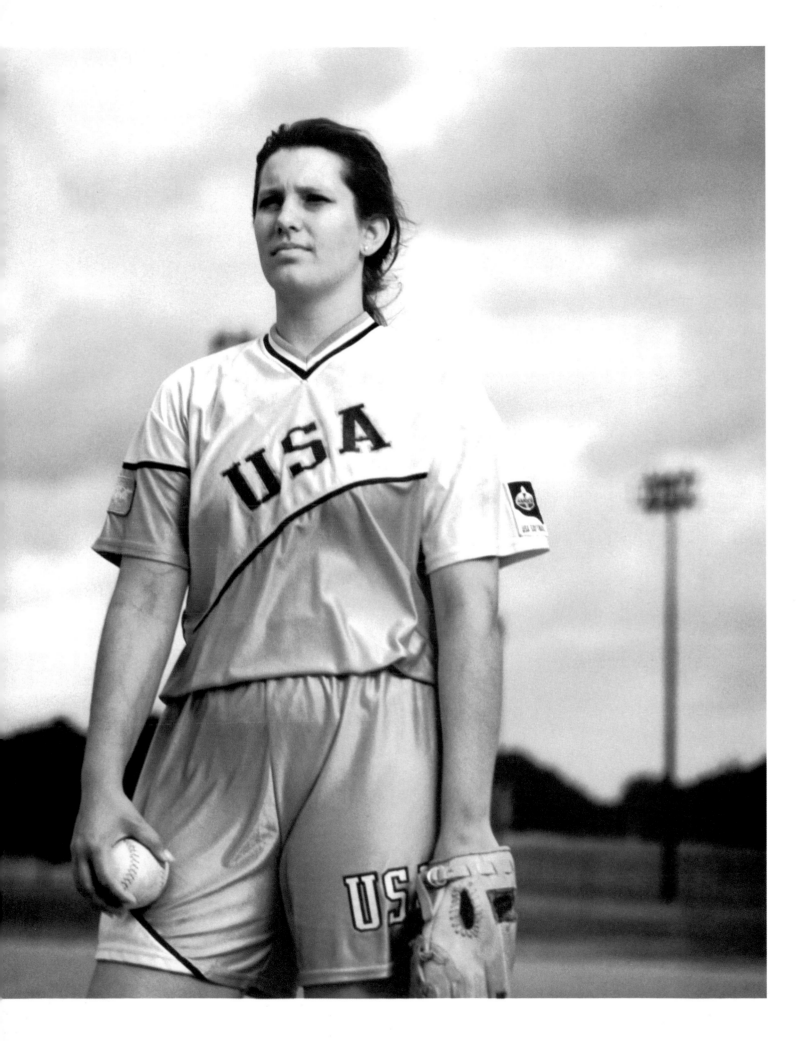

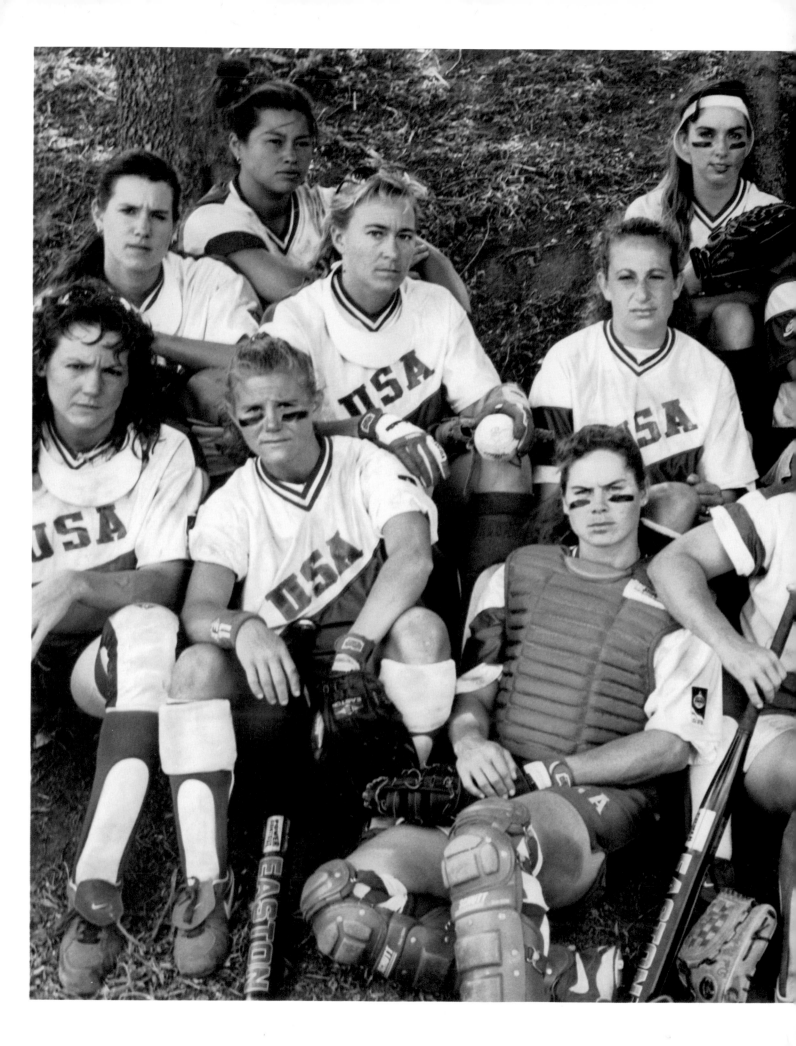

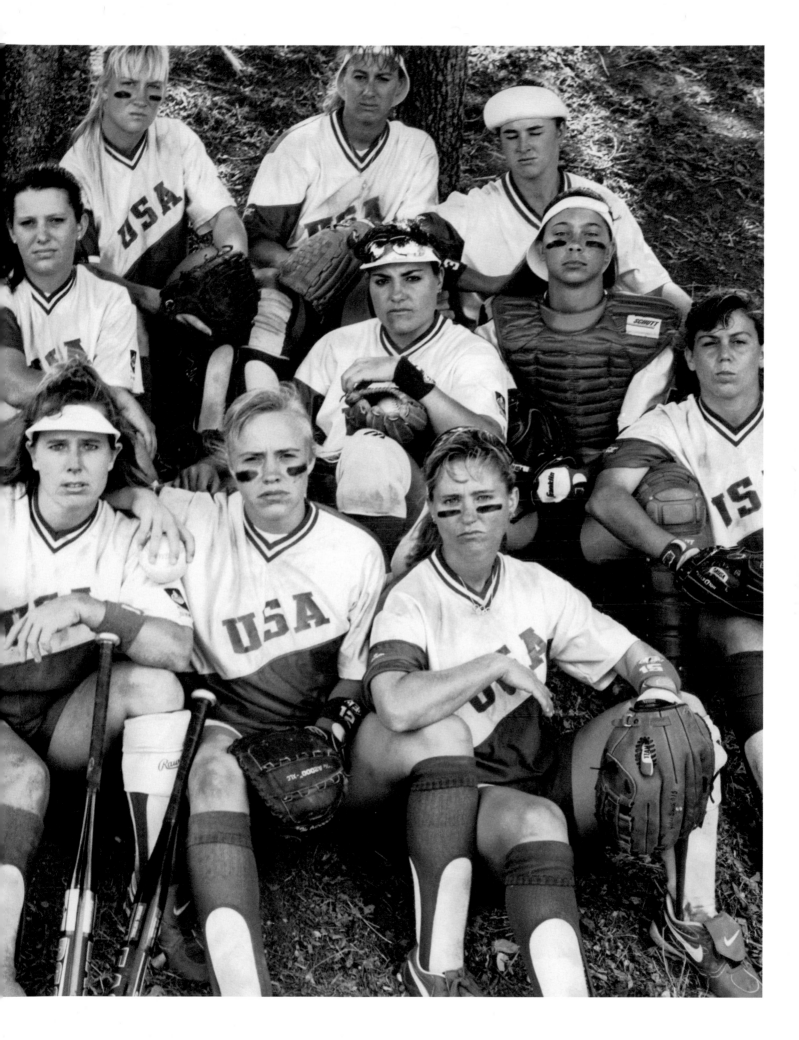

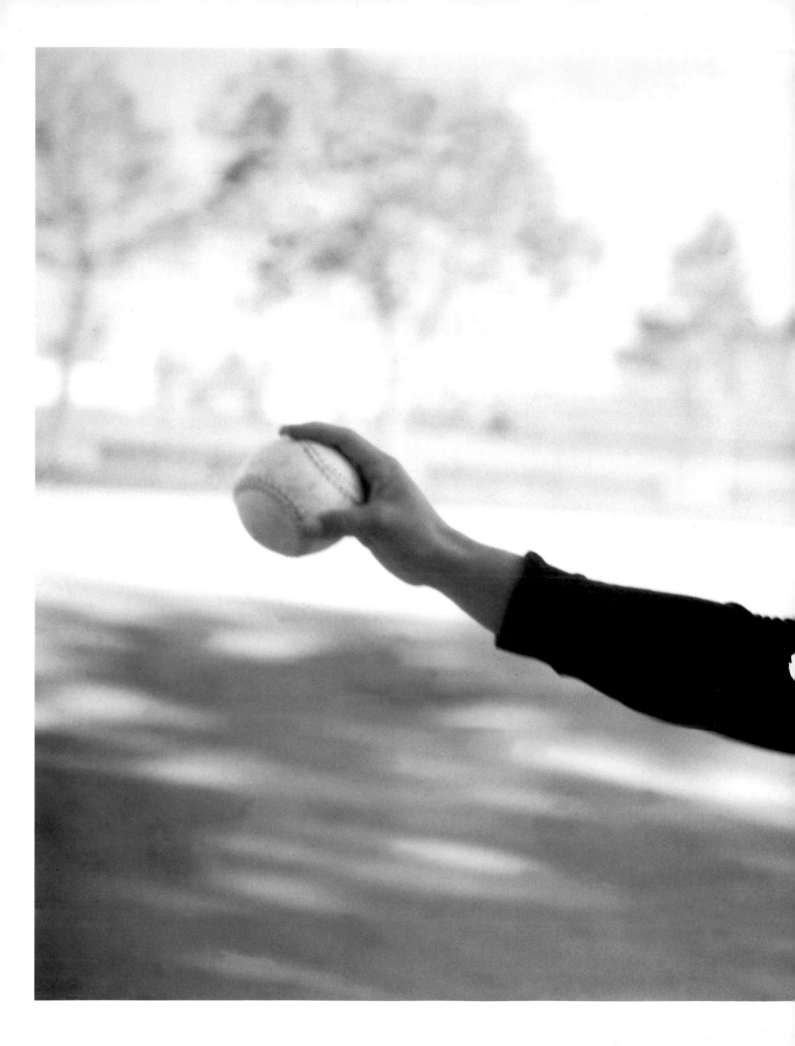

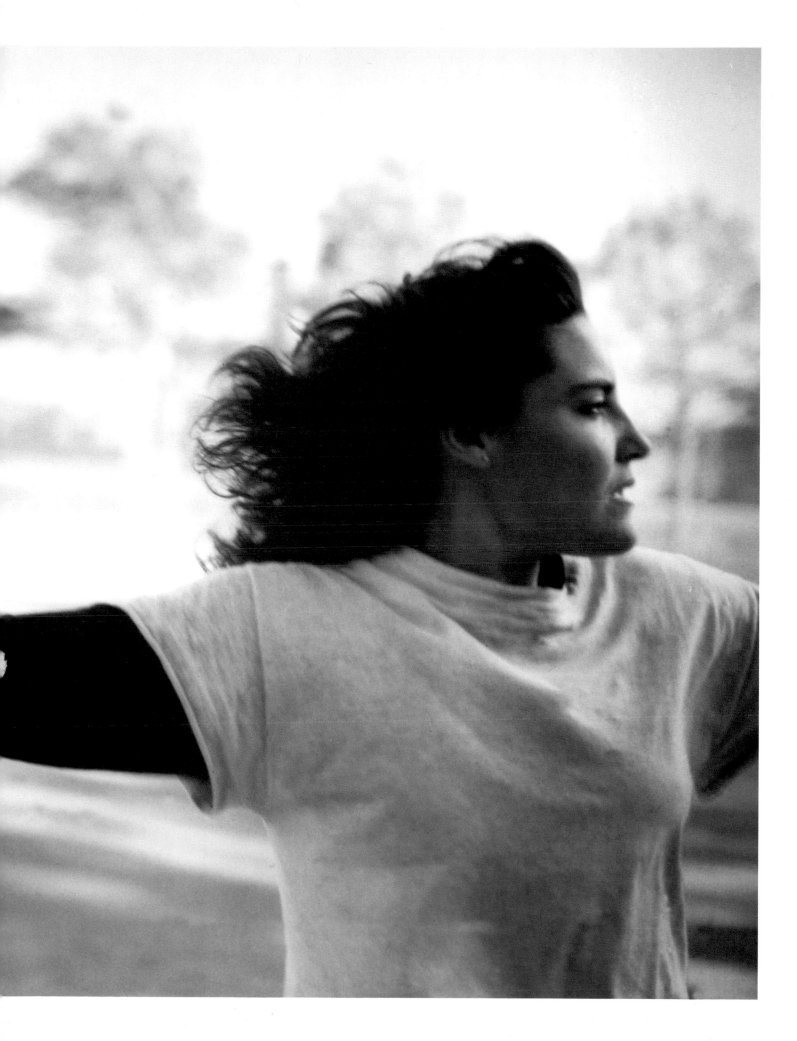

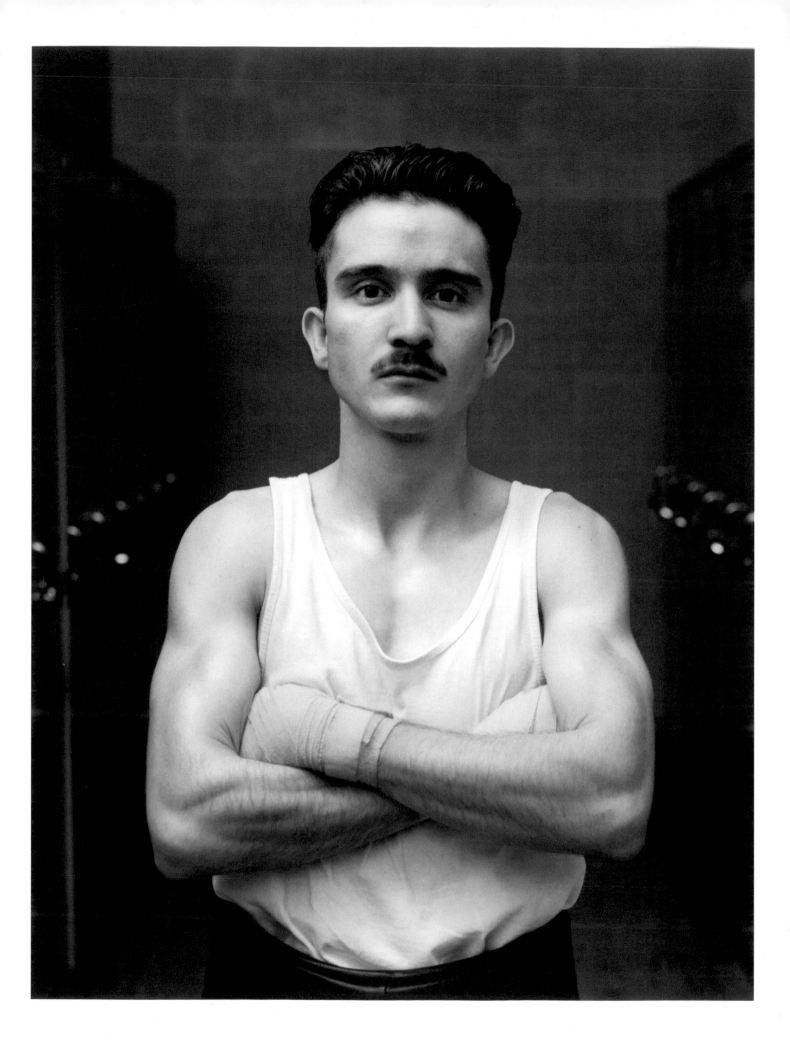

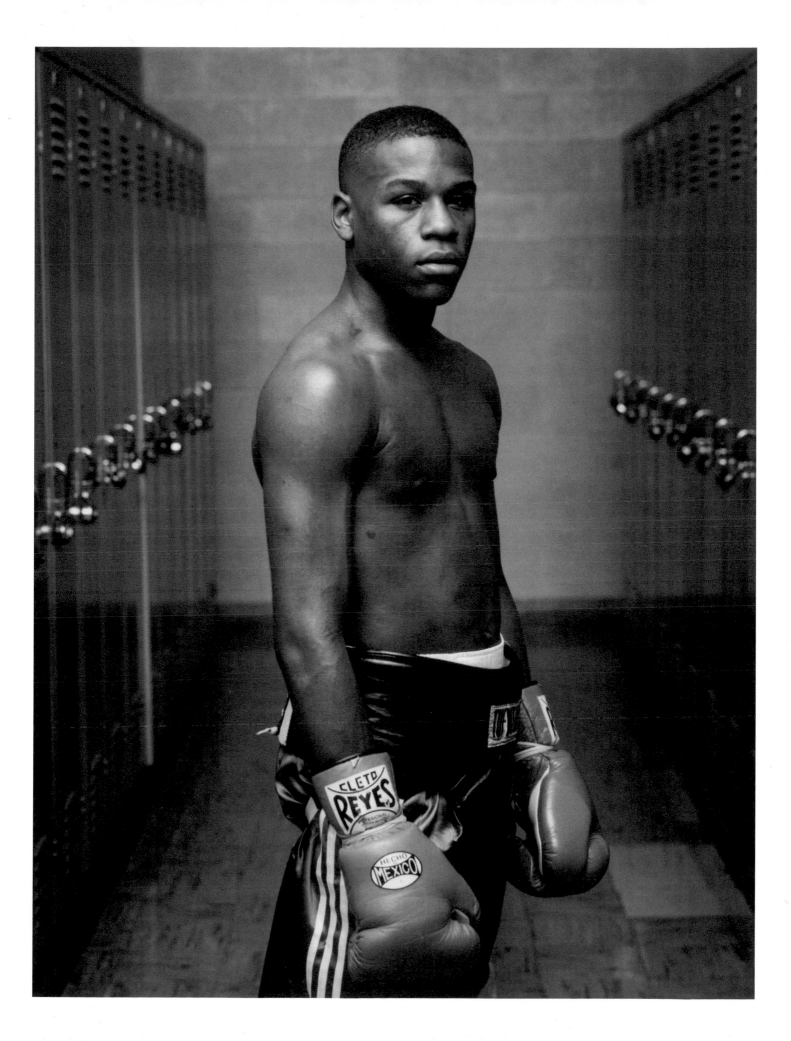

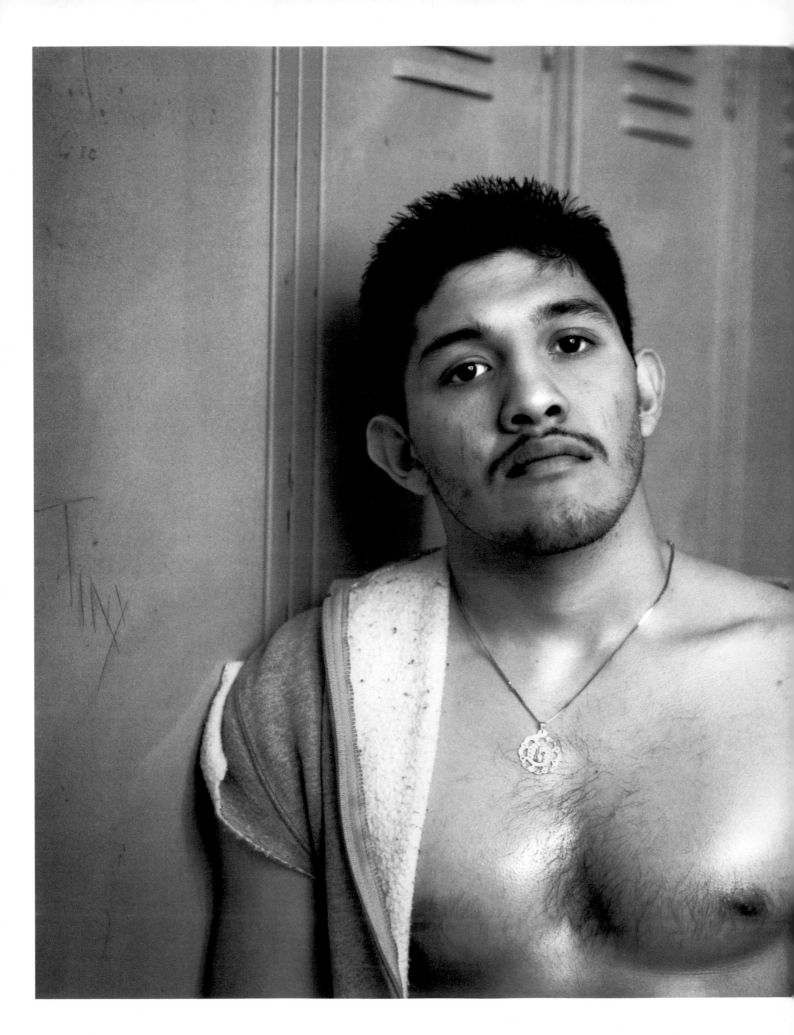

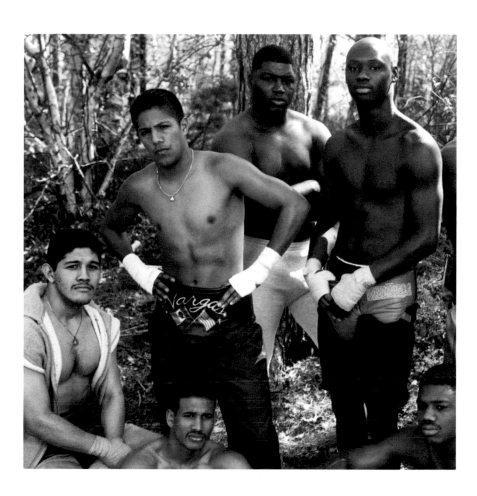

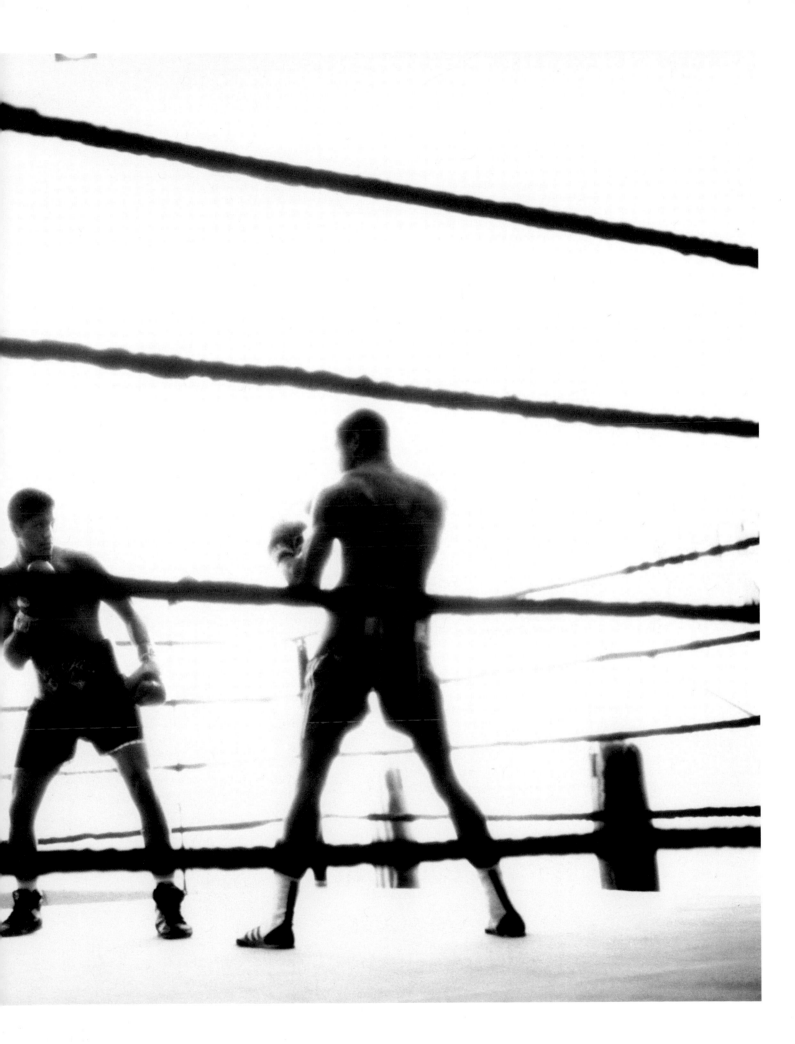

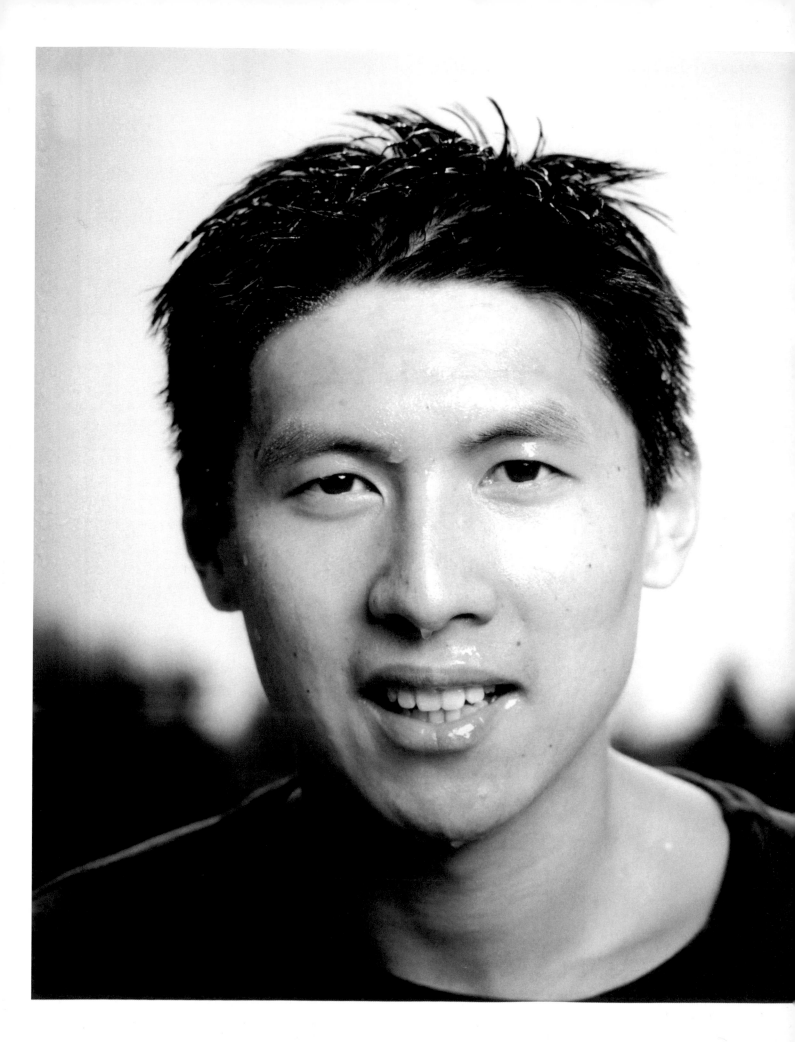

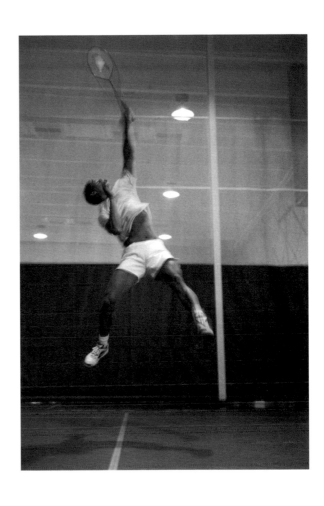

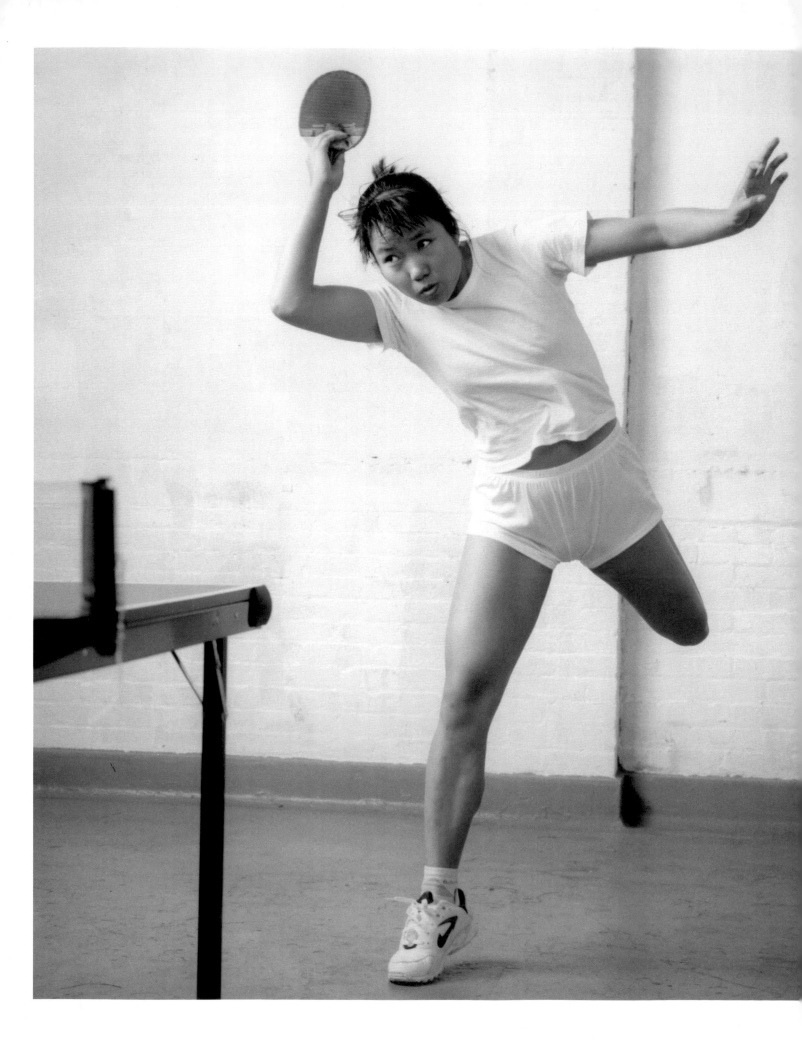

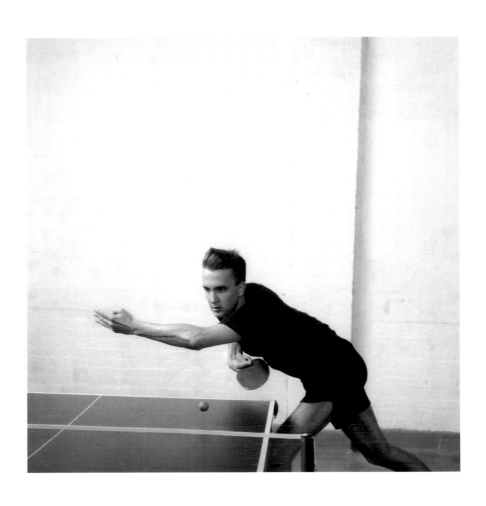

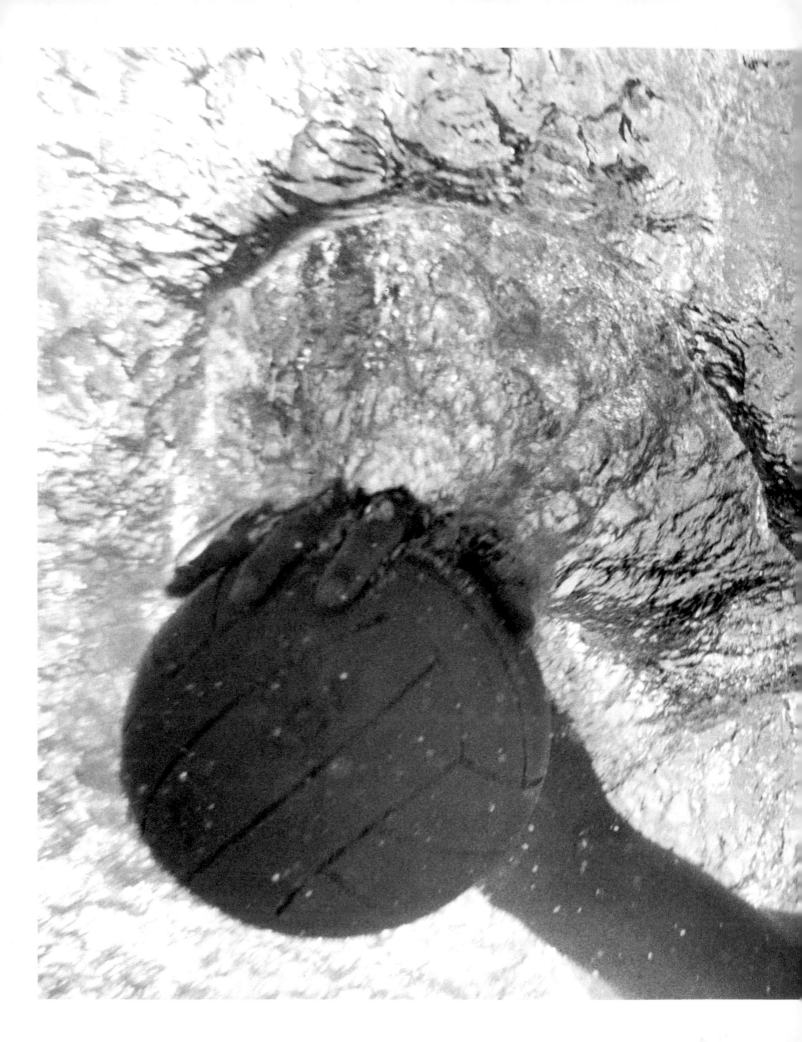

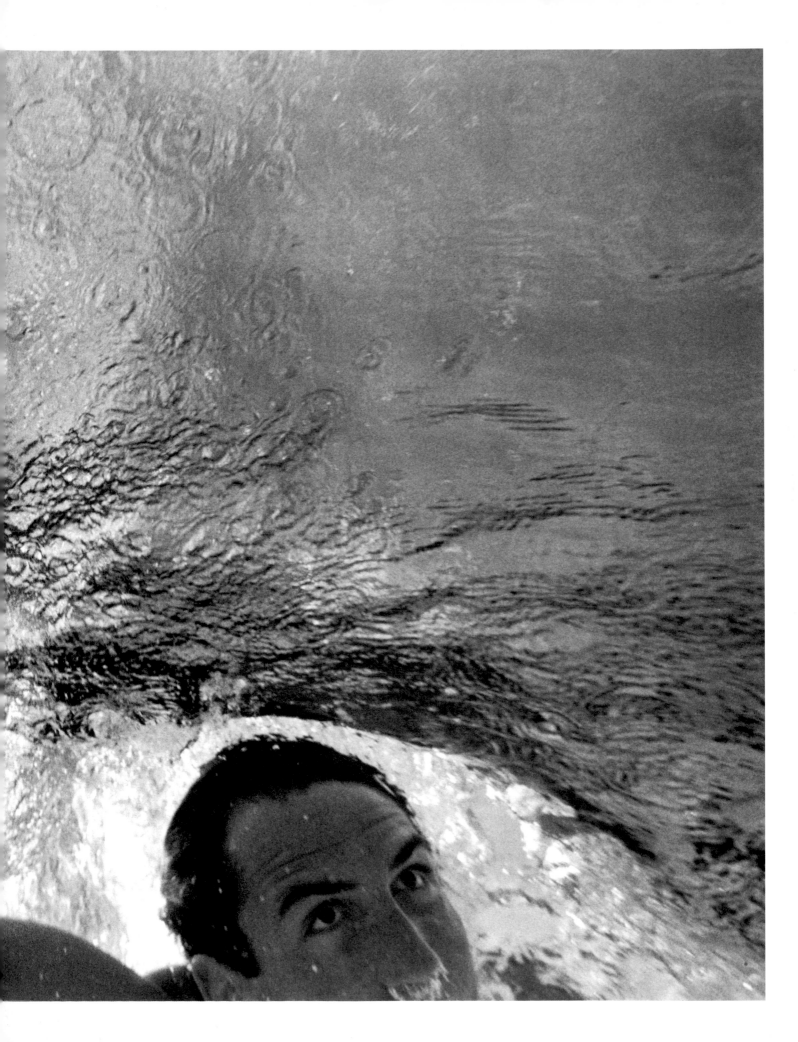

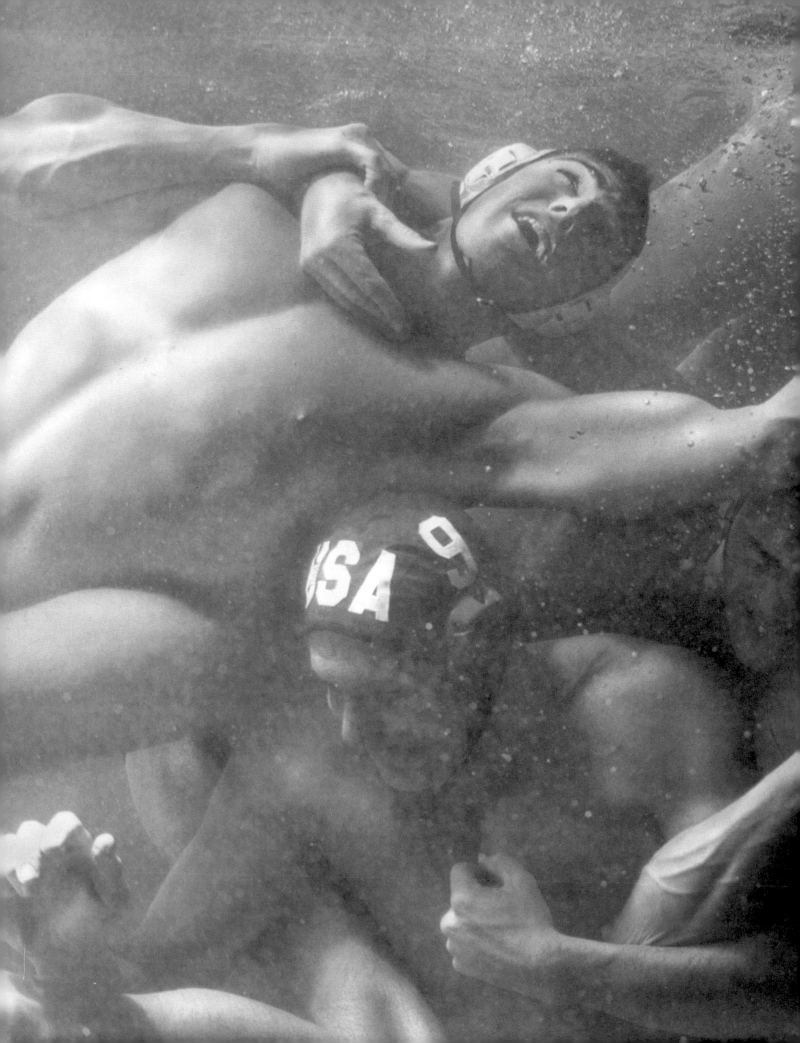

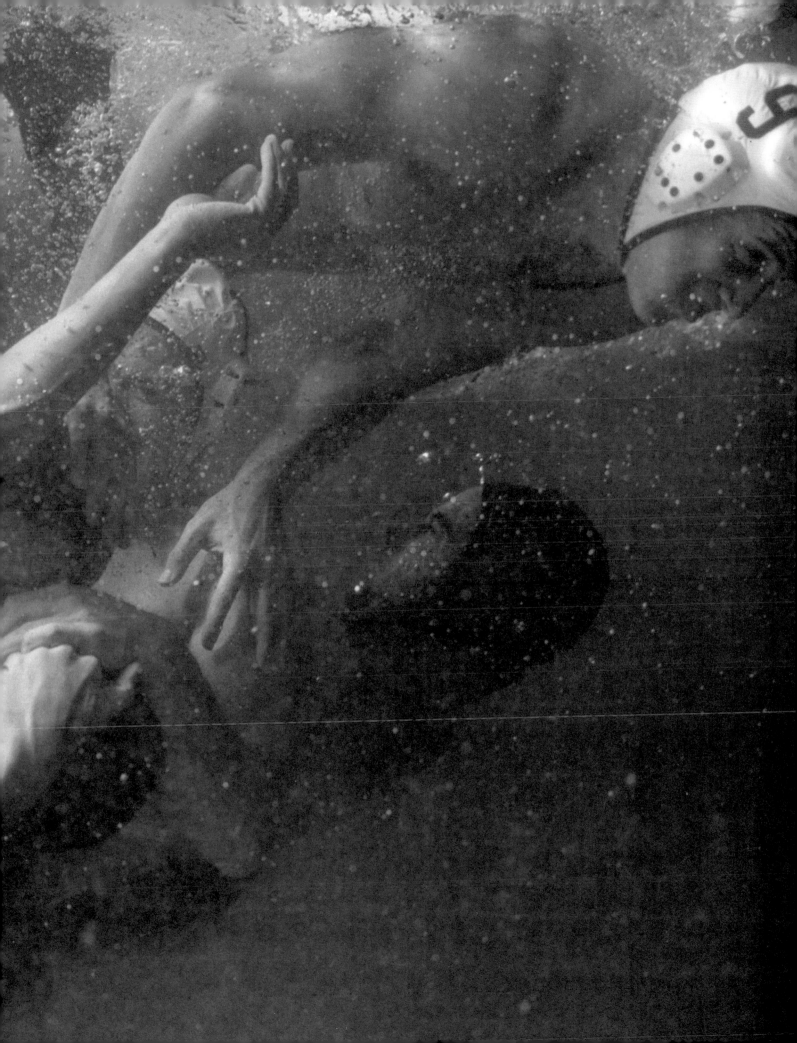

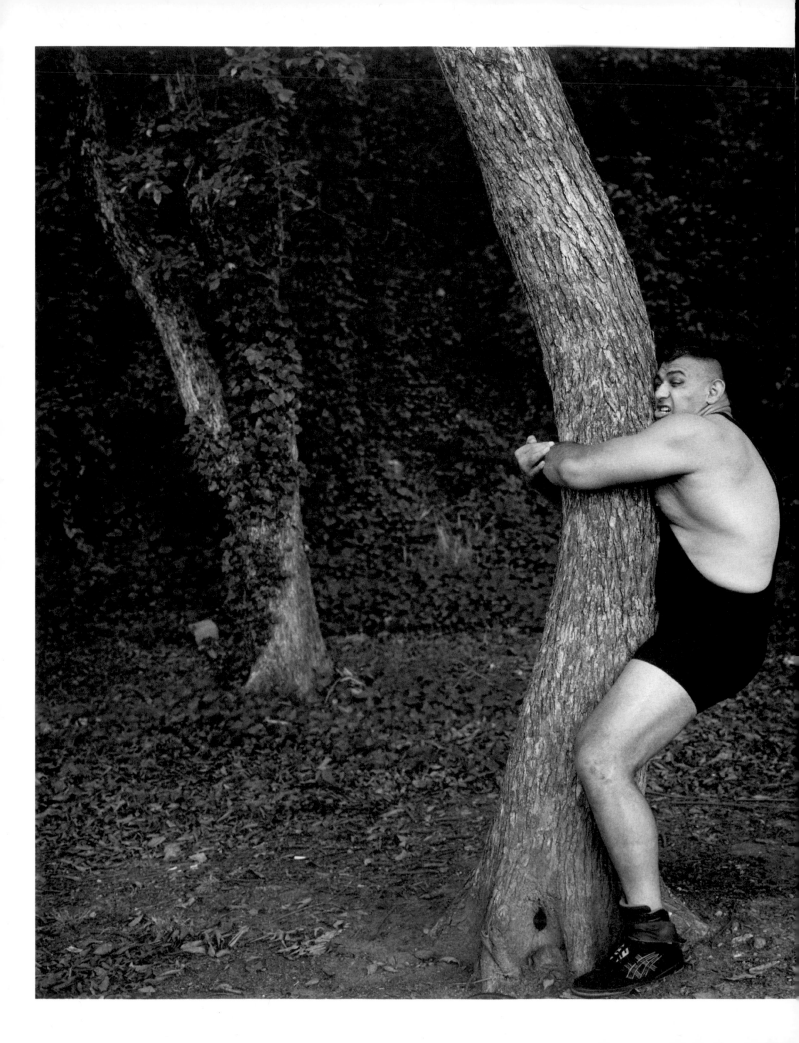

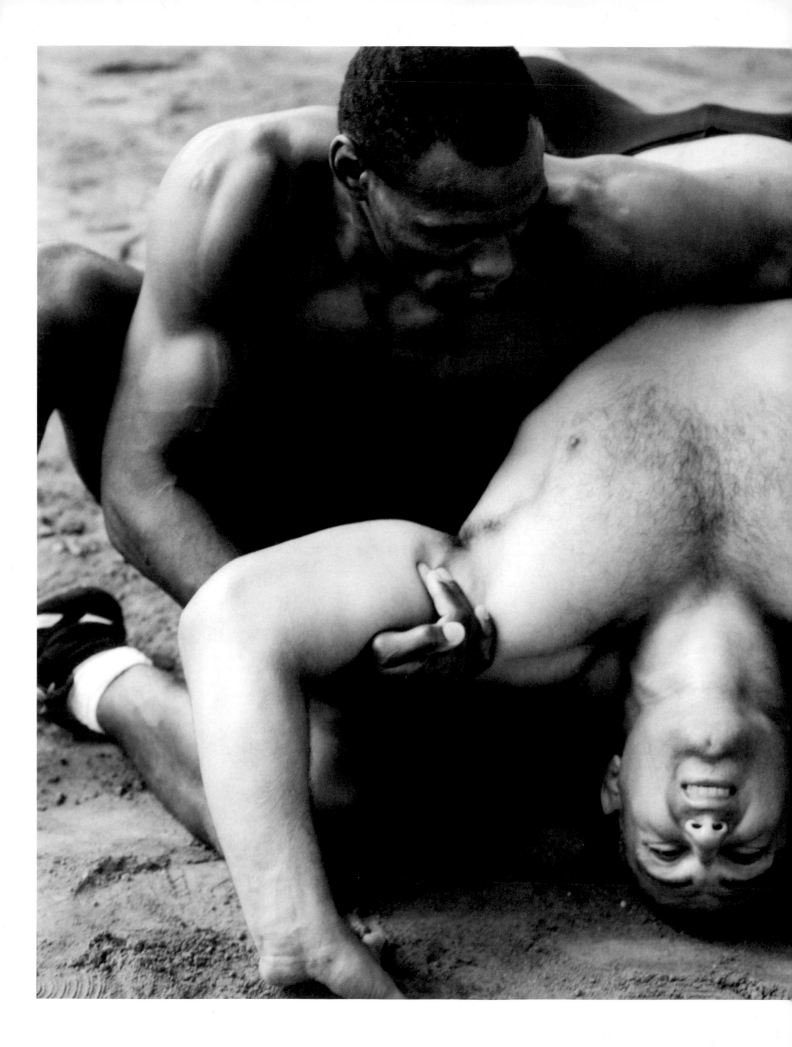

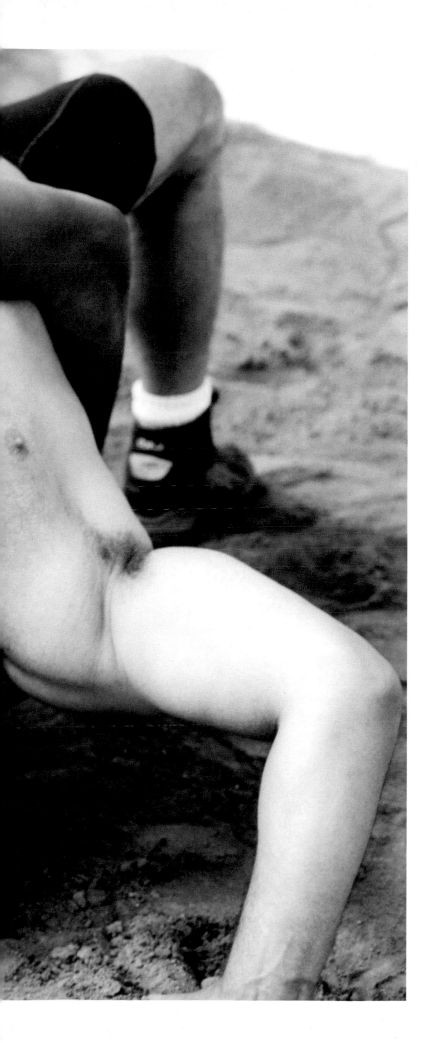

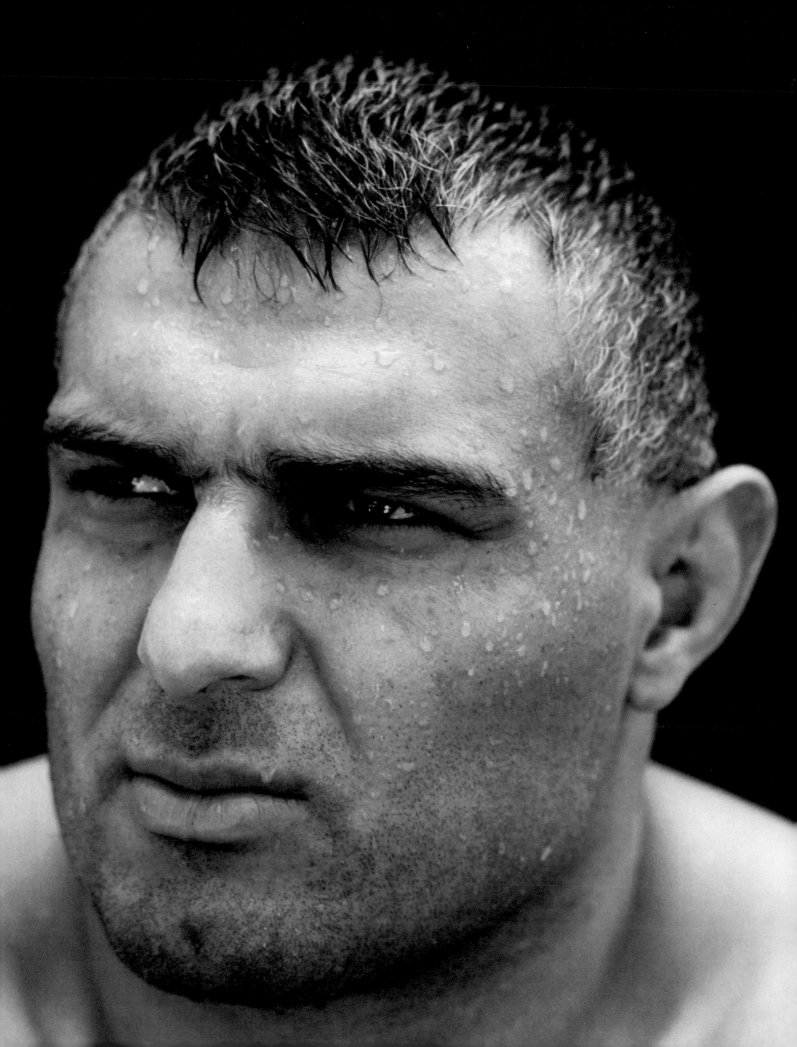

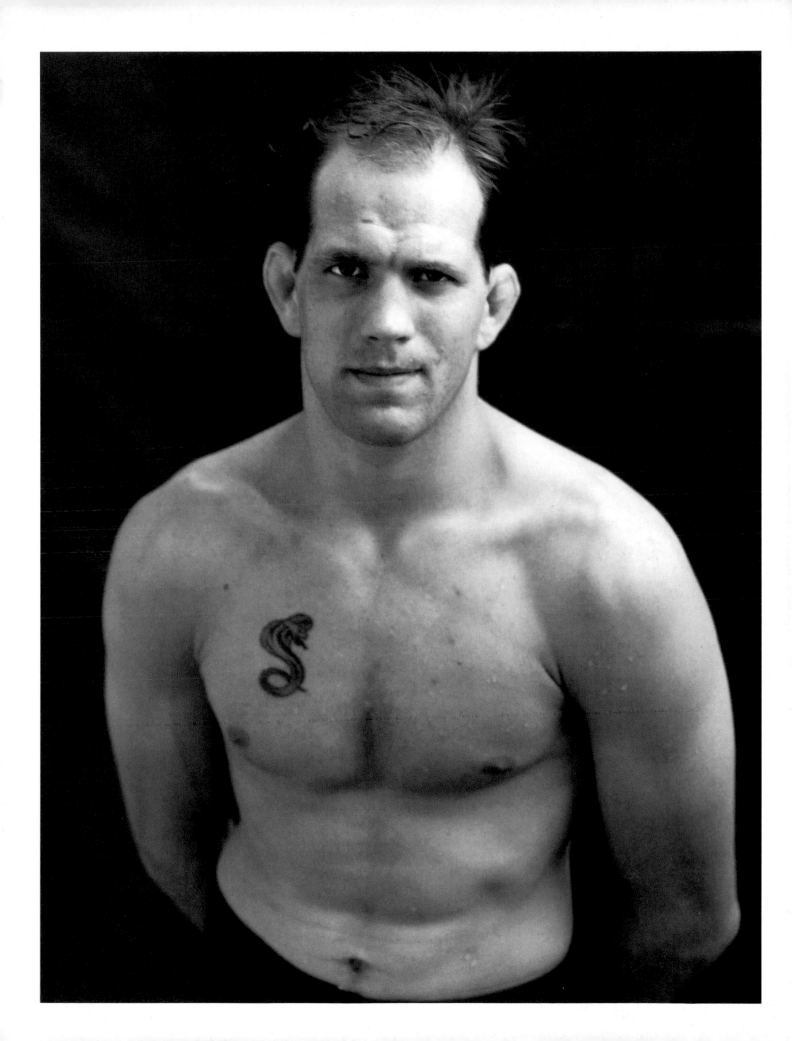

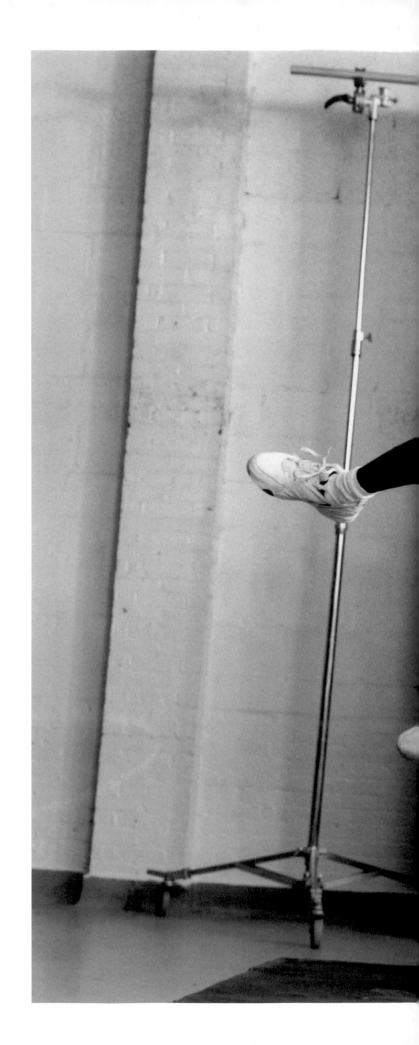

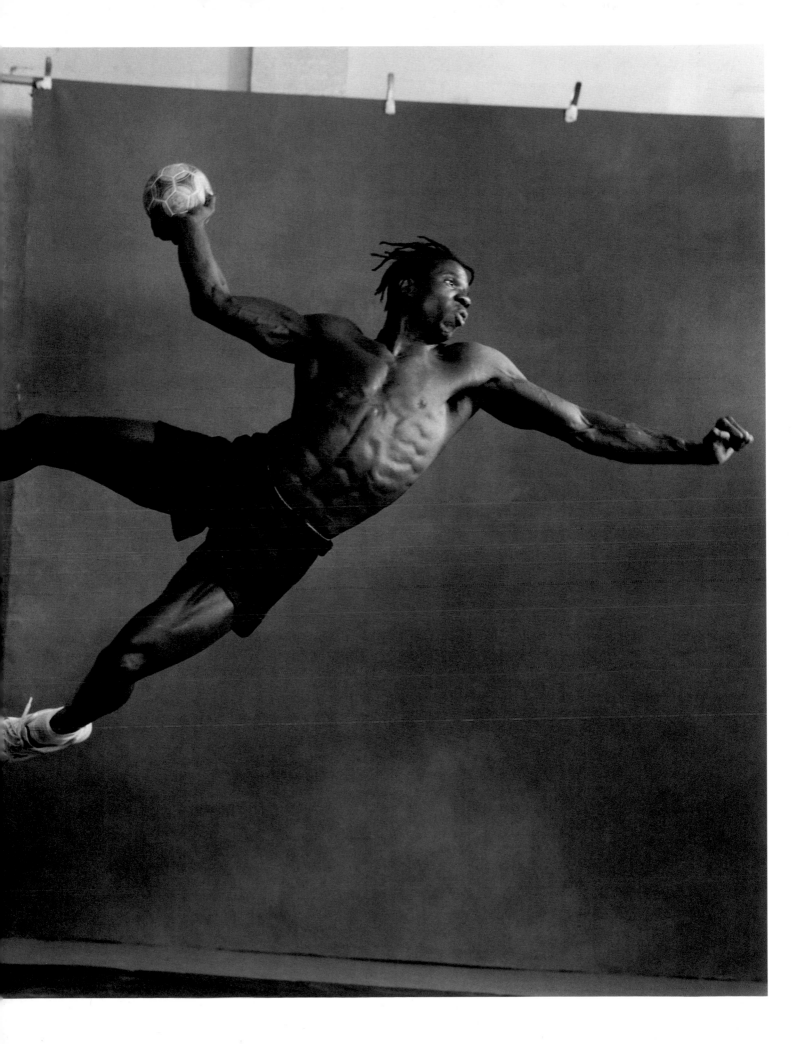

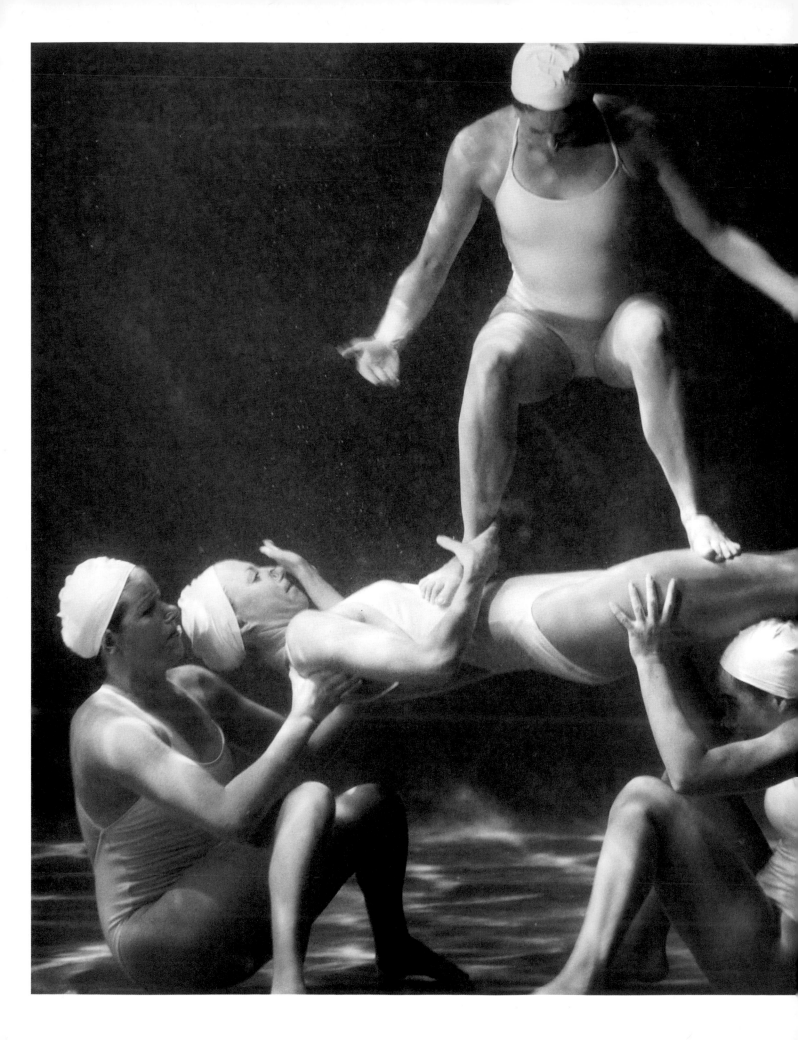

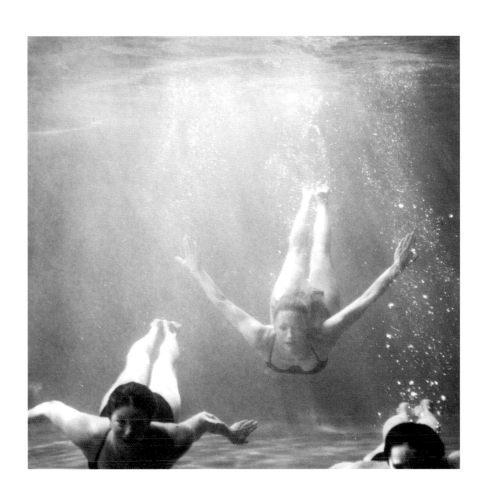

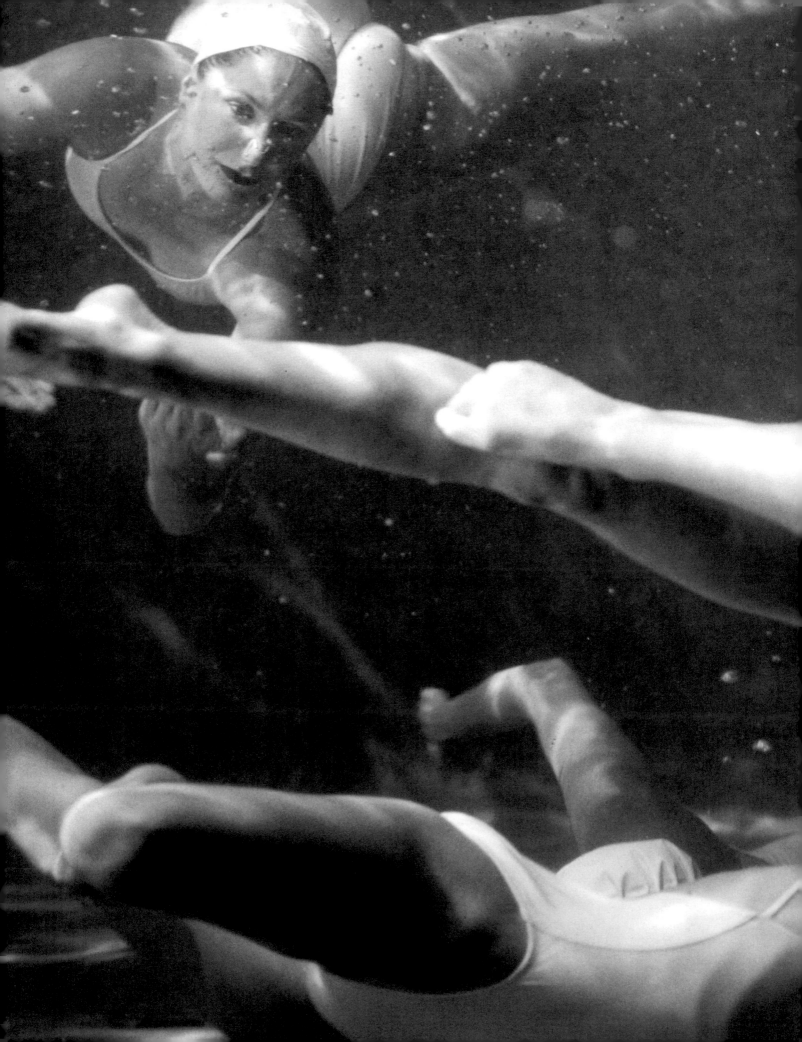

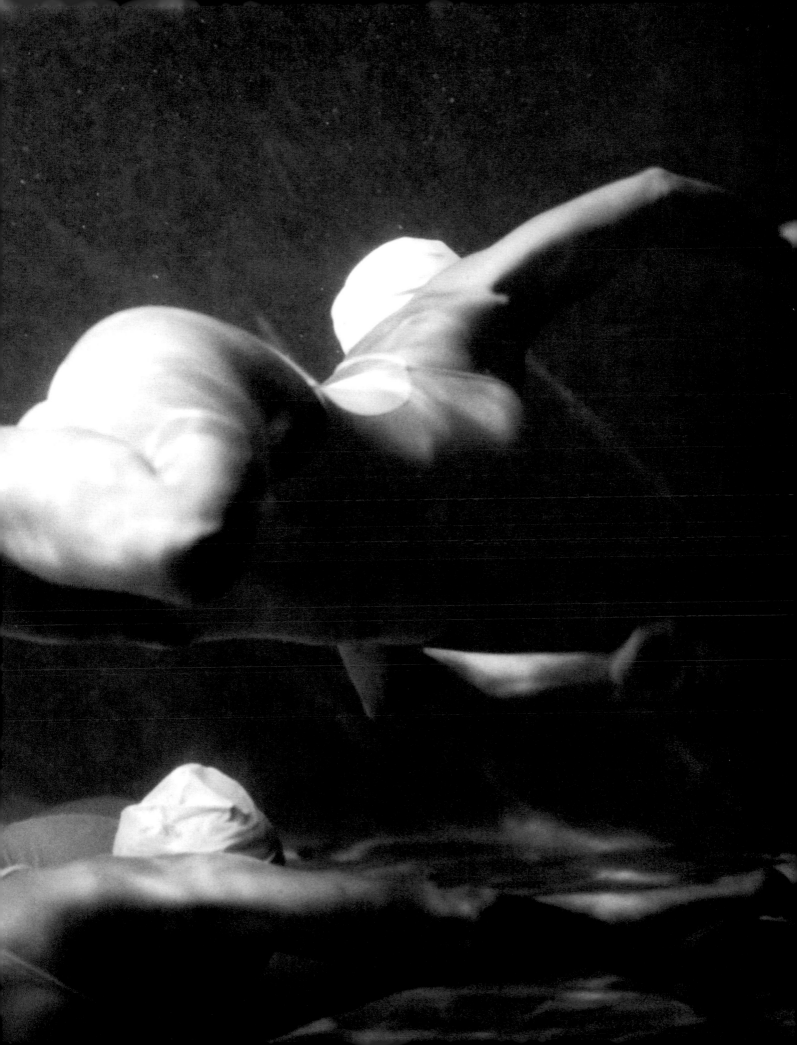

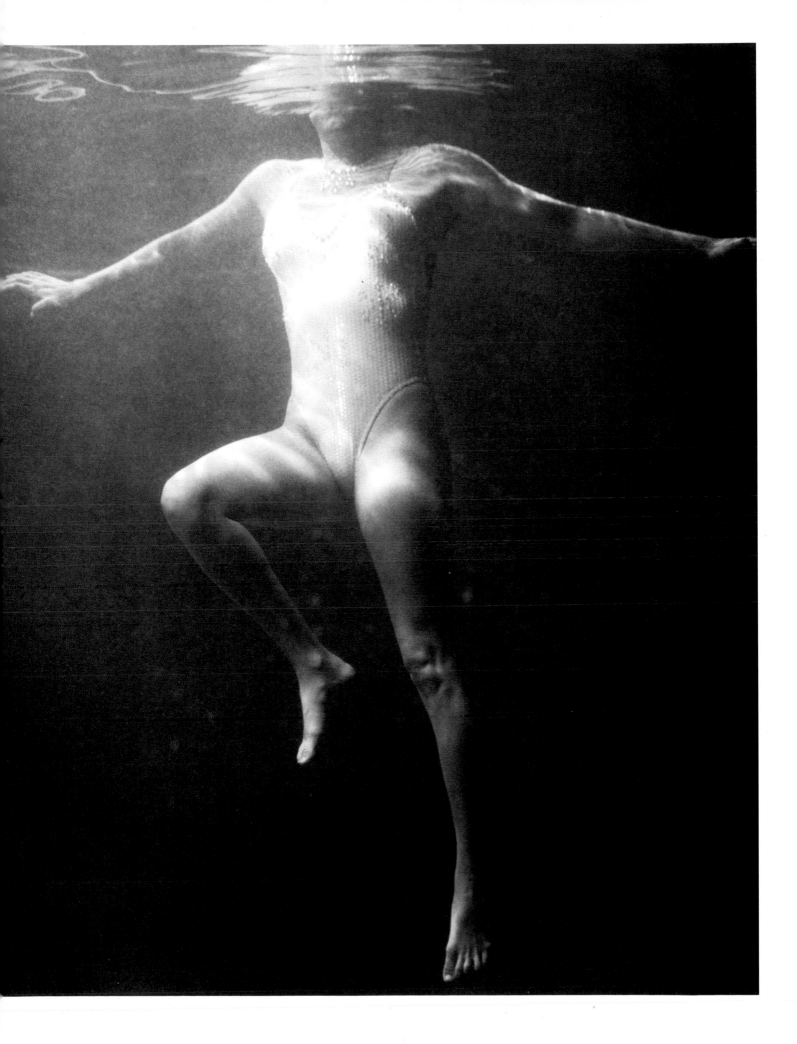

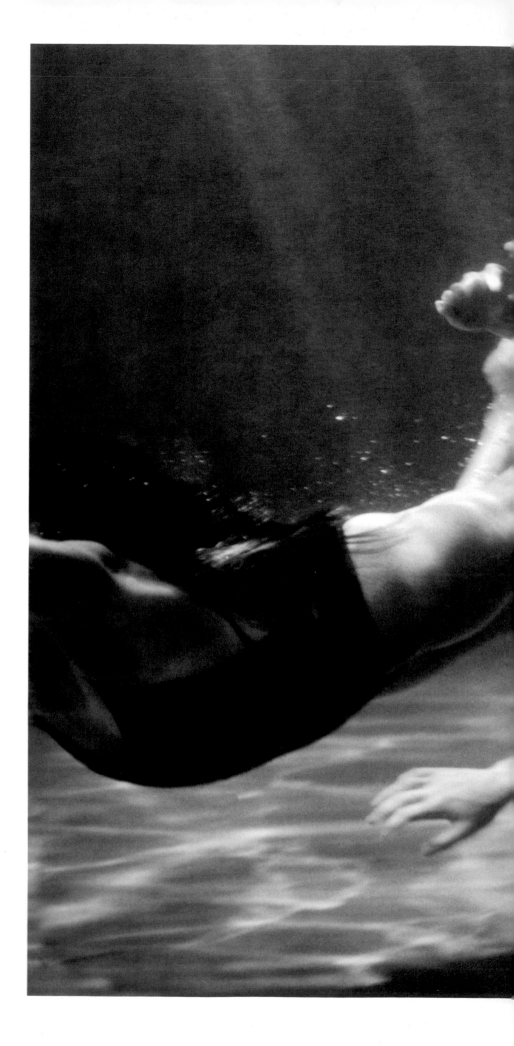

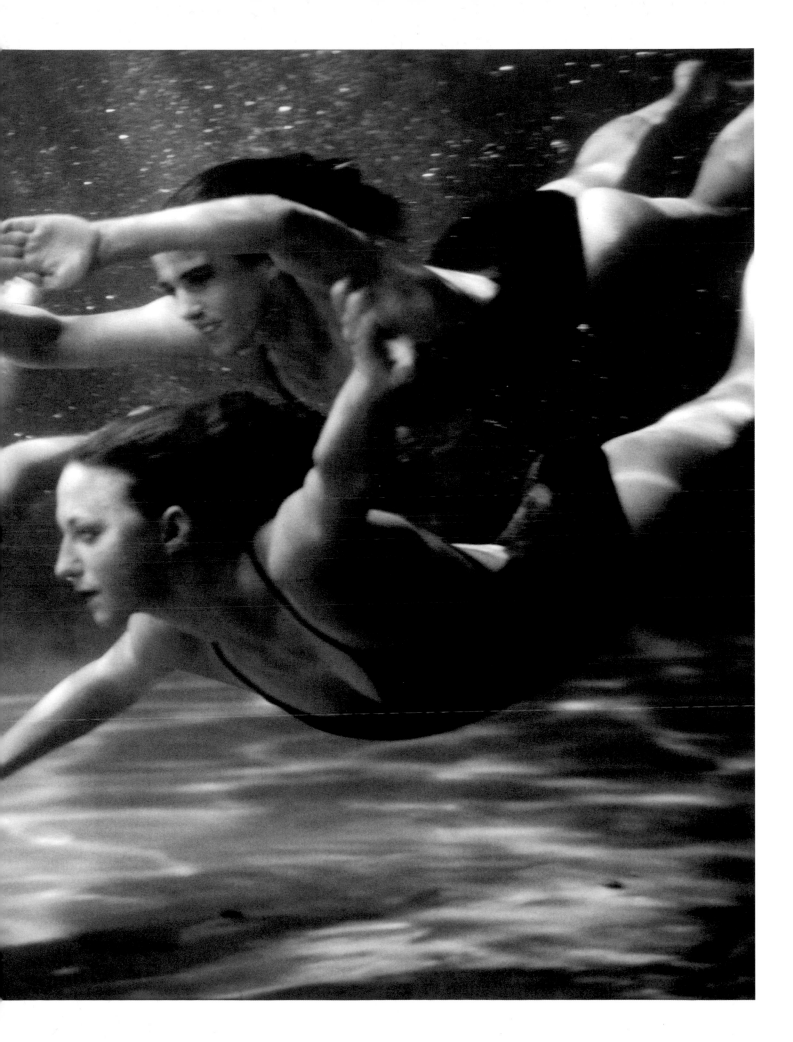

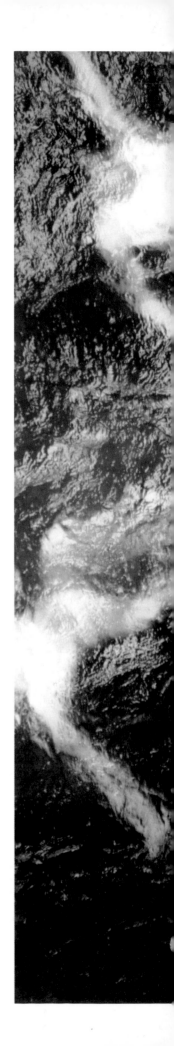

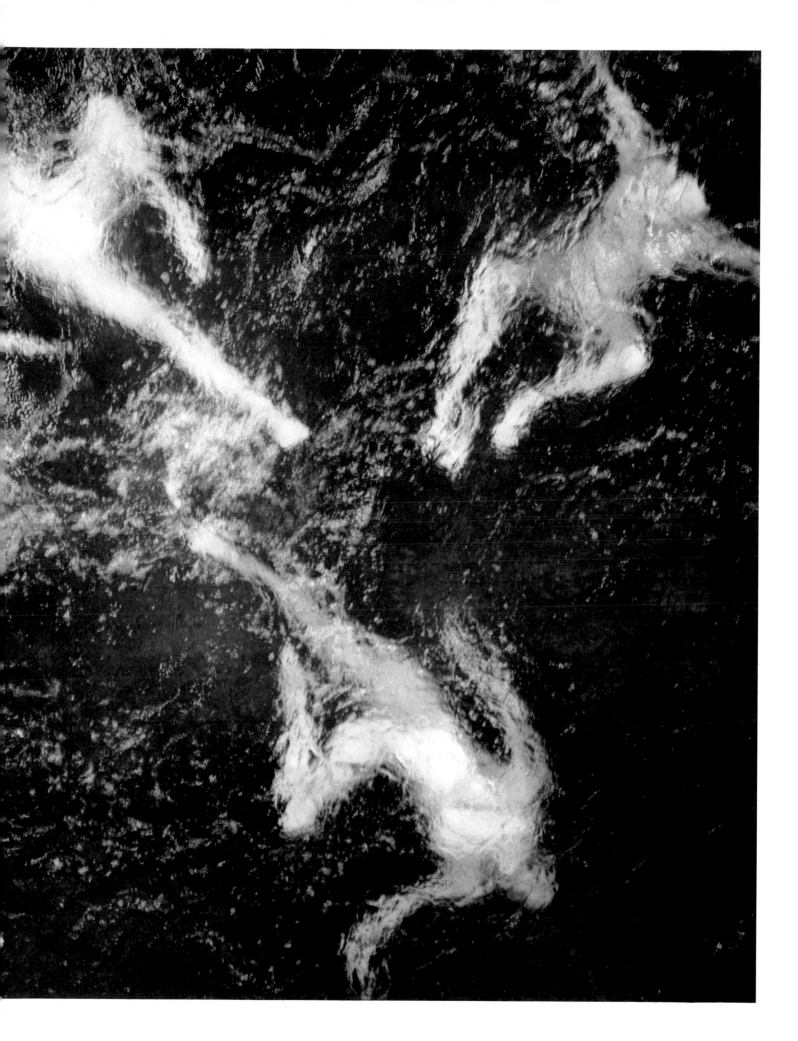

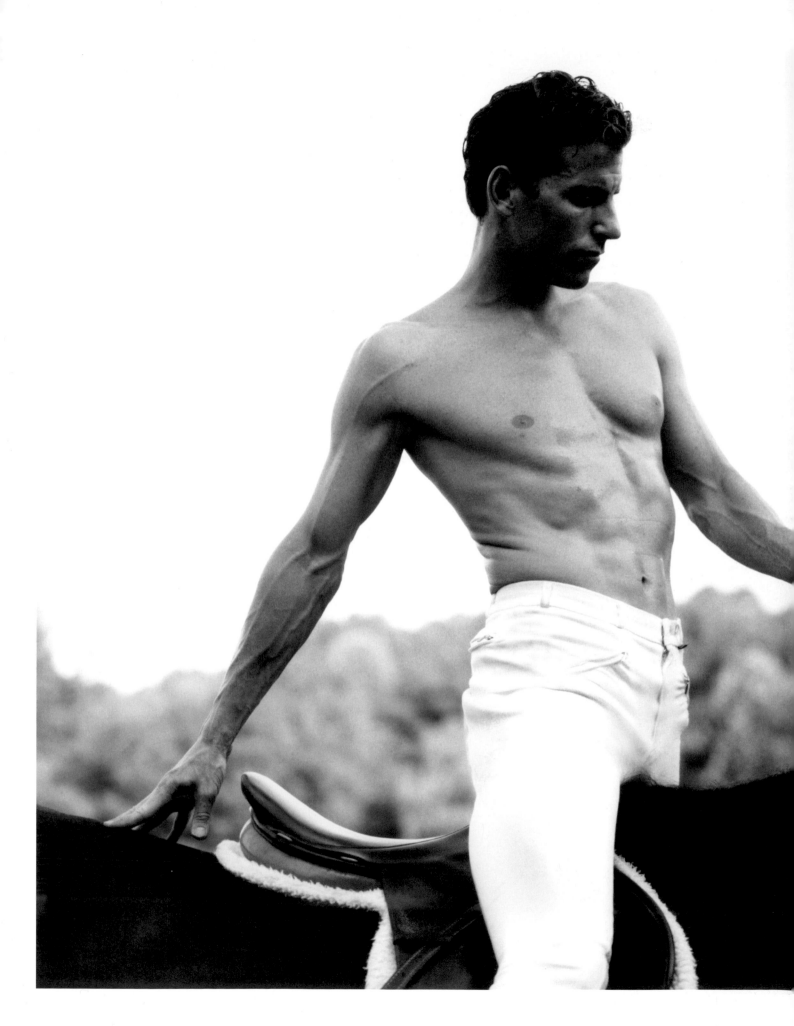

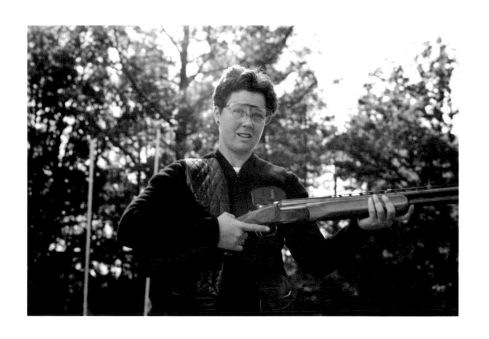

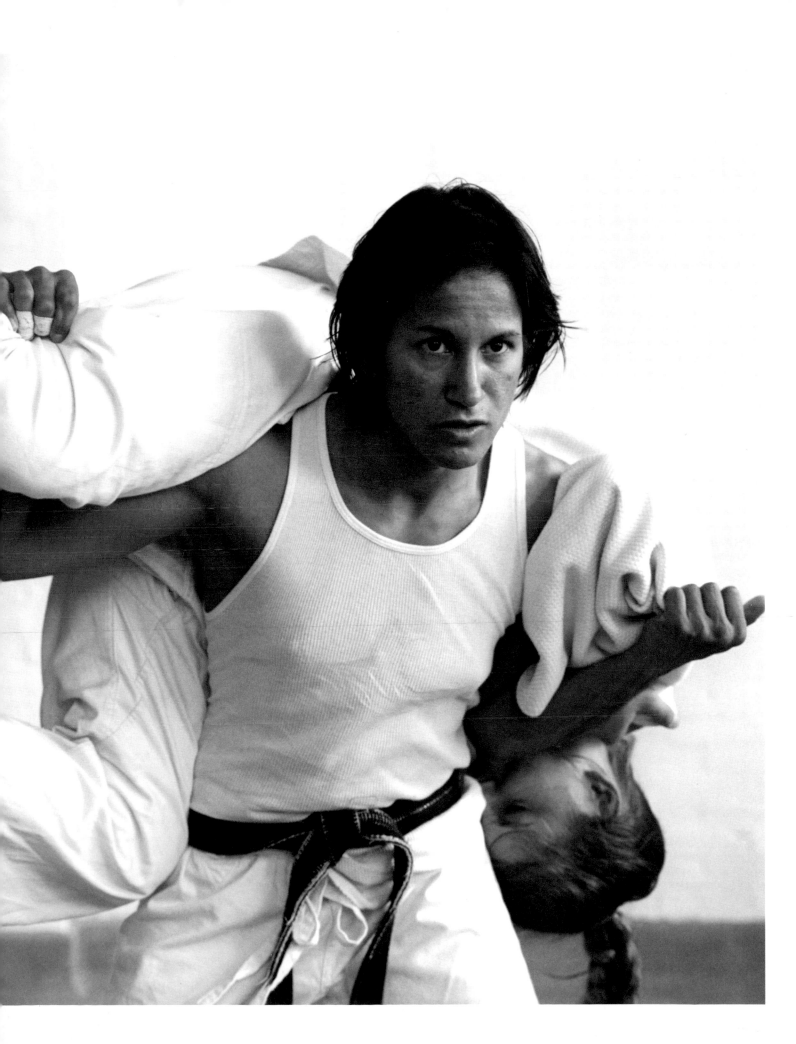

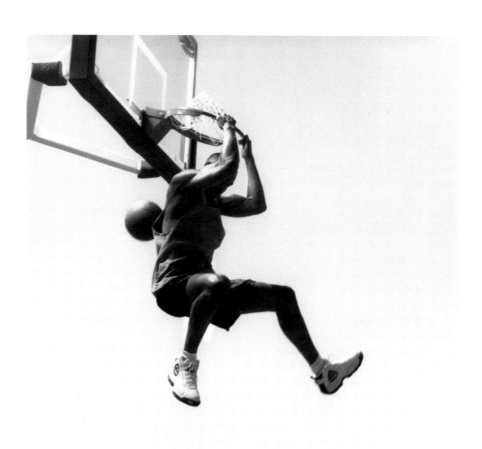

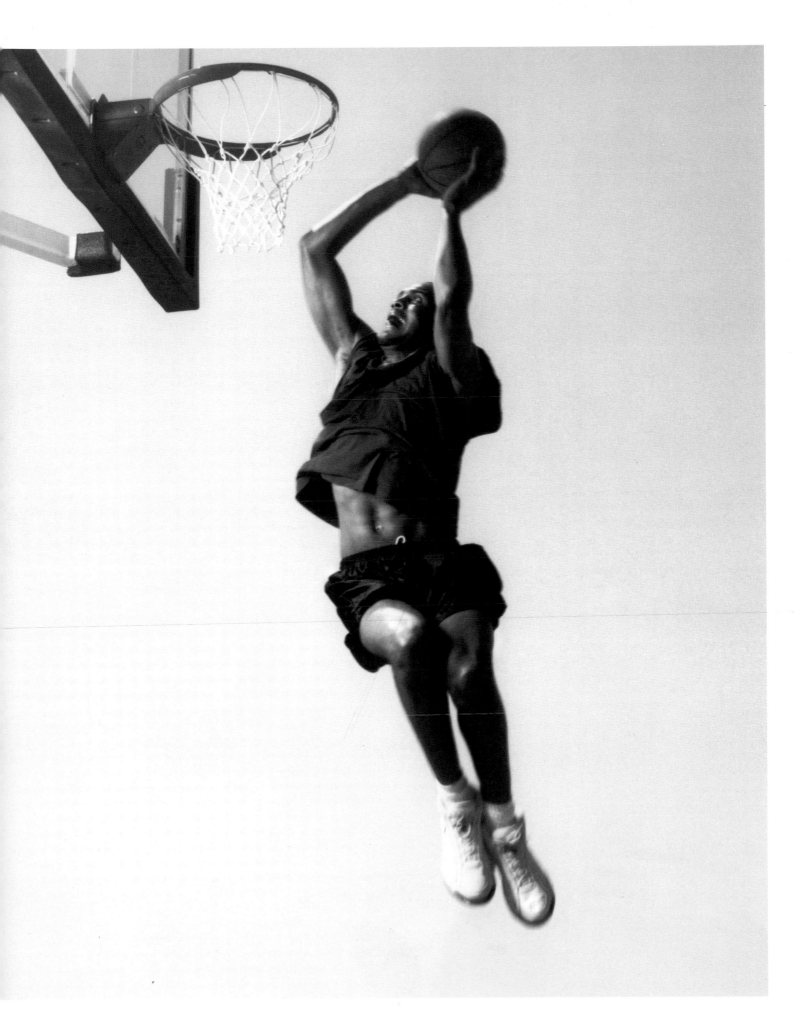

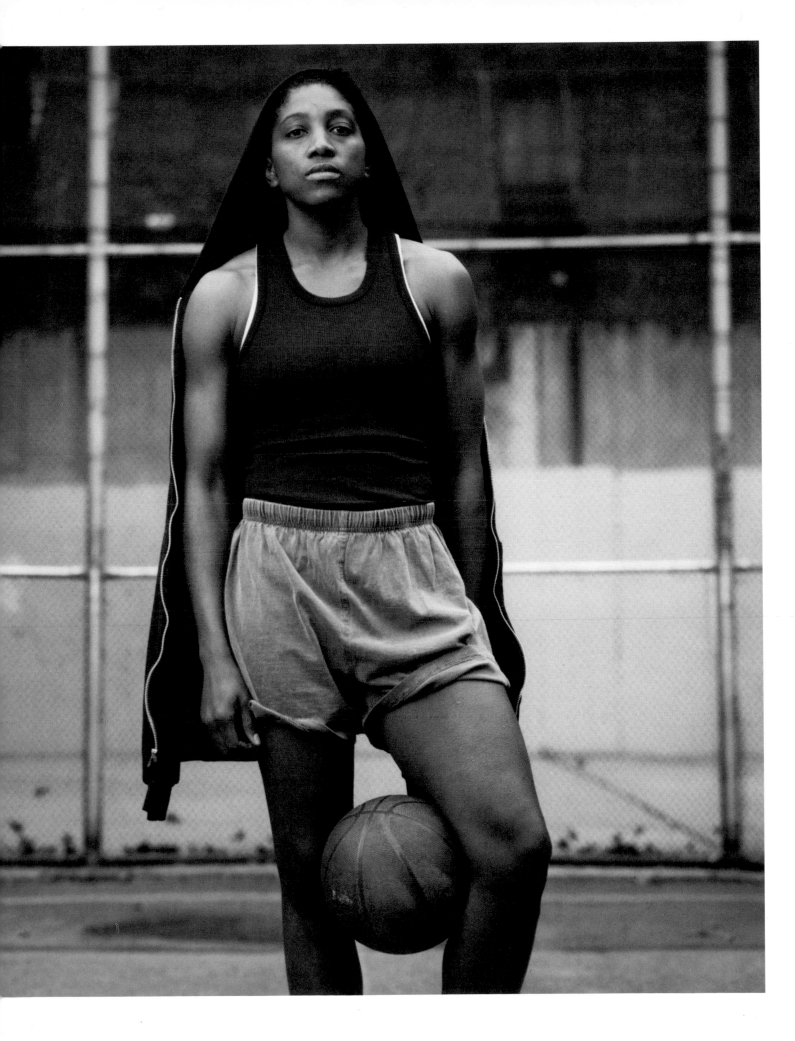

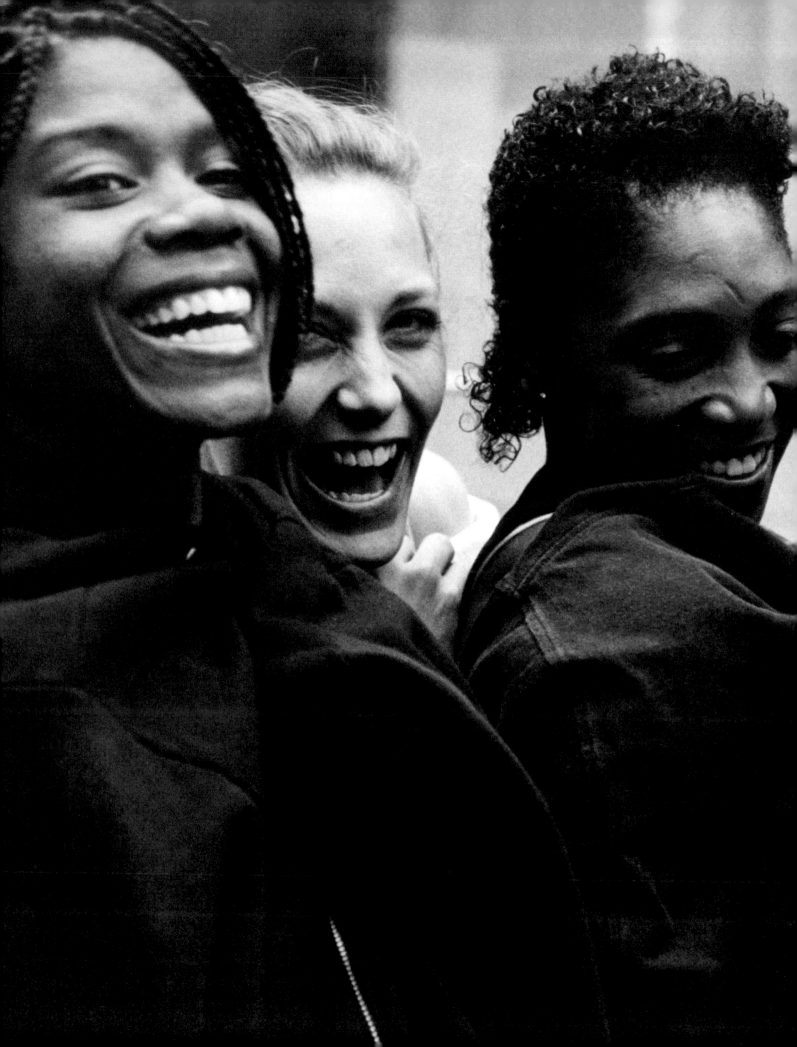

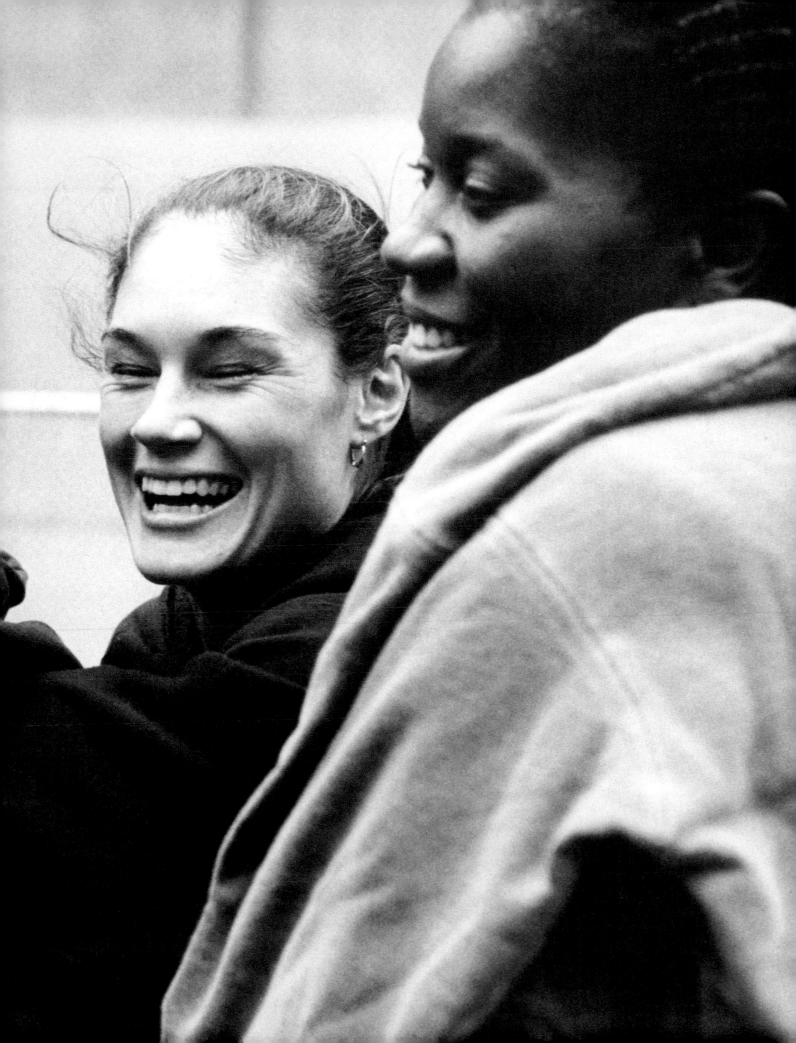

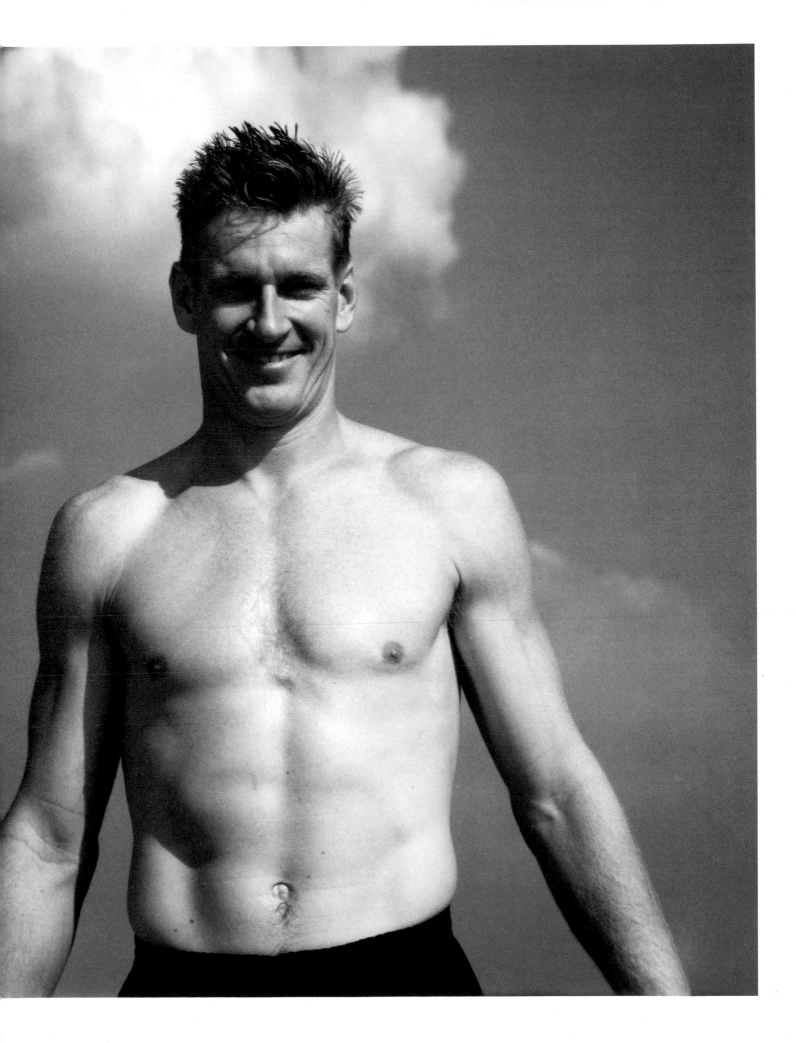

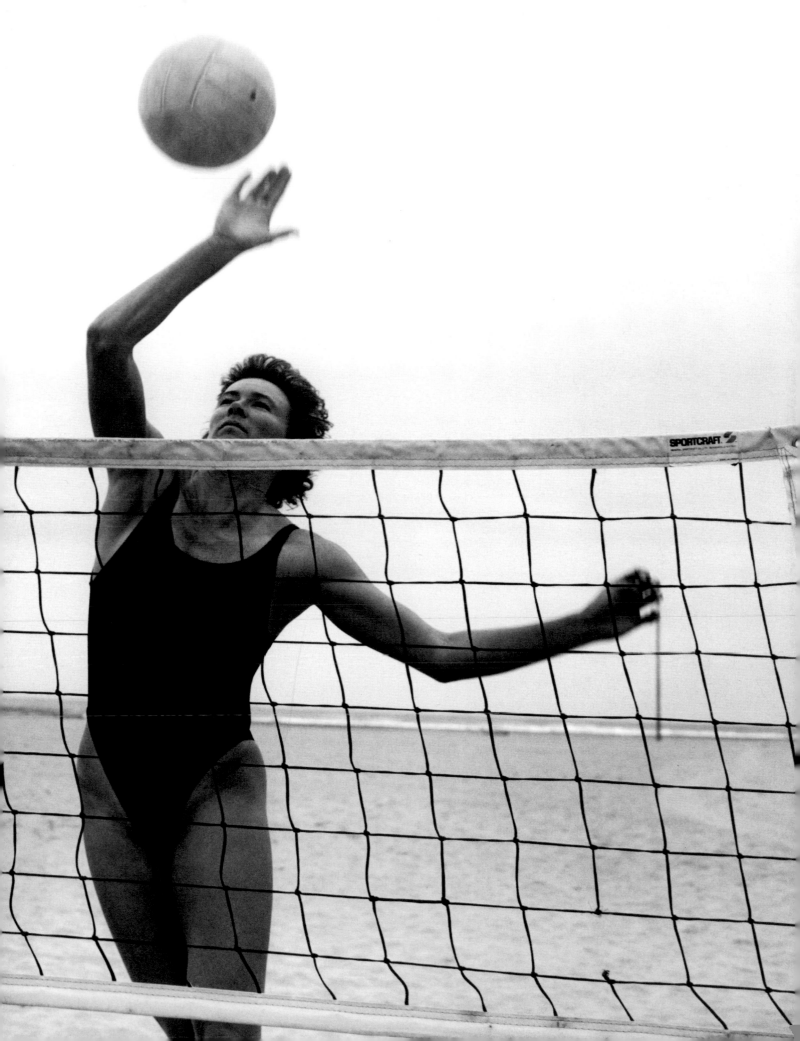

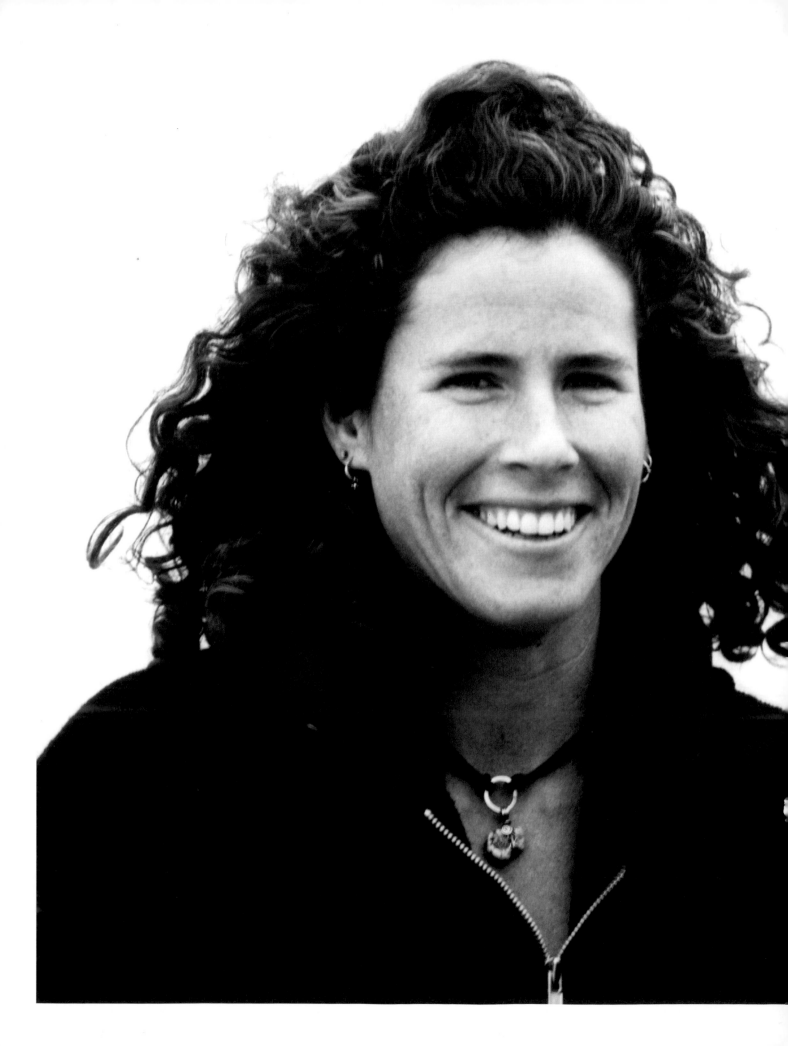

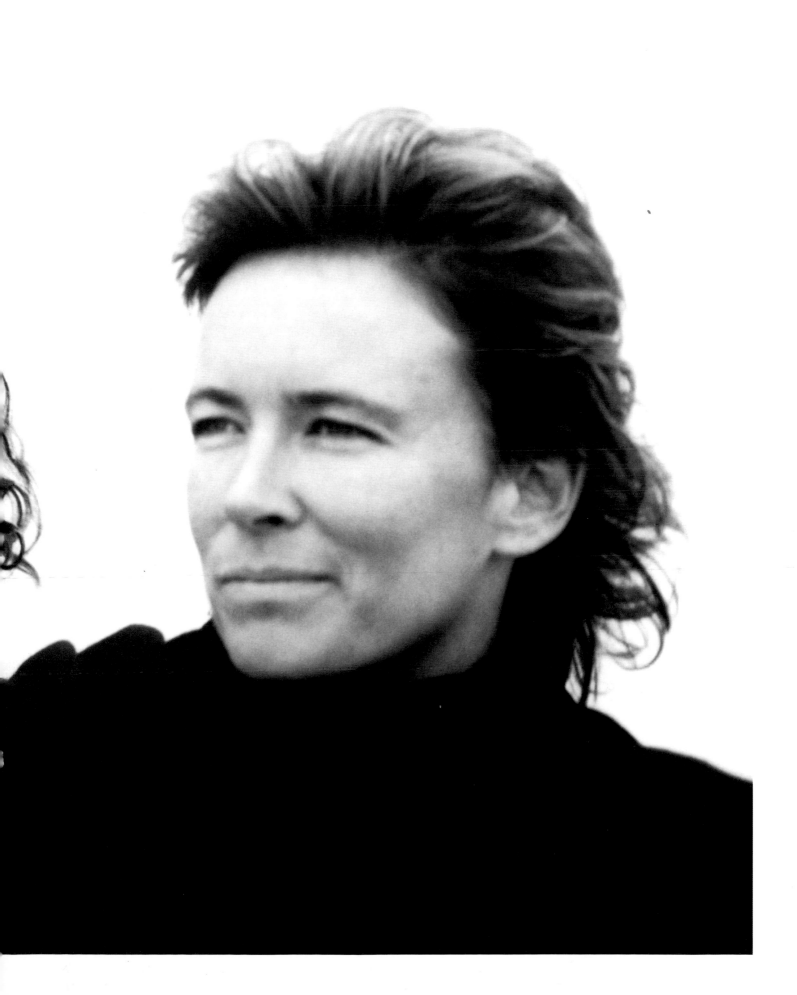

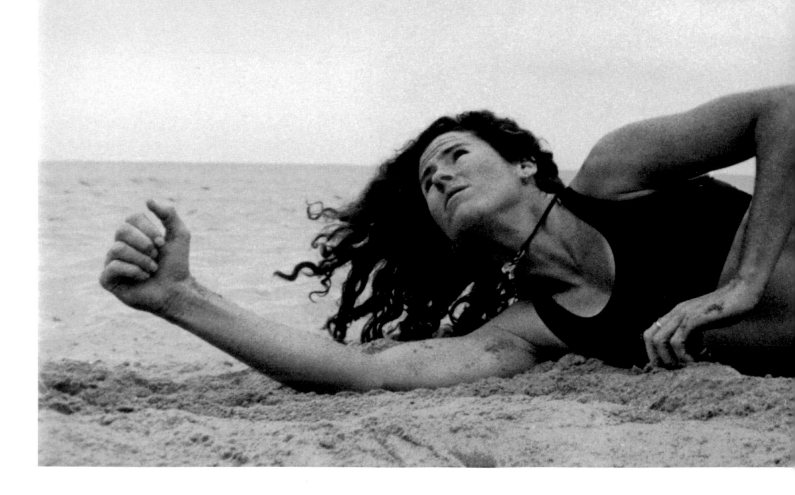

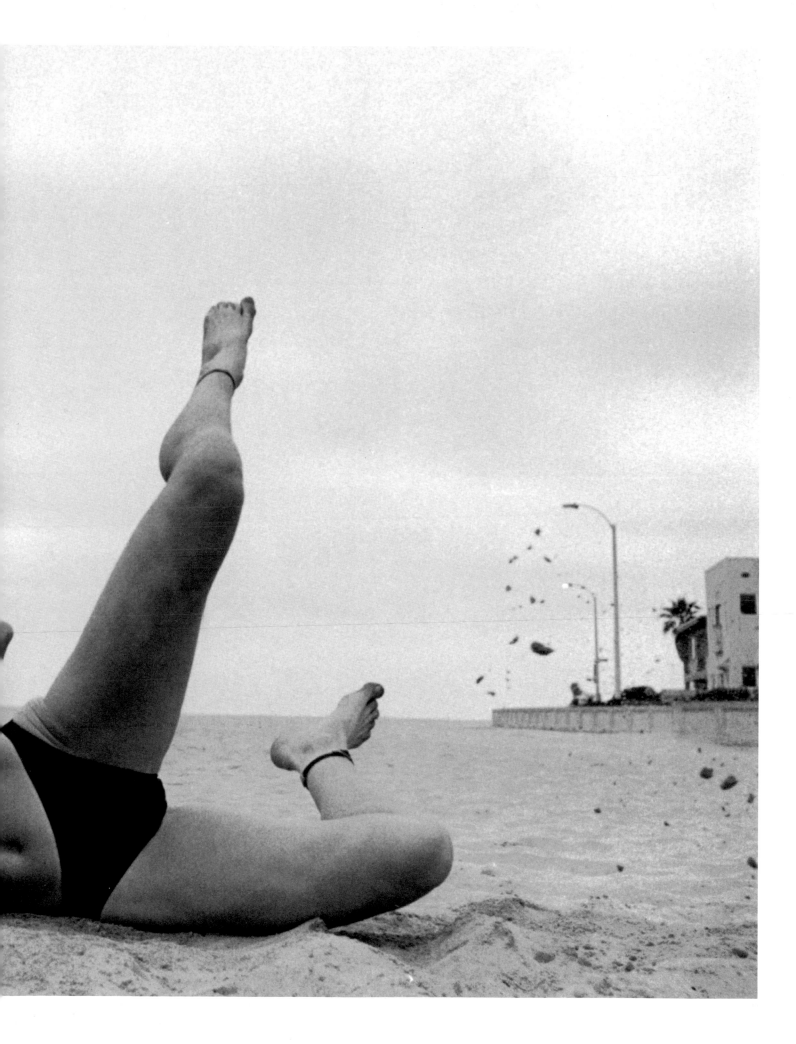

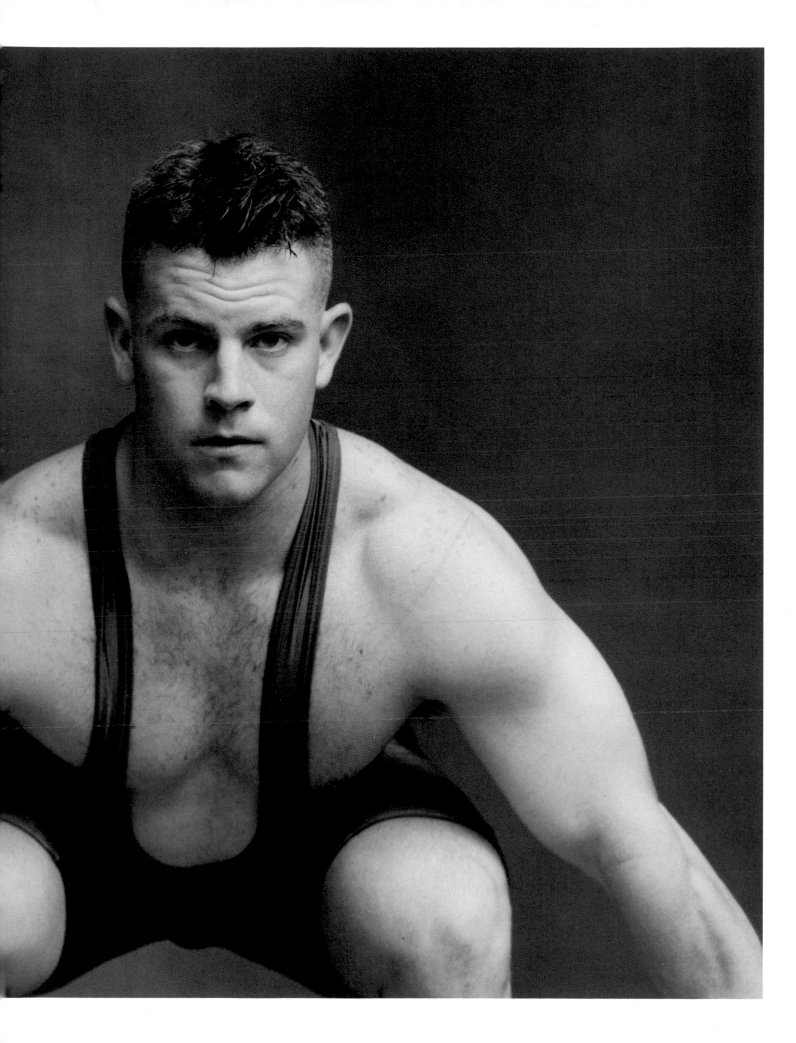

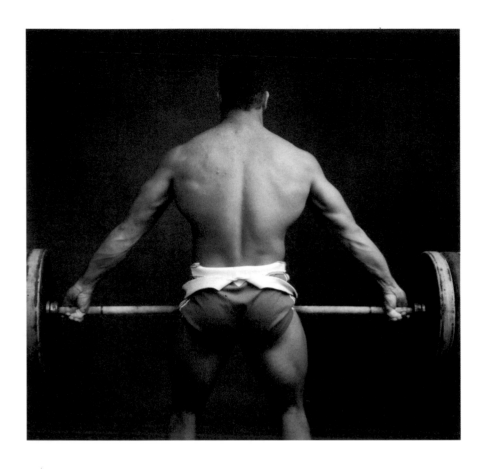

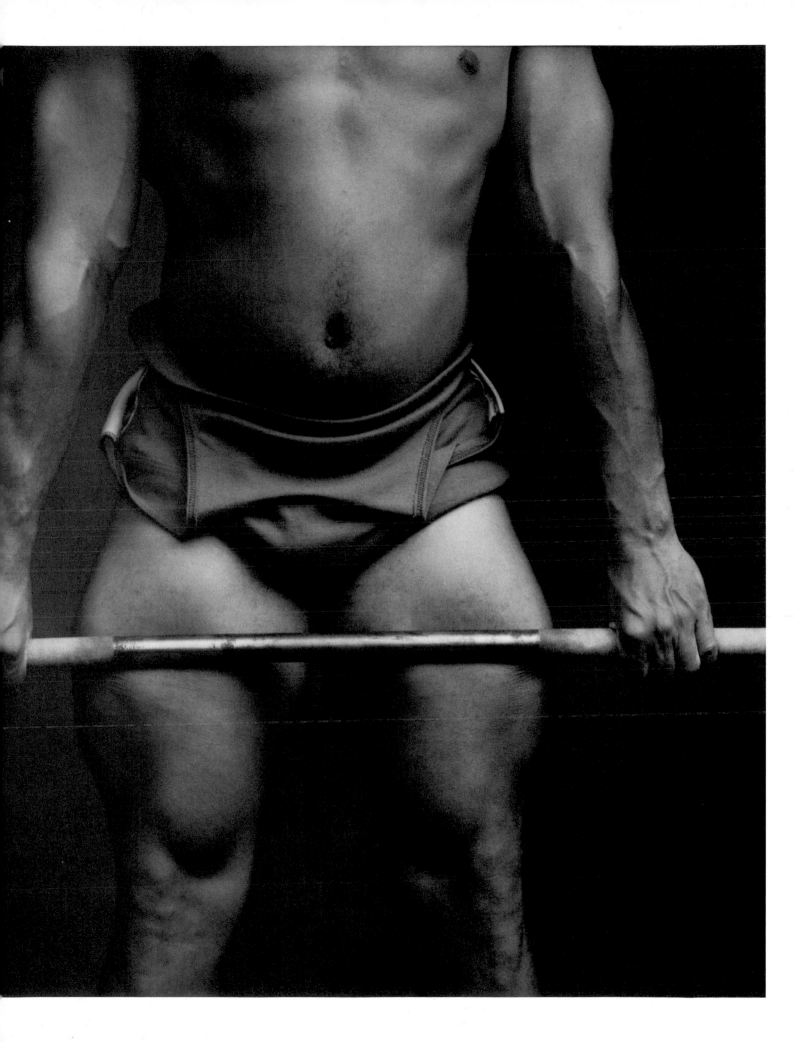

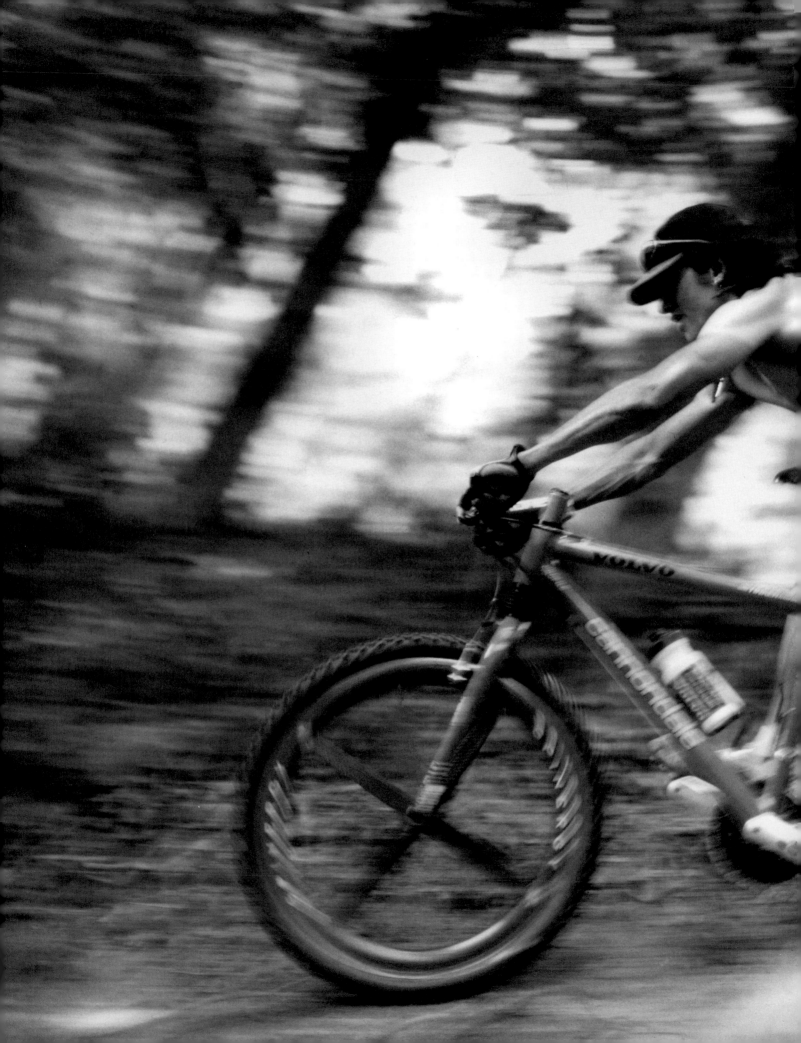

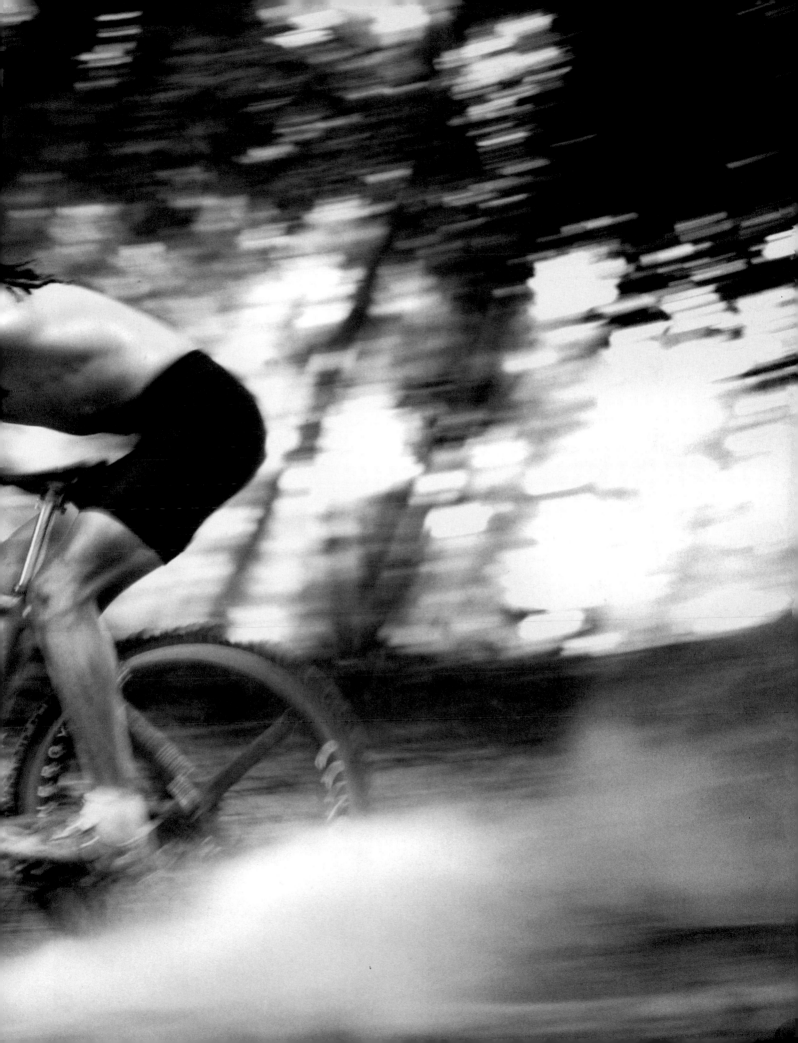

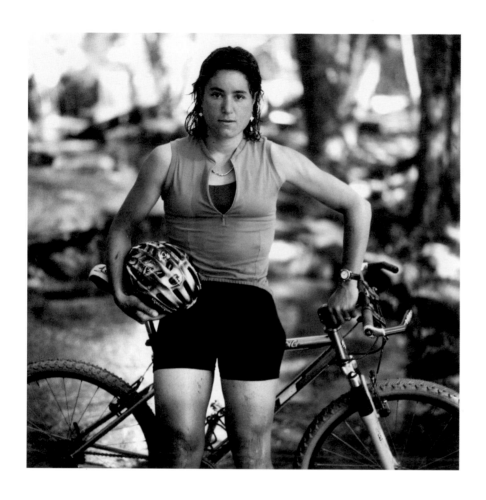

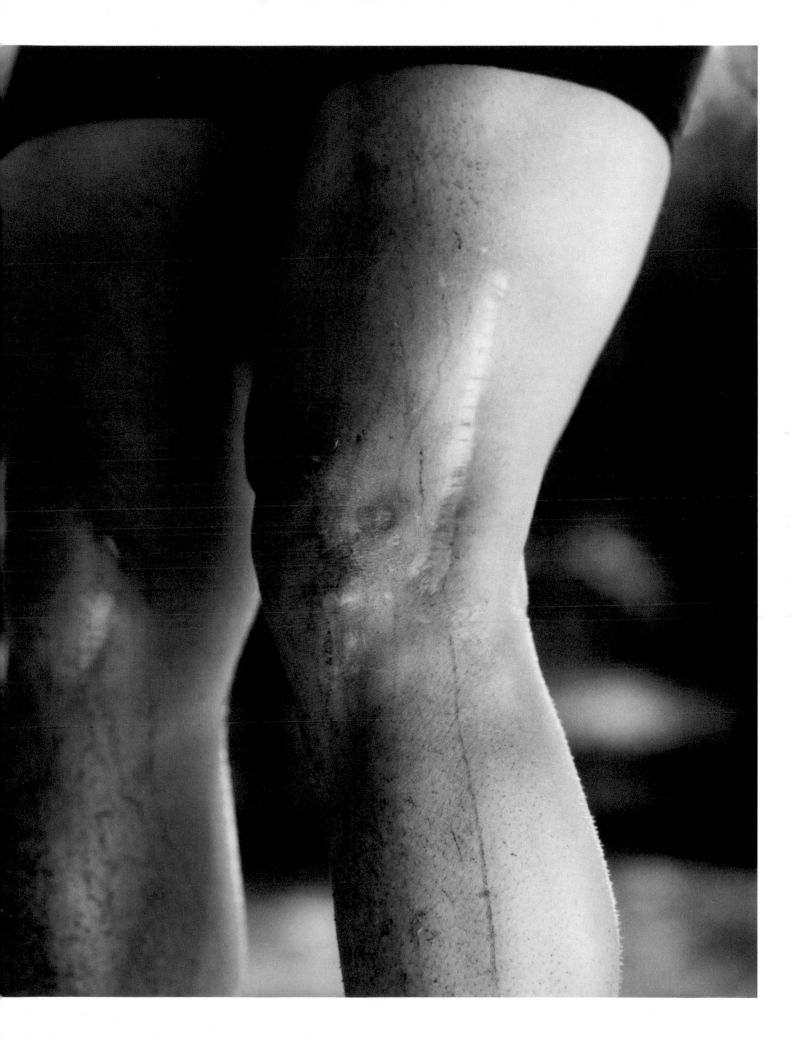

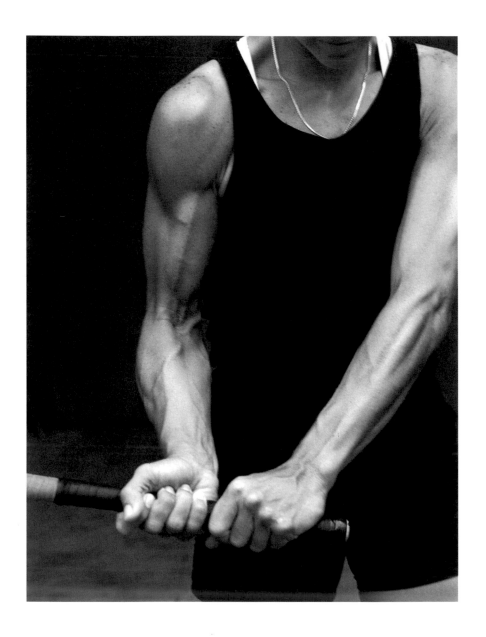

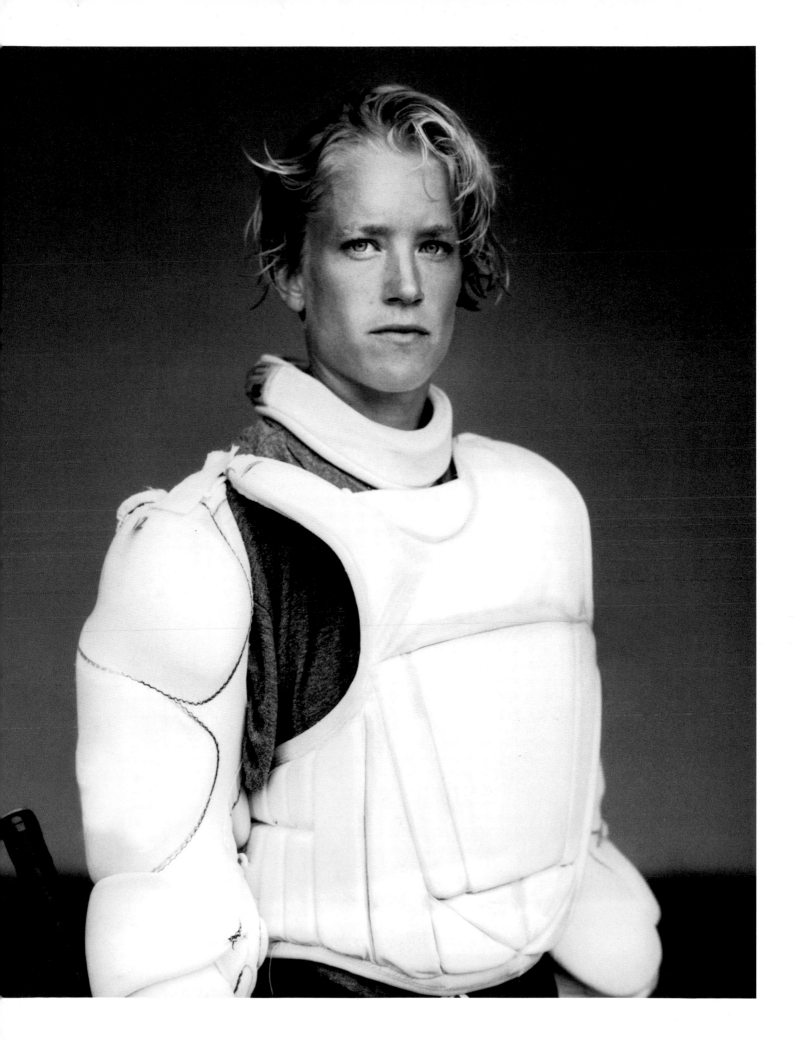

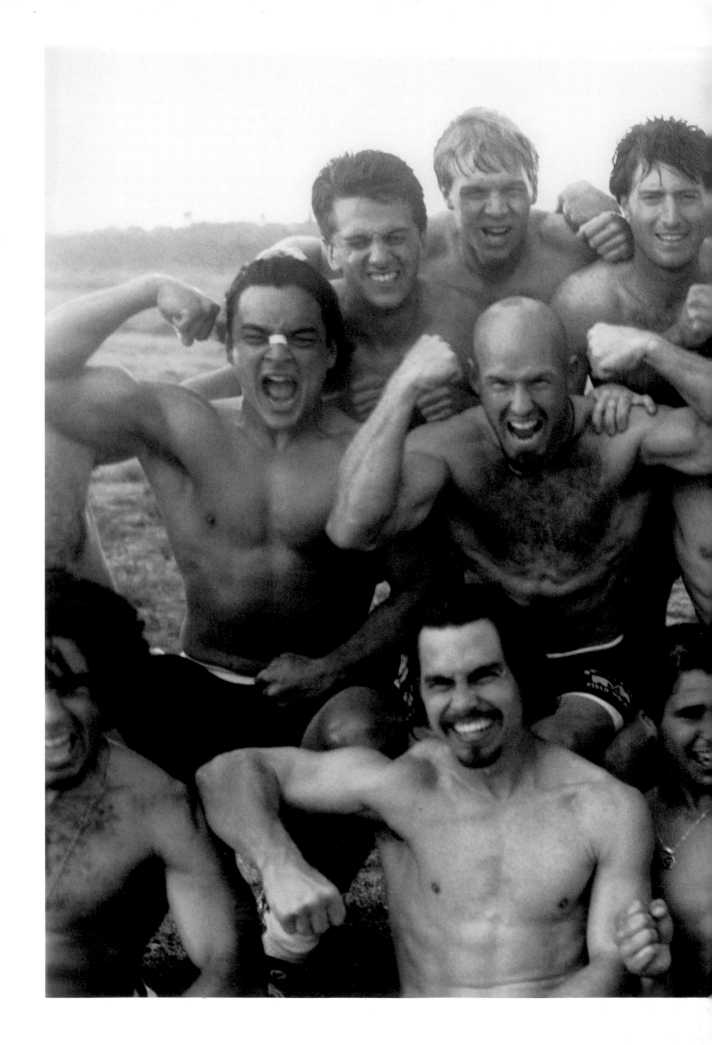

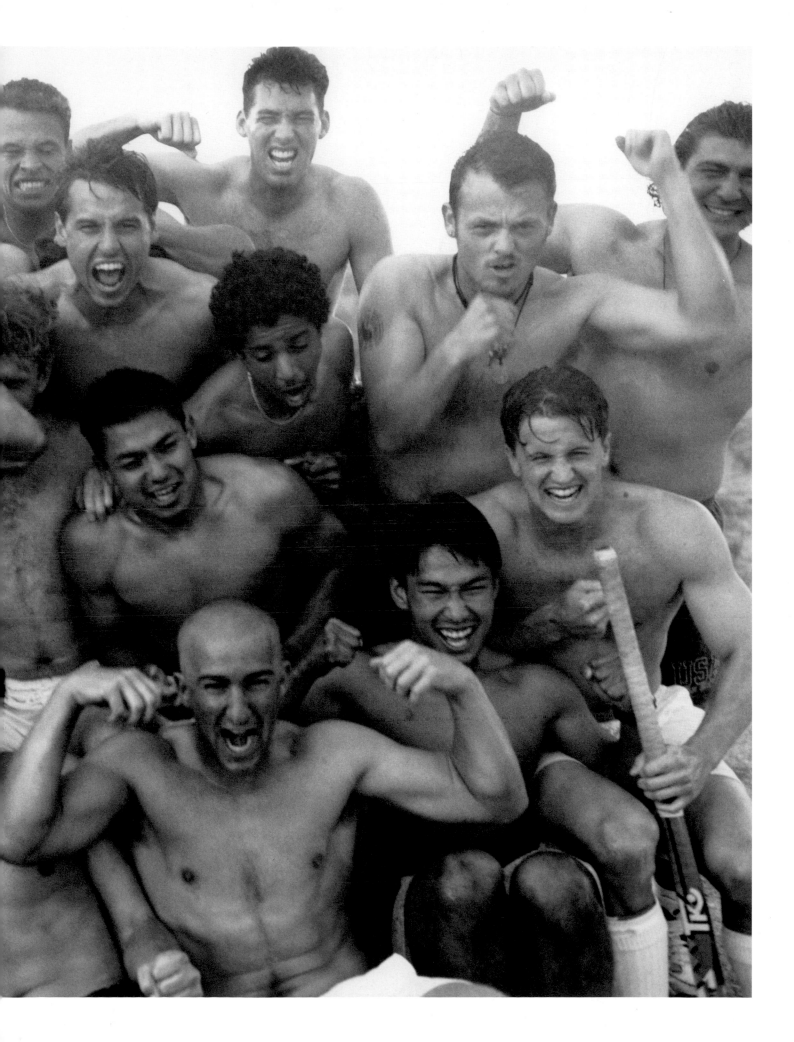

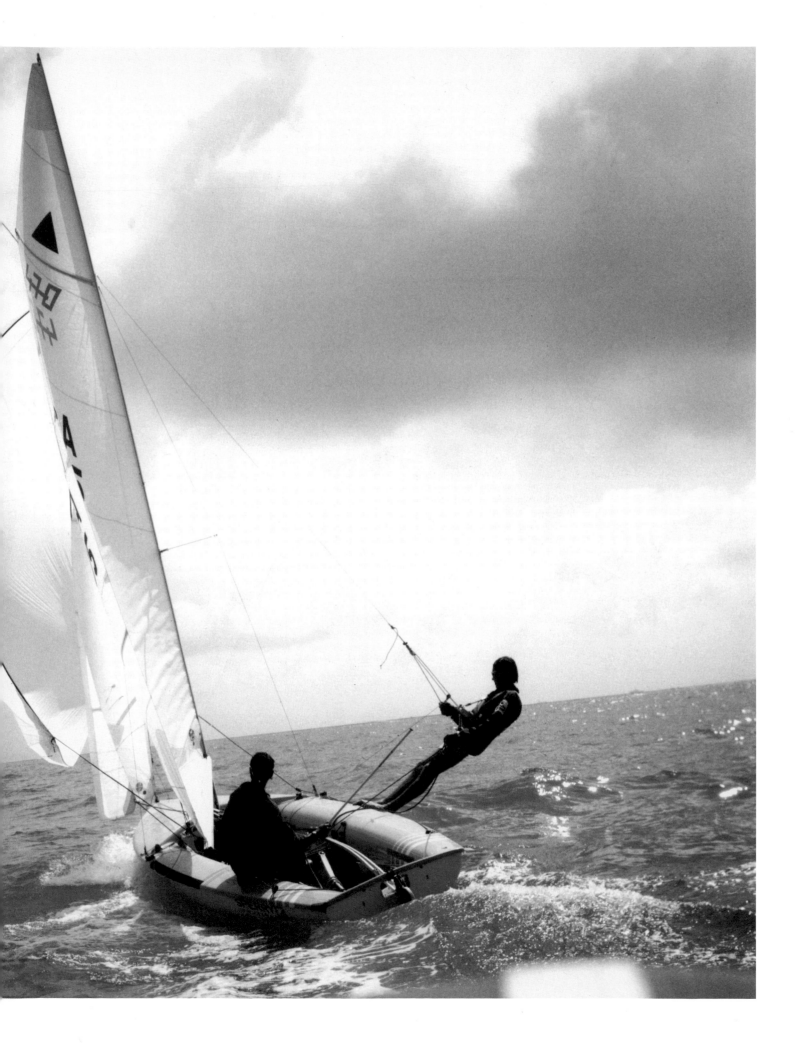

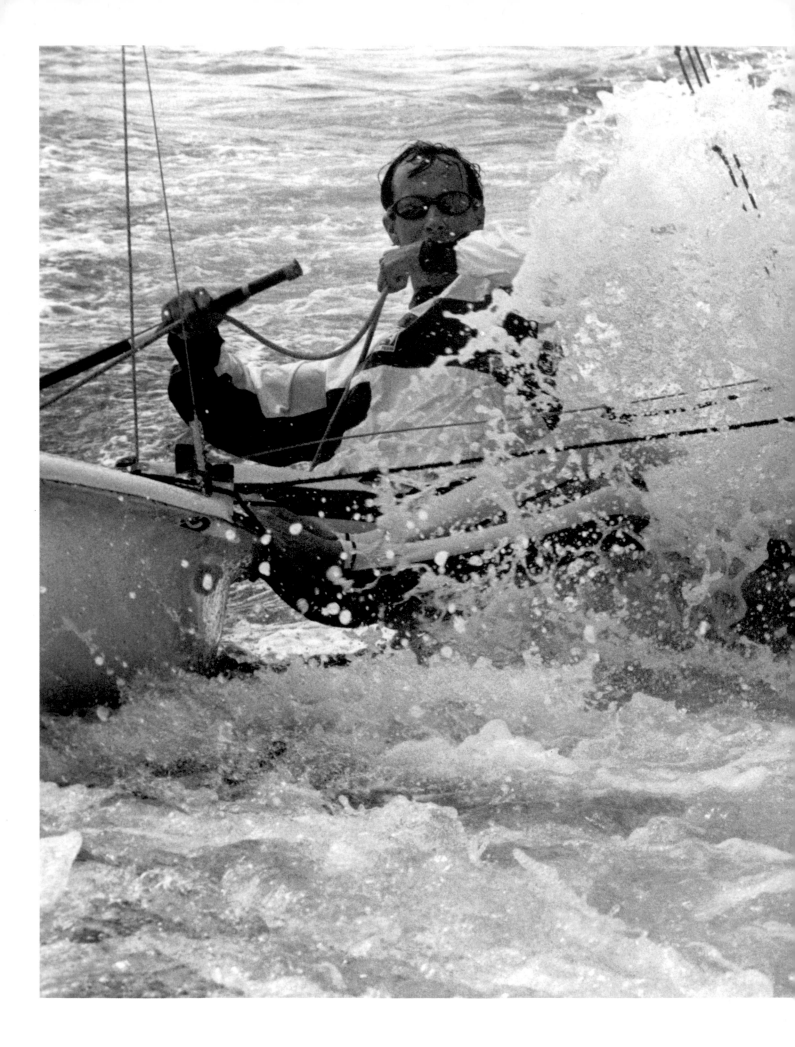

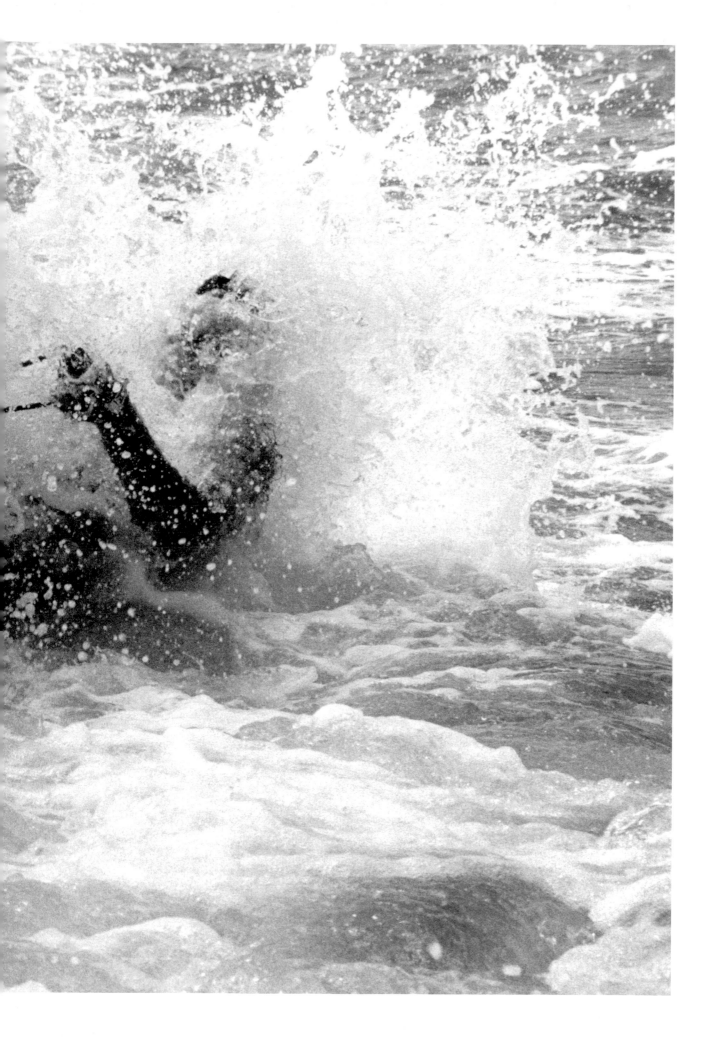

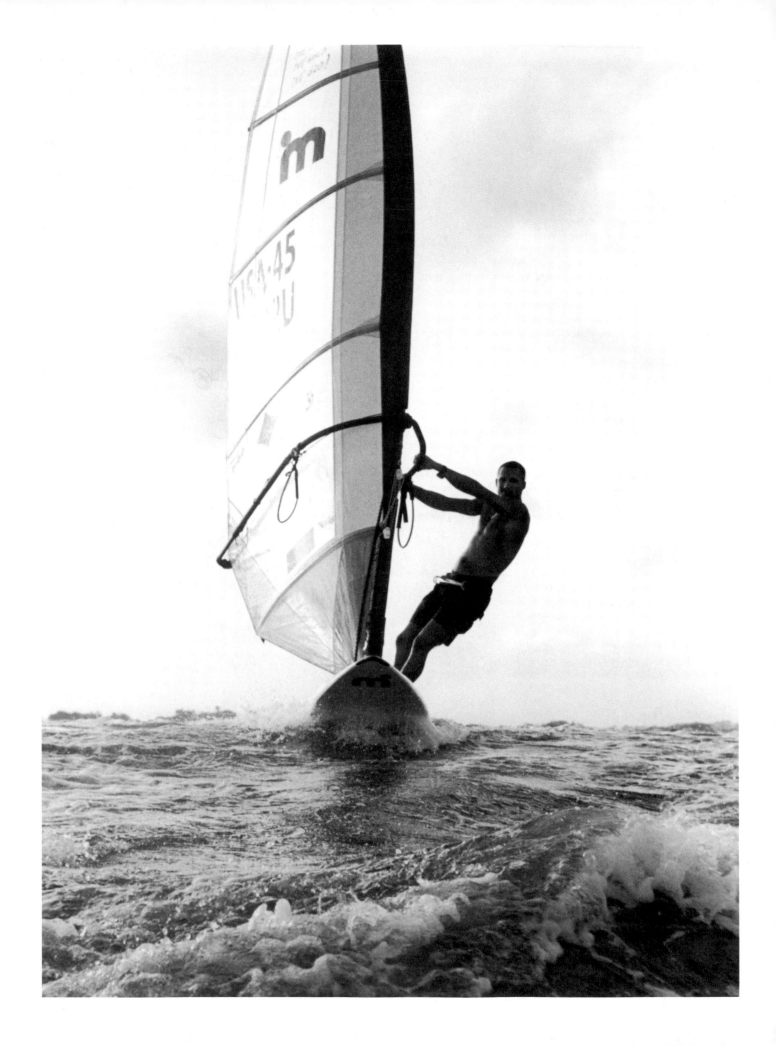

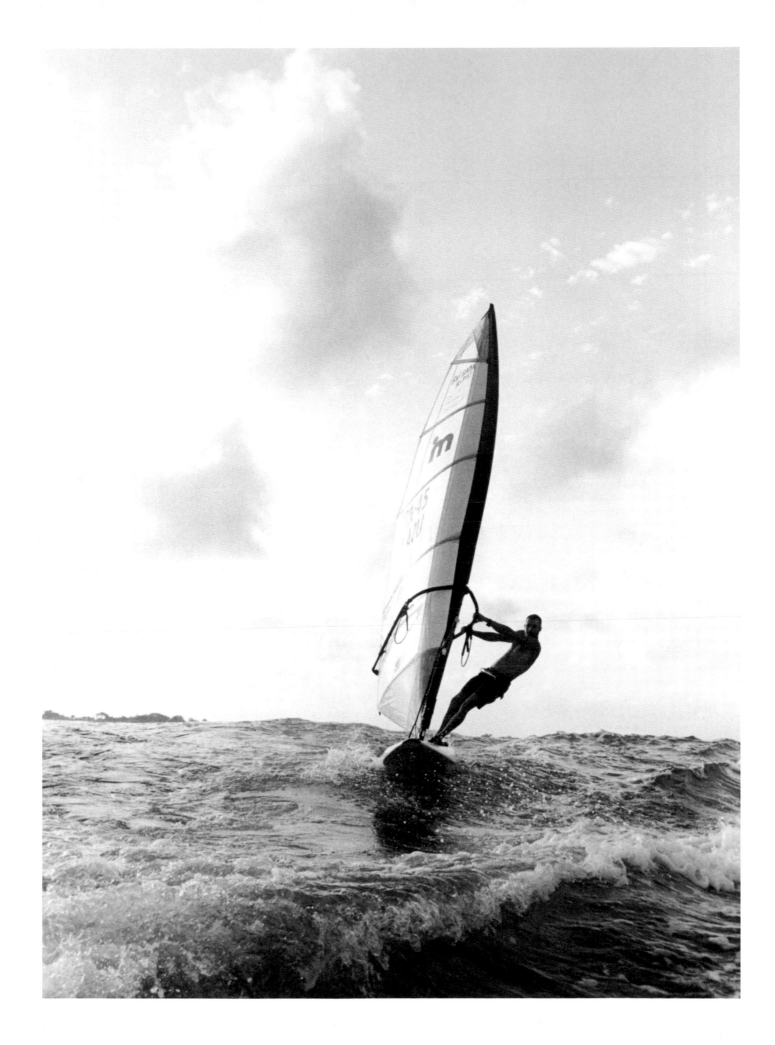

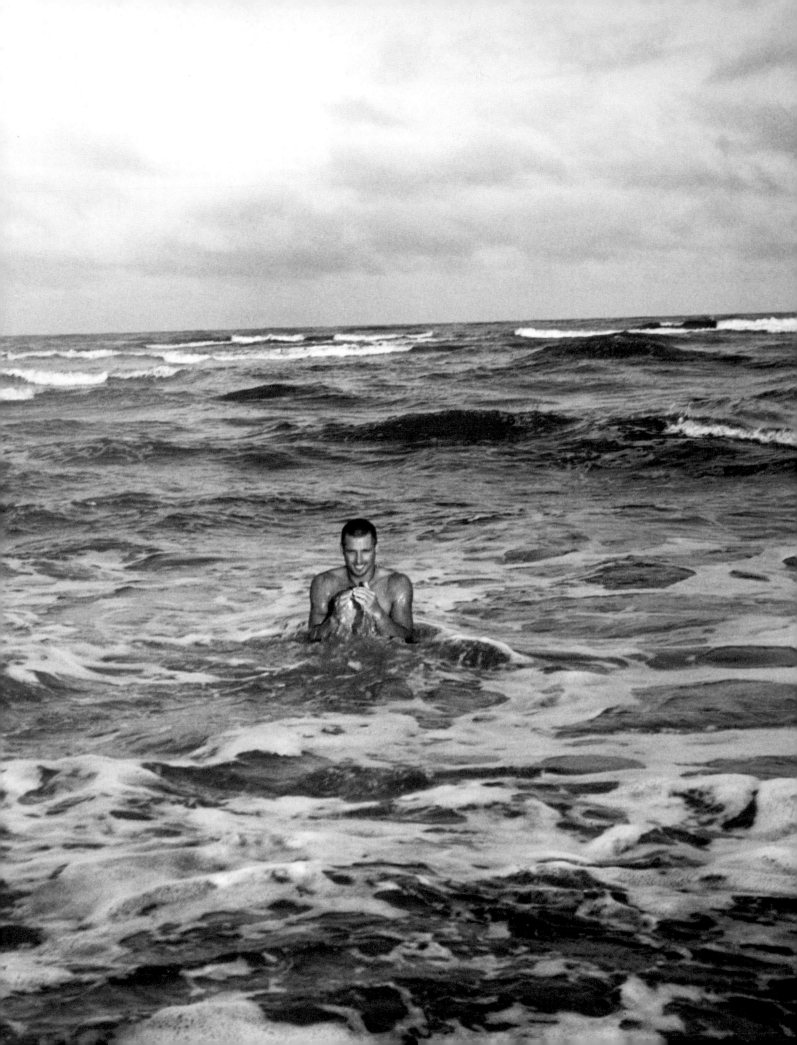

OLYMPICPORTRAITS
ANNIE LEIBOVITZ

* As of June 5, 1996, these
team trials were still in progress.

MY WARMEST THANKS TO

CASSANDRA HENNING JIM MOFFAT

LISA LAMATTINA

RAUL MARTINEZ

RICHARD BALLARD, DARIEN DAVIS, JULIAN DUFORT, MARTIN SCHOELLER

CAROLYN KASS

MICHAEL FISHER, MARGARET PLEYN, WALTER SAUNDERS
FOREST HOECKEL, ANDREW THOMAS, JOHN LIN

JOHN COOPER III

JIM MEGARGEE & CORNELIA VAN DER LINDE

AND TO

| Benita Fizgerald | Director
ARCO Training Center |
| Jon Root | Program Director
Atlanta Centennial Olympic Properties |

AND THE OTHER OLYMPIC OFFICIALS WHO MADE THIS WORK POSSIBLE, ESPECIALLY

John Krimsky, Jr.	Deputy Secretary General United States Olympic Committee
A.D. Frazier, Jr.	Chief Operating Officer Atlanta Committee for the Olympic Games
William Porter Payne	President & Chief Executive Officer Atlanta Committee for the Olympic Games
William B. Campbell	Vice President, Olympic Programs Atlanta Centennial Olympic Properties

Photographs in this book will appear in
Olympic Portraits — Photographs by Annie Leibovitz
an exhibition in the 1996 Olympic Arts Festival
generously supported by SWATCH.